D1086391

Conceptualism in Latin American Art

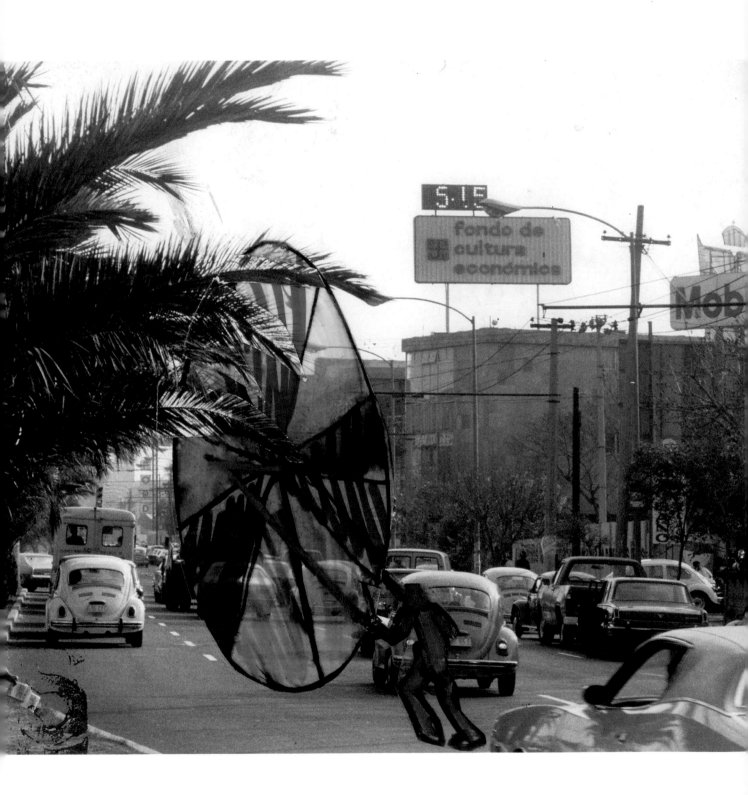

Conceptualism in Latin American Art: Didactics of Liberation

by Luis Camnitzer

University of Texas Press ◆ Austin

Joe R. and Teresa Lozano Long Series in Latin American and Latino Art and Culture

Copyright © 2007 by the University of Texas Press
All rights reserved
Printed in China
First edition, 2007

Requests for permission to reproduce material
from this work should be sent to:
 Permissions
 University of Texas Press
 P.O. Box 7819
 Austin, TX 78713-7819

www.utexas.edu/utpress/about/bpermission.html

∞ The paper used in this book meets the mini-
mum requirements of ANSI/NISO z39.48-1992 (R1997)
(Permanence of Paper).

Library of Congress Cataloging-in-Publication Data

Camnitzer, Luis, 1937–
 Conceptualism in Latin American art : didactics
of liberation / by Luis Camnitzer. — 1st ed.
 p. cm. — (Joe R. and Teresa Lozano Long series
in Latin American and Latino art and culture)
 Includes bibliographical references and index.
 ISBN 978-0-292-71639-1 ((cl.) : alk. paper)
 ISBN 978-0-292-71629-2 ((pbk.) : alk. paper)
 1. Conceptual art—Latin America. 2. Arts—
Political aspects—Latin America—History—20th
century. 3. Conceptualism. I. Title.
 NX456.5.C63C36 2007
 709.8—dc22 2007008229

To Selby, for helping me to Anglicize my language and, more importantly, for her love and patience, both of which allowed me to have a taste of saintliness

Contents

Acknowledgments

The origin of this book can be traced to 1991 when Catherine de Zegher was in the process of organizing the exhibition of Latin American art "The Bride of the Sun" for the Royal Museum of Antwerp. I was one of the invited artists and, given my intrusive nature, immediately crowded her with suggestions about how the show should be both organized and politicized. Catherine's plans were not at all shaken, but she kindly suggested that I write down my ideas. She thought they might be useful in generating another kind of exhibition. The suggestion engendered an initial two-page laundry list. Subsequent rewritings enlarged the ideas to about 120 pages by 1994. Later, my friends Rachel Weiss and Jane Farver read this version, first as a friendly gesture, but then they suggested that we should organize an exhibition. Further discussions and reality checks about funding and venues made it advisable not to limit the exhibition to Latin America, but to give it an international scope. Thus, unexpectedly, the text became a modest and incipient seed for Global Conceptualism: Points of Origin, 1950s–1980s, an exhibition shown in the Queens Museum in New York five years later.

I returned to the manuscript intermittently. By the time I had 320 pages, in 2003, I decided to apply for a Rockefeller Foundation Bellagio residency to finish it. The contribution of that stay cannot be overemphasized; it was an idyllic and pampered month. Living in the confinement of a Lago di Como postcard, I had the undivided attention and help of my wife, Selby Hickey, to organize my chaos and transform my English into understandable language. At the time, I mistakenly thought I was done. Louis Hock, a fellow resident at Bellagio, and Susette Min and (once again) Rachel Weiss, upon my return to the United States, proved me wrong and sent me back to the keyboard. I scrapped some chapters, but the manuscript kept growing nevertheless, and then my son Gabo added his well-taken reservations and perspective representative of a much younger generation (he also taught me text messaging). A year later, with 370 pages and fourteen years of brooding, I decided that maybe it had become an obsessive enterprise and decided to call it quits. Which is, of course, wishful thinking. At this writing, there is still an index to be made and the University of Texas Press copyediting

procedure to be gotten through, during which I'll undoubtedly keep introducing more changes and additions.

In any case, the whole process went on long enough that I may have unfairly and unforgivably forgotten many friends who gave me pointers, suggestions, and help. Among the ones I do remember are Carlos Basualdo, Minette Estévez, Rick Estévez, Agnaldo Farías, Andrea Giunta, Shifra Goldman, Nicolás Guagnini, Ana García Kobeh, Cuauhtémoc Medina, Susette Min, Frederico Moraes, Víctor Muñoz, Gerardo Mosquera, Héctor Olea, Justo Pastor Mellado, Gabriel Peluffo, Gabriel Pérez Barreiro, Mari Carmen Ramírez, Gabriela Rangel, Mario Sagradini, Patricia Sloan, and Zuleiva Vives. To the others, I apologize.

I should also note here that I would have liked to reproduce fully the work by Lygia Clark. I refused, on principle, to pay the $400 the estate wanted for the reproduction right, as I feel that such a fee curtails the free flow of scholarly information. Thus, a glimpse of Clark's catalog will have to suffice.

Finally, and this is a while later than all of the above, I want to thank Nancy Warrington for her wonderfully precise editing. After receiving her corrections, I realized that she must have felt as if she was walking on wet mud, with very few twigs to hold on to.

TRANSLATION NOTE: All translations from non-English sources were done by the author unless otherwise indicated.

Conceptualism in Latin American Art

Introduction

You believe you are different because they call you a poet and you have a separate world beyond the stars.

From watching the moon so much, you have stopped knowing how to look, you are like a blind person who doesn't know where he goes.

<div align="right">—FROM A SONG BY ATAHUALPA YUPANQUI</div>

Anything that keeps something upright helps the work of the police.

<div align="right">—INTERNATIONALE LETTRISTE 2 [1]</div>

In my imagination, art started with some cave person doing something so unexpected, unknown, and awesome that it escaped any word available at the time. Somebody then must have decided that it should be named art (since I am writing in English). Since that event, people have been trying to fit into the word and not into the experience. They followed the techniques used for that first experience and neglected to deal with what caused its use.

As a result, we live in a world rigidly defined by crafts and disciplines. During the mid-1960s, I and many of my colleagues slowly, and for different reasons, retreated from a craft-defined art and shifted into the realm of ideas. In cultural centers like New York, the shift was done through reduction and dematerialization of the work of art.[2] The focus was primarily on the material support and on what was called its dematerialization. But this quest was confined to a disciplinary view of art. There were things that belonged to art, and there were things, like politics, that did not.

On the periphery, Latin America included, the accent was on communication of ideas, and given turmoil, economic exploitation, and cold war, a great percentage of ideas dealt with politics; thus politics were in. This created a big divide between center and periphery. The center—in this case identified primarily as New York, which had taken over the previous role of Paris—created the term "concep-

tual art" to group manifestations that gave primacy to ideas and language, making it an art style, historically speaking. The periphery, however, couldn't have cared less about style and produced conceptualist strategies instead. These strategies were formally open ended and much more likely to be interdisciplinary.

However, since art history is written in the cultural centers, this difference got obscured, and only those artists who are seen as fully fitting the style are recognized. What I am trying to do here is to trace the roots and genealogies of Latin American conceptualism from its own tradition rather than treating it like a derivative product of what was current in New York and Paris, often many years later.

As an art student in Uruguay during the 1950s, absorbed in a student body that was probably as militant as the rest of the Latin American students of the time, if not more so, and immersed in an atmosphere of dreams about social change, I discovered that one of the recurring topics of discussion was whether art could have real impact on the world. Was art, as we would pose schematically, a "weapon" or only an elitist pastime? Never mind that during the 1950s Uruguay was still affluent, democratic, and proudly fitting the stereotype of "the Switzerland of Latin America." The country had profited richly from the wars of others by selling beef, and it afforded a stable government, a rabid separation of church and state, free education through final degrees, equality for women, early retirement, and pretty much whatever one would hope from a progressive state. But we still posed those questions that would be debated with more cogency in the following decade. Maybe the fact that we were dealing with a nonreciprocated image—Switzerland was never called "the Uruguay of Europe"—was a giveaway of what international perception was about.

Nevertheless, we art students went on with our questions, such as, Was it right that art was an activity performed in isolation from the daily experience? Even then it was clear that the controversy over socialist realism versus abstractionism held no meaningful answer to this question, despite what many of our teachers claimed. Nor did it help to put up the works of artists like Uruguayan painter Pedro Figari (1861–1938)—with what could superficially be seen as charming postimpressionist landscapes—and Mexican painter Rufino Tamayo (1899–1991)—with apolitical and pleasing murals—as examples of a true autochthonous art in opposition to militant Mexican muralism. This trick served to define Latin American bourgeois identity within the narrow field of art and taste, but it wasn't of much help for anything else. There was an atmosphere of complacency in what we were learning and doing.

It was the emergence of the Tupamaro guerrilla movement in Uruguay during the mid-1960s that made me see things a little differently. Not long ago I

found a scrap of paper from 1970 on which, for reasons I don't remember, I had written down a kind of genealogy: Dada—situationism—Tupamaros—conceptualism. Over the years, the sequence in this list lost significance for me, partly because I stopped believing in one seamless global history of art, and partly because the list itself came to seem too narrow and rigid in its exclusive concern with "art" history. But the idea that the Tupamaros' operations were a valid form of art making stayed with me. It made me think more about the artificiality of some of the distinctions we make between people's activities, and it led me to seek local histories in which both art and other actions are revealed as responses to immediate surroundings. A global history of art or a unified master narrative of art history becomes less absolute and fixed in this way. An outside view that does not take this history for granted makes one healthily paranoid about hidden agendas, and then assumptions as to cause and effect in the history of art (e.g., realism-impressionism-cubism, etc.) suddenly become suspect.

All these concerns became very important for me, beginning in 1966, and they led me to pursue conceptualist strategies in my own work since then. Around 1968, coincidentally and not as a consequence of international turmoil (student revolts, anti-Vietnam rallies), pressure from art theoreticians and galleries started to build up in the New York scene to fit all conceptualist endeavors into what is known as conceptual art. Some issues, like institutional critique and dematerialization, seemed to overlap with our work. Thus, it became important at the time to try to figure out the ideological and formal differences, if there were any, between what my generation of Latin American artists was doing and what was being produced in the cultural centers shaping hegemonic culture: New York and Paris.

One of the perceptions shared by that Latin American generation was a Latin Americanism that went further than the feeling that one belonged to one nation-state, and, without opposing it, fell somewhat short of the other feeling that one belongs to one world. Not that there was a clear definition of what "Latin American" actually meant, beyond sharing a more or less common language and to some extent an irritation or worse toward imperialism. Maybe that is one reason why, when we talk about Latin American conceptualism, there is the danger of equating precise geography with general and vague characteristics attributed to the whole continent. To tell the truth, the work we associate with conceptualism was not that evenly distributed geographically and did not happen simultaneously. For unexplained reasons, the clear first centers were seated in Brazil and Argentina and within the community of Latin American artists living and working together in New York. Uruguay followed, and then a slow expansion took

the narrow-mindedness of history preceding him. Ozenfant's book on modern art is highly personal, really a manifesto. I don't know if he wanted to clarify the history of art, but I think he wanted to challenge many of the ideas held about art in his time, and thereby force an understanding of his generation of artists. I am hoping that this same honorable description may apply to my own text. Ozenfant definitely was a revisionist at his worst. I may not agree with his formalist ideology, but I appreciate his explicitness about his project. One doesn't have to dig to find out what he stands for, nor is one misled by affectations of objectivity. In my experience, histories invariably serve a purpose that goes beyond the organization of information. The form in which data is selected and compiled bears messages. From this perspective, multiple histories are essential, enriching rather than impoverishing interpretation.

The two quotations I put at the beginning of this introduction attracted me because they seem to set the tone for much of the Latin American art I am concerned with. They also tell about the direction my revisionism will take. Atahualpa Yupanqui, an Argentine Amerindian poet and singer who was particularly fashionable while I was growing up in Uruguay, warns about elitism in art. The *Lettriste* statement, an antecedent to later declarations by French situationists, prefigures the antiauthoritarian rebellions of Paris in May of 1968. It points to the potentially subversive nature of dematerialization, hinting at a sort of political dematerialization. The quotes should be read together, since what interests me is not subversion for subversion's sake, but rather the way Latin American conceptualism synthesizes a commitment to art with a commitment to a better life. Today, when, unfortunately, being ethical seems to be the only tool left with which to exercise resistance, proactivity may appear to be a romantic and dated pursuit, but to me it remains an issue worthy of understanding and, I hope, useful for survival—which, of course, puts this text into a perspective dangerously close to a review of political activism in art rather than an analysis of an aspect of regional making of art. But, not being an art history scholar, I can allow myself to do this.

In any case, there is more than political activism in this exercise and in what is described here. While we had a good education that included all the expected great thinkers, we also read authors less acknowledged in the cultural centers.[8] For example, one of the intellectual influences my generation had while I was a student was the body of writings of Italian writer Giovanni Papini (1881–1956), particularly his book *Gog*. Papini was widely read in Latin America during the 1950s, and I consider him to be one of the most relevant authors in preparing the

ground for modern-day Latin American conceptualism. His own connection with art was not considerable except for a short membership in the futurist movement and for his book *Gog*, originally published in Italy in 1931. But *Gog* proved to be a piece of seminal importance. Gog is a millionaire who keeps receiving proposals from artists hoping for his financial support. Each submitted application is described in a corresponding story. In "Musicisti" (Musicians), a Bolivian composer asks for funds to compose music pieces based on silence. According to the composer:

> All music tends to silence, and its power lies in the pauses between one sound and the next. The old composers still needed these harmonic crutches to unravel the secrets of silence. I have found a way to dispense with the superfluous structure of notes and offer silence in its genuine state of purity.[9]

After hearing this, Gog enthusiastically ripped a check from his checkbook, filled it with the requested amount, and handed it over, unsigned, to the composer.

In "L'industria della poesia" (The Industry of Poetry), Papini describes several experiences with poets. A German poet known for his precision managed, after twenty years of work, to condense 50,600 verses into one single word: *Entbindung*, which means "to unbind," "to untie," but also "to deliver or release," and, more literally, it refers to the separation of mother and child by the cutting of the umbilical cord. Another poet, this one from Uruguay, composed a poem based on the sound of the chosen words, totally disregarding any meaning. The last poet, a Russian count, firmly believes that poetry only exists in the conjunction of poet and reader—the first suggests; the second fills in. His creation consists of a book with one title per page on otherwise empty pages.[10]

When these ideas entered Latin America via Papini, nobody was aware of either Marcel Duchamp's transposition of his notes for *The Bride Stripped Bare by Her Bachelors, Even* and the use of lyrics based on dictionary meanings of "*imprimer*" (*Faire une empreinte; marquer des traits; une figure sur une surface; imprimer un scau sur cire*) into musical scores ("Erratum Musical," 1913),[11] or John Cage's silence piece "4'33"" (1952). Cage's composition, so amazingly close to the Bolivian composer's work, was particularly influential in the development of U.S. conceptual art. It is not clear if Cage was aware of Papini's story (the English version of *Gog* was published in the United States in 1931), but Cage credits Robert Rauschenberg's *White Paintings* (1951)—which he saw during his residence at Black Mountain College—as his inspiration, and not Papini.

In these stories, Papini was able to carry the absence of subject matter to an extreme. The dematerialization within an already dematerialized medium intended to ridicule the reductive tendencies of the avant-garde movements of his time. Papini's intentions were sarcastic, and one should not make the mistake of placing him in a protoconceptualist tradition. However, his writings, when read in the late fifties, had a completely different impact compared to when they were initially published. *Gog* was probably indebted to the French Incoherents and to the artists belonging to Hydropathe and Hirsute (often the same people), who during the 1880s had created works critical of the French academy and the Salons.[12]

These nineteenth-century pieces were pranks, not theoretical statements, even if their liberating effect paralleled that of subsequent movements, and one can assume that they might have informed them. The same can be said about the pedagogical aspects of the Russian poet in Papini's story. He poked fun at progressive teaching as exemplified at the time by the methods developed by Maria Montessori and Rudolf Steiner. These systems stressed the participation of children in their own education, and the Russian can be interpreted as an advocate for the complete emptying of "teaching" of any substantive content. Papini approaches the process itself and makes believe that he is completely empowering the reader.

Papini's perspective adapted well to the Latin American context. While he offered an "anthropological" critique, so to speak, and shared conservative positions on social and artistic issues, it was very easy to read him equally well from a progressive point of view on art forms and politics. Thus, a syllabus for a sculpture class developed in the School of Fine Arts in Montevideo in 1960 lifted a Papini description from *Gog*. It was a story about a sculptor who created his sculptures out of the smoke coming from a fire built in a garden. He quickly shaped the smoke by hitting it with a piece of cardboard.

1 Salpicón *(Medley) and* Compota *(Sweetmeats)*
A SECOND INTRODUCTION

I needed some kind of a methodology for this book, and *salpicón* and *compota*, in spite of their cuteness, seemed useful methodological metaphors. They allow for my sifting through all the variables while maintaining the view from the periphery. Other metaphors considered—"genealogy," "constellation," and "*ajiaco*"—seemed problematic for different reasons.[1] In fact, to describe the Latin American situation with precision, the closest thing would probably be one of those enormous rhizomic configurations that can go underground and span several (small) countries, popping up everywhere as what we visually identify as mushrooms. Each mushroom is seen as a single fruiting body, or whatever mushrooms are, but it is just one of many tips sprung from one entity that acts as fertile ground and a connecting web for all of them. There is no cause-effect link between the mushrooms; still, they are equal signs of the same thing.

The need was for a diachronic approach that avoided any evocation of genes or folklore, the takeover by dogmatic lineage, or linear legacies and sequential traditions. "History" is a term that implies a linear causality and expresses a direct chain of influences. "Genealogy," which I used in an earlier version of this text, keeps the linearity and avoids the causality, but linearity is not right for this.[2] The word "constellation" seems to reflect better a coexistence of events in a unified class, but it bears the liability of allowing for excessive disconnection. "*Ajiaco*," a Caribbean soup of leftovers with room for literally anything edible, is an image initially used by Cuban anthropologist Fernando Ortiz and then widely applied by Cuban critic Gerardo Mosquera to the analysis of Cuban art. It seemed useful, yet too remote.

The other two food metaphors are based on dishes from southern Latin America. Both *salpicón* and *compota* are more organized than *ajiaco*. *Compota* consists of fruit cooked in its own juices with sugar added to the liquid while boiling reduces it. *Salpicón* is a medley usually made with chicken and some vegetables in mayonnaise. This may sound very much like chicken salad, but for some reason it tastes much better. The word comes from *salpicar* (to splash on; to sprinkle) and seems to be a good analogy for actions and events that seem haphazardly

scattered in history, somehow connected, but not necessarily having a causal relation between them.

Salpicón is a form of identifying shared postures, primarily in the context of underdeveloped areas versus developed centers, respecting the different sequences of events and the speed this context generates. *Compota*, on the other hand, is a good image to describe the adjustment, the acquisition of density, and the tuning process these splashes underwent through cooking, to finally lead to a more scholarly term like "Latin American conceptualism."

One reason an unusual metaphor is needed is that the issues addressed in this book come from personal experience, and specifically from a process in which I myself tried to make order. Added to this is a wish to incorporate several seemingly unrelated and extra-artistic topics. As mentioned earlier, one is the body of operations performed by the Uruguayan Tupamaro urban guerrilla movement during the second half of the 1960s and the early 1970s. Another is the written work of the nineteenth-century Venezuelan author Simón Rodríguez. Then, as I said, I consider pedagogy, poetry, and politics, and the blurriness of the borders that separate them from visual art, as crucial to understanding the shaping of Latin American conceptualism.

I should say that for a long time I have felt that these two particular historical events—the Tupamaros and Simón Rodríguez—are much more intimately connected with what is known as Latin American conceptualism than any artworks produced by either the European or North American stream of conceptual art. Although mainstream strategies involving dematerialization and re-signification must also be recognized as having been influential, the Tupamaros and Rodríguez somehow help complete the picture and position Latin American conceptualism on its own axis. The value of considering the Tupamaros and Rodríguez is that their activities reflect, in the first case, a synthesis of art and politics, and, in the second case, a synthesis of art and pedagogy in one integrated expression. Or, maybe more accurately and selfishly, I see them as making vivid a panorama into which I can fit myself more easily as a practicing intellectual.

Many links connect the Tupamaros and Rodríguez as if they were members of the same family who had never met or heard about each other. Perhaps the most important connection is their contribution to what can be called a *didactics of liberation*. In this task, the Tupamaros used aestheticized military operations. Rodríguez, for his part, resorted to ideological aphorisms. He wrote these (preceding Stéphane Mallarmé) with the unusual devices of breaking up the text and changing fonts in the same paragraph. For both the Tupamaros and Rodríguez, the central concern was not aesthetics, but the erosion of information. In their own

language, this probably could simply be called "directness." Both clearly addressed a specific public in an effort to raise consciousness to a maximum level of clarity and understanding. The Tupamaros were all-encompassing in this; Rodríguez tried to cover as much as was possible in his time.

Rodríguez published many of his works in newspapers, which at that time (the early nineteenth century) were both a tool for dissemination and a vehicle for addressing a tiny literate segment of the population. Both Rodríguez and the Tupamaros had a utopian view of society as perfectible and capable of nurturing mature and healthy individuals within a collective structure. It was typical of the spirit of socialist democracy, as distinct from that of liberal democracy, in which society is viewed as no more than an accumulation of individual atoms. In the case of Rodríguez, his socialist position was influenced by Jean-Jacques Rousseau and by his opposition to Spanish tyranny. In the case of the Tupamaros, it was based on a socialist vision distanced from the Soviet Union and drawn from local reality, and on opposition to the oligarchy that owned what they called democracy at the time.

The Tupamaros

My classification of the Tupamaro operations as artistic events is not casual or of recent origin. It first occurred to me in 1969, when I was in a meeting with students and faculty of the School of Fine Arts in Montevideo—my former peers and colleagues—and we were discussing the state of the school, which I found to be very deteriorated compared with what we had achieved with curricular reforms before I had left Uruguay five years earlier. The country was already a de facto dictatorship, although legally it only became one in 1973. I found myself suggesting then that the presence of the Tupamaro form of guerrilla warfare, with its unusually high creative component, was important enough to merit and demand profound reevaluation and changes in the school's curriculum, not in terms of activism, which would have been irresponsible, but with regard to the analysis of art historical issues and the approach to creation. The discussion was heated and to some degree unfriendly to my position. Sometime before, and to the embarrassment of the school, one of the sculpture teachers had turned out to be a leader in the Tupamaro movement and was summarily fired after being arrested for bank robbery.

Later that year I pushed my point further, referring to the Tupamaro guerrilla operations as the only worthwhile Latin American aesthetic contribution to the history of art. I felt that the Tupamaros showed that the utilization of creativity,

usually reserved for art, to affect cultural structures through social and political ones was possible and already happening. The system of reference in this situation was decidedly alien to the traditional art-reference systems, but the operations of the group were functioning through expressions that contributed to a total structure change while maintaining a high density of aesthetic content. For the first time, the aesthetic message was understandable as such, without the help of the "art context" given by the museum or the gallery. The message was going directly from the object to the situation, from the elitist legality to subversion.[3]

Several years later, I continued to elaborate on this thought with the idea that the Tupamaros had, with their operations, created the only work of art that managed to deeply change the political consciousness of the people and, probably, the only political work that succeeded in establishing parameters for aesthetic perception in Latin America. Even if the history of art would never register these events, in a free Uruguay, in whatever future, the teaching of art should not be possible without this information.[4]

On each of the three occasions mentioned above, I had what I saw as firm ground on which to base my arguments, but I also believed that pressing the point to an extreme had value. So, each time I dealt with this topic, I went a little further. Today, armed with a more subtle historical perspective, and with some of the old partisanship now subdued, I am going to revisit the arguments and try to find a way to preserve their usefulness.

What the Tupamaros did, beyond their political agenda and without any art historical ambition, was to set in motion the breakdown of the boundaries that kept isolating art from life. Institutional critique and the fight for change were blended into actions that made the art object an obsolete vessel. Unlike the traditional avant-gardes, the Tupamaros did not stop at a definition of art in institutional terms. To be more accurate, they didn't even bother with that idea, despite having former art students and artists among them. Instead, they went directly to the activation of creative processes in nonartistic arenas. Their "work," therefore, made clear how artificial the frontiers are that define and delimit the artistic commodity. The relation between art and politics was made to seem entirely natural and mutually supportive. The Tupamaro guerrilla movement was no more focused on art than any other movement of its kind envisioning a social revolution, but in their development they came as close as could be to erasing the line that separates politics from art.

I don't believe it was a coincidence that the activities of the Tupamaros developed in a parallel fashion to those of the Latin American conceptualists in art,

who in their own realm were consciously trying to erase the limits imprisoning traditional art and to secure freedom by another route. With frontiers of thought and perception under siege and beginning to crumble, mutual leakage between art and politics was unavoidable, especially since Latin American art was always strongly oriented toward content, and content was easily politicized. Often paralleling thoughts of the French Situationists as they influenced the student rebellions in Paris in 1968, the Tupamaros were able to go a step further and fully enter the praxis.

Simón Rodríguez

My first encounter with the body of writings by Simón Rodríguez (1769–1854) took place during the early 1980s. It was then that I started to find citations of his aphoristic statements that seemed extremely precise. As early as 1828 he had given a warning that, even today, we have not completely acknowledged:

> We have been fastidiously citing facts of the same species and doing it *by imitation* of what others had done *by ignorance*, [just] to prove that we have studied history well.[5]

And, speaking of those of his countrymen who faithfully copied European directives, he challenged:

> Let them imitate originality, since they try to imitate everything![6]

Donde irémos a buscar modelos ? . . .
— La América Española es *orijinal* = ORIJINALES han de ser sus Instituciones i su Gobierno = i ORIJINALES los medios de fundar uno i otro .
o *Inventamos o Erramos* .

Figure 1.1. Simón Rodríguez, "O Inventamos o Erramos" (Either We Invent or We Fail), *Obras completas,* 1:343.

Rodríguez is revered in Venezuela more because he was Simón Bolívar's tutor than for his own work. In the rest of Latin America, he is practically unknown. Rodríguez initially seduced me just with his ideas, but, as I found out later, he had also developed a very particular visual structure for his writings, which anticipated the formal developments worked out by Mallarmé by about seven decades. Given his relative obscurity, his work certainly cannot be taken as a causal link in the cultural process leading to conceptualism. But the formal tex-

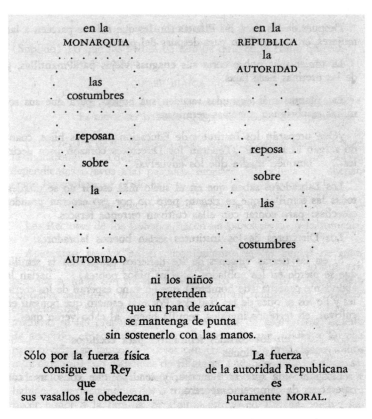

en la
MONARQUIA
· · · · · · ·
· ·
· las ·
· costumbres ·
· ·
· reposan ·
· sobre ·
· la ·
· · ·
AUTORIDAD

en la
REPUBLICA
la
AUTORIDAD
· · · ·
· ·
· reposa ·
· sobre ·
· las ·
· ·
· costumbres ·
· · · · · ·

ni los niños
pretenden
que un pan de azúcar
se mantenga de punta
sin sostenerlo con las manos.

Sólo por la fuerza física
consigue un Rey
que
sus vasallos le obedezcan.

La fuerza
de la autoridad Republicana
es
puramente MORAL.

Figure 1.2. Simón Rodríguez, "En la monarquía" (In Monarchy), *Obras completas,* 1:231.

tual devices he used to give more precision to the communication of his ideas, added to his use of his writings as a tool for struggle and resistance, certainly parallel and presage those of later Latin American conceptualists.

These two examples allowed me to look at Latin American conceptualism in a different way. Until now, Latin American conceptualism was linked to the European Arte Povera and the North American conceptualist movements and, with some juggling of the dates, had been classified as their belated offspring. However, the idiosyncratic character of the Latin American version, particularly in its interrelation with the ethical and political reality, makes this lineage fragile, incidental, and oppressive. One of the latter's most relevant aspects, de-institutionalization, barely appears in the rhetoric. Most conceptualist movements claim de-institutionalization as a big deal, but the definitions are mostly local and nontransferable. The term often refers only to de-institutionalizing art itself or its organizations. Here we are talking about something much deeper, an effort to seriously and radically change society, wherein museums and galleries are just small symptomatic manifestations of the problem.

Obviously, in a disciplinary sense, neither Simón Rodríguez nor the Tupamaros are part of a history of Latin American conceptualism, but they are incidental to its understanding. One is an example of creative pedagogy, and the others show how to put into action creative and active resistance. I want them to illuminate my arguments within the same regional tradition.

"Conceptualism" (as a separate term from "conceptual art") challenges not only aesthetics but also the attitude toward the role of art—the ways of producing it and its intended impact. This means that two ruptures have to be discussed, not just one. Of these ruptures, one is *formal* and the other *institutional*, and each has different historical significance. Hegemonic art history has not yet managed to keep these differences apart. The confusion becomes particularly problematic when conceptual art is used as an example of mainstream rupture from modernism. Chilean critic Nelly Richard warned about the use of these "rupturist dynamics of the new" to analyze art history in Latin America. In both mainstream and Latin American modernism, these dynamics are based on a European present that defines past and future according to a dominant idea of "progress" that was validated as a canon without considering the periphery.[7]

It was a mixture of miscellaneous forms of resistance that defined identity in the Latin American tradition; therefore, the rupture in attitudes was less significant.

2 *Agitation or Construction?*

If we approach issues from a nonformalist and non–art historical perspective, we can see the Latin American artistic panorama in a much clearer and more consistent way than we have been led to believe by art historians. For example, we can see how important utopian thinking was in the development of Latin American conceptualism, with some ideas dedicated to Latin America in particular, like having one unified continent free from imperialist pressures and with economic prosperity for everyone.

To address a utopia that it was hoped would become global some day, Latin American conceptualism carefully went through a series of somewhat fictional steps that were perceived as real. First, there was a belief in the "local community," which was then guardedly expanded into the "nation." After that, the hope was to achieve a cohesive, transnational continent able to establish itself as a supernation. In turn, this would supposedly lead to the consolidation of the whole of the Third World into one self-sufficient and nondependent entity. Finally, there would be the creation of an internationalist structure to operate in a truly horizontal fashion, rather than with the present vertical tendencies toward an imperial globalization. Any form of hegemonic rule was seen as being destructive and clearly not anything stylistic or related to art; it was socioeconomic and political conditions that would prevent us from reaching our goals.

One of the problems artists had to face in this progression toward utopia came from the imprecision of the category "Latin American conceptualism." The label was not current at the time—its use here is a concession to hegemonic taxonomy—but there was a general shared awareness to which the term can be applied for expediency. Superficially, Latin America is a conglomerate of nations and cultures knit together by religion and by language, mostly Catholic and mostly Spanish. But it also is an entity glued together by both a culture of resistance against invading cultures and a utopian longing for continental unity. I would go as far as to say that the concept of "Latin American" is in itself a utopian construct. One could even say, negating Simón Bolívar's dream, that Latin America is not much more than a conceptualist piece—a protoconceptual-

ist piece, as the mainstream would have it. Entangled with the modernist utopia, it is a work created under its own fairly negative conditions. The countries that make it up have both a different measure of European influence and different attitudes toward what to do with it. Self-images in terms of race and ethnicity change from place to place. In Argentina during the 1970s, the ruling dictatorial regime thought it might improve its international relations and attract investments by proclaiming the country "the eleventh whitest in the world," while Brazil consistently advertised itself as "completely integrated." Meanwhile, most nations on the continent refused to incorporate Amerindian languages into the schooling system and forced their native populations to read and write in Spanish, submitting them to a double colonization. The baggage of European colonization was carried for a long time. Just as in the United States, there is still nostalgia for the aristocracy and ludicrous attempts among the ruling classes to identify with it. In Uruguay during the forties and fifties, a time of democratized wealth and progressive thought, the word "*criada*" (raised) was still used as a synonym for "*sirvienta*" (servant) and "*limpiadora*" (cleaning lady). It was a given at the time that the role was a feminine one, but what's worse, "*criada*" didn't even refer to the job but to having been raised in and for servitude, the oligarchic system that followed the abolition of slavery during the nineteenth century and made it a custom to raise the children of lifelong domestic help to continue the service to the "family."

Levels of income and of class division vary rather strongly, not only within each country but also between countries. The amount of direct U.S. interference through unilateral deals, military bases, and often direct advising of army and police forces differs according to perceived fragilities, something that at times became an irritant for the United States as well. The Plan Cóndor during the 1970s and 1980s, when Chile, Argentina, Uruguay, Brazil, and Paraguay were ruled by dictatorships, tried to address this problem by allowing police personnel of the different countries to ignore borders when looking for political activists opposing the respective regimes.

All these variables and variations made a unified continental vision very difficult. In general, however, the values and the internalized tastes reinforced by market pressures were fairly consistent all over. The desire to assimilate into that market existed in all the countries, as did an opposition to these pressures. The thing is that any belief one held on the periphery in regard to this topic got translated into a political position. Unlike the traditional hegemonic view, in which art is mostly an expression of personal freedom defined as "the individual in contraposition to the collective," in Latin America art also became an expression ei-

ther of collaboration with the market or of a resistance that might help achieve a collective freedom.

Given the high political charge of the Latin American daily experience, it is not surprising that so much artwork addresses and reflects this tension, sometimes surpassing the concrete interests one expects from the more narrow and traditional definitions that limit the field of art. More interesting, however, is that in some instances the work goes beyond mere reflection and outside the field. As if the artist became impatient just spending time making things in the studio, the activity spills out and tries to directly affect and change political conditions. The urge to create is sometimes taken over by the need to agitate.

Faced with these options, the artist can schematically be seen either as an agitator or as a constructor of culture. Following canonic thought, we are normally led to believe that the aesthetics of agitation are at total odds with the aesthetics that correspond to shaping culture, even in the cases where they share a common sociopolitical ideology. The artist's job is one thing; the artist's role as a citizen is supposedly a completely different and unrelated one. This split is particularly accepted in the mainstream art world, and it is understandable and revealing that Sol Lewitt, writing within U.S. conditions, would state that "artists live in a society that is not part of society. . . . The artist wonders what he can do when he sees the world as pieces around him. But as an artist he can do nothing except be an artist."[1]

Another separation exists within the art field between the construction of culture and agitation. This separation is embodied by abstraction as opposed to realism. Abstraction, the modernist tool for utopia (particularly as used by the constructivists), is taken to typify the most extreme form of construction. It functioned as agitation, but only during the initial and short period when it was perceived as an aesthetic (dis)rupture. Art in this case guides our ways of seeing, of making connections, and, secondarily, affects our taste. Mostly, the modernist belief implied that good art would help make a good society.

Abstraction thus managed to evade Walter Benjamin's description of the assumed opposition between commitment and quality for the author (in Benjamin's case, the writer, but it holds true for the artist as well): "*On the one* hand one must demand the right tendency (or commitment) from a writer's work, *on the other* hand one is entitled to expect his work to be of high quality."[2] For the abstract artist, the *right* tendency (meaning the correct tendency) or commitment didn't necessarily exclude agitation, but only as long as it escaped the provincial confines of locality. So abstraction, in Benjamin's way of thinking, was

really immaterial. Meanwhile, realism, a form of visual storytelling, preaches by illustration and is therefore allowed to more overtly be a tool for agitation.[3] This is so because there is an ingrained assumption that agitation is possible only with a narrative and a recognizable reference to visual reality, that is, a literal and realistically rendered message. Therefore, supposedly, it is also better suited for local expression.

But, in truth, we cannot measure the real difference between agitation and construction by a limited check of which formal style has been adopted by the artist, by what is being said in the "story" the work is telling us, or by whether it is telling a story at all. The real difference only becomes apparent when we look at the amount of power the artist is given to shape society (and what the definition of that shaping is) and how that power is used. Or, rather, the amount of power the artist naively believes he/she has.

The power attributed to agitation is very small. Basically, one expresses an opinion and tries to disseminate it—not much more than that. In that sense, we can attribute much more power to cultural construction in terms of changing society. Here one actually wants to affect the ways of perceiving and is closer to effecting a structural change. It is very odd, then, that the establishment feels much more threatened by agitation than by the acts of constructing and shaping culture. Maybe it is because the different effects are not understood. Or maybe it is because a more modest use of power is less likely to be harnessed and controlled, and for that reason it can be more effective than a comprehensive and, essentially, utopian approach. In the Latin American context, no matter what position one takes, it means flirting with subversion.

Subversion is often confused with a form of political nihilism, and for that reason the point needs elaboration. My generation, the one intellectually formed during the U.S. intervention in Guatemala in the 1950s, was educated with the idea that art is a tool for combat. In revolutionary movements of the period, some artists took this rather literally and simplistically, but in its essence the idea was really founded on the belief that subversion is essential to refresh society. To subvert a situation means to create a perceptual distance from the status quo, one that prompts reevaluation and elicits the will to make changes. Subversion allows for the introduction of common sense and the missing justice into stultified conditions. Art, for my generation, was a good tool for subversion. But the premise behind this idea, powerfully persuasive at the time, was that there was already a community or, at least, a public available that had the potential to become a community. Using this premise, subversion was a viable tactic for so-

cial improvement, since it addressed and was specifically designed for this chosen public. To work with ideas rather than forms became the natural vehicle to connect the artist with this chosen public.

What has seemed to happen in the development of Latin America Conceptualism is that it has become a unifying strategy for both agitation (sometimes including subversive agitation) and construction. A favorite example of this, in part because of its endearing literalness, is Víctor Grippo, Jorge Gamarra, and A. Rossi's *Construcción de un horno popular para hacer pan* (*Construction of a Popular Oven for Making Bread*). Grippo (Argentina, 1936–2002) and his partners made this brick construction in a public space in 1972, both to keep alive and to dignify a popular tradition and to denounce the increasing pauperization of the working class in Argentina.[4] In his description for this piece, Grippo specifies his intention as: "To translate an object known in a specific environment by specific people, to another environment frequented by another kind of person." The action included "(a) construction of the oven, (b) making the bread, (c) breaking the bread," and the "pedagogical result" was "an interchange of information."[5] Grippo unified all these concerns into one strategy, and therefore the issues of style and separation of narration from form became of secondary importance. These points were only tools.

In either case—agitation, shaking the platform that is taken for granted; or construction, helping to build a new culture—the impact of work made under these conditions was always intended to go beyond the objects produced. We can speak of such an impact because the works often didn't even cling to their "art identity." Artists frequently turned against art itself, going far beyond what one would aim for with a simple stylistic rupture. Art somehow became a target because it proved to be too restrictive to deal with the surrounding reality. Thus, making art, at least in its formalist version, stopped being the real issue. The aim became to organize a receptive community, which is a political issue.

Art and politics are always told in two separate histories. Occasionally, one character may appear in both, as was the case with the Mexican muralist David Alfaro Siqueiros (1896–1974), who not only filled Mexico with murals having political content, but was also active himself in militant politics. However, even when this happens, leakage is negligible. There is no real unified interdisciplinary field yet for "political art," or for "aestheticized politics" to compensate for this fragmentary perception. Even worse, when we talk about these things, the evocations are ideologically tainted. "Left-wing stuff" is the name used for the first, and something close to "national socialism" is applied to the second, and

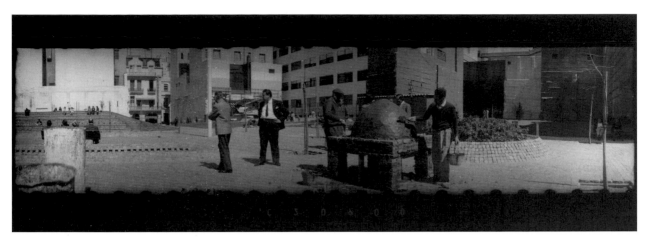

Figure 2.1. Víctor Grippo, Jorge Gamarra, A. Rossi, *Construcción de un horno popular para hacer pan* (*Construction of a Popular Oven for Making Bread*), 1972. Photo Víctor Grippo, courtesy of Nidia Olmos de Grippo.

the merger becomes even more difficult. And then there is the problem of how the histories are written and who writes them.

Once we entered a world of ideas beyond or before the technical ways of presentation, as is the case with conceptualism, we often combined many more ingredients than we used to in more traditional art forms. Strong interdisciplinary dynamics came into play that tended to merge into art many elements that had been kept out for a long time. The outcome of the merger often did not resemble any known art formats. This upheaval of classification, a sort of anarchy in knowledge that makes topics much more interesting than any traditionally organized system, was not limited to Latin American conceptualism, nor was it reduced to an inclusion of politics alone. Pedagogy and poetry accompanied politics, and all three of them have to be considered on the same level with the achievements corresponding to visual/formal solutions. In many cases, all three ingredients have to be considered part of the artist's palette. They seem to influence each other much more in Latin America than in the mainstream, and it is something that becomes more evident when comparing Latin American and mainstream conceptualisms.

Art, politics, pedagogy, and poetry overlap, integrate, and cross-pollinate into a whole—a form of overcoming the agitation/construction polarity. When hegemonic mediations and art as a form of fashion making are left aside, we are able to read art as a sign of socioeconomic and cultural differences, bringing us closer to a better understanding of reality.

3 *The Terms*
"INDEFINITIONS" AND DIFFERENCES

Art history developed an enormous array of terms that, though useful for the powers that administer it, turn out to limit and distort the perception of what actually happens on the periphery. One could start with the definition of what constitutes a professional artist. The mainstream has a much more disciplinary and narrow definition of professionalism than the periphery has. As a consequence, the investment in branding a style is much higher, and a larger body of work and greater consistency is required to be an "accepted" artist in the mainstream. While on the periphery a good, important idea may give an artist recognition and have a cultural effect, mainstream artists have to prove themselves with a whole line of production. This, in turn, often casts a light of "unprofessionalism" onto periphery artists when they are judged under mainstream standards.

Closer to the topics of this writing, problems abound with the term "conceptual art," at least when we try to cover all the artistic activities that took place around the world and have their point of departure in some form of concept. The term is generally used in that curiously inclusive/exclusive way that is customary for hegemonic styles in art: "Yes, it is international and not local," and, "No, you are not really part of it because your stuff is different." Benjamin Buchloh is one author who, early on and in the end correctly, limited the term "conceptual art" to Europe and North America. Increasingly, the label has been reserved for the stylistic shape that conceptualism took in North America (language, grid paper, a degree of ephemeral quality, documentation, etc.). It should therefore designate a movement based on its formal attributes.[1]

The clarification of this distinction between "conceptualism" and "conceptual art" was one of the topics addressed in the exhibition Global Conceptualism: Points of Origin, 1950s–1980s. It seemed appropriate to place North American conceptual art as one example among the many forms of conceptualist strategy that appeared between the 1950s and the 1980s. While the international critics accepted this decision, most of the reviewers in the United States were deeply offended by it and refused to accept a distinction between the terms. The gallery

guide of the *New Yorker,* in a text that appeared repeatedly during the weeks of the exhibit (June–August 1999), was wonderfully clear and succinct in its reaction:

> The show's basic thesis holds that Conceptualism developed in the sixties as several independent movements in different locales, in contrast to its generally accepted history, which emphasizes a core group of mainly American artists—Joseph Kosuth, Lawrence Weiner, Sol LeWitt, Hans Haacke, and others—and certain important European satellites. The premise is fine as a means of bringing to light hitherto neglected works, but the studious avoidance of the traditional history and figures becomes annoying.

As threatening as this clarification between "conceptual art" and "conceptualism" may be to U.S. views and beliefs, without it, the use of either term creates serious distortions. The use of "conceptual art" as a blanket term gives importance to any formal resemblance to conceptual works produced in the cultural centers and ignores how art addresses its audience. Those works that deviate from the canon because they introduce elements (in both form and content) of local interest or relevance are ignored (as those of Hélio Oiticica and Lygia Clark were for a long time) or seen as less important. Ironically, it is often those works that are not necessarily accessible outside their primary audience that have a greater local impact and cultural importance.

Moreover, this more extended use of "conceptual art" doesn't let us see that the same works of art and events may play different roles and have different projections in different histories.[2] This would be a problem with any stylistic movement, but it becomes particularly dangerous in this case, since one of the major claims of mainstream conceptual art, as a postminimalist form, is an aspiration to purity. Joseph Kosuth and Lawrence Weiner try to isolate meaning from any form, narrative, or material support as far as possible. Thus, as a form of "spiritualization," this search for purity sometimes leads to arcane but heated elucidations. One of them, for example, is the difference there may be between the "declarative" and the "performative" qualities of a work of art (i.e., some works by Kosuth, Weiner, and Robert Barry in the U.S. context). The maintenance service required to hone this identity often makes people sound like refined theologians.[3]

Although I am advocating a separation in the use of "conceptual art" and "Latin American conceptualism," I do not want to suggest that Latin American conceptualism belongs among the "aboriginal" expressions of the continent, or

in the arts, that to look at it with detachment and understanding is nearly impossible. Nevertheless, I prefer to consider "local unpredictability" instead of "originality" in determining the interest, impact, and influence of a work of art. With this term, I hope to get away from the ideas of individual achievement and market success and come closer to that of cultural articulation.

Any "original" work that managed to make a first breakthrough is important because, in a given context, it had an unpredictable quality. In that same context, a work that is locally derivative because it rehashes something already known by its audience is not unpredictable but redundant and trivial. The process of appropriation and recycling often facilitates the quality of unpredictability in new localities. The difference from its origin adds a choice of mixtures and contexts. In *One Hundred Years of Solitude*, Colombian writer Gabriel García Márquez described the reaction of the people of Macondo on seeing a block of ice for the first time. The feeling of magic was underlined as the primary and persuasive experience. A technologically advanced culture could disregard this encounter as a sign of ignorance and primitiveness, but such an interpretation would be a clear symptom of deafness, not of superiority.

Mistakes, however, can also be made in the opposite direction. Over the years, a backlash likes to portray cubism as derived from African art. There is a nice, but fleeting, feeling of triumph in this revision. But by literally sticking to this view, we don't see that the triumph only shows that we are continuing to follow the same hegemonic rules. If we weren't obsessed with losing and trying to win, we would appreciate the appropriation that took place and the recycling of devices that was used. As with the people of Macondo and the lump of ice, European artists were rightfully dazzled by African art. They put the ideas it contained to work in their local context and gave it a different meaning. It is here where the quality of unpredictability occurred and contributed to Europe's culture in that particular moment.

The interest in unpredictability brings me to another term: "rupture." In the aesthetic development of Western cultures during the twentieth century, rupture has been accepted as something positive, at least when it is applied to art issues. Mainstream conceptualist movements have been both a form of rebellion against, and a consequence of, preceding art movements, and that earned them a rightful place in the corresponding history. This aspect of rebellion (and therefore rupture) serves to identify the movements from within. As in a fight, the artists suddenly know where or on which side they belong. Seen from outside, the same features in that fight help observers to classify movements. Rupture is also helpful for marketing, since it is equated with originality. That mark of in-

dividuality, if kept within limits of decency and understanding, is always rewarded within a capitalist society.

Rupture within the master narrative of art usually is a formal consequence of whatever art styles came before. Art historically speaking, the qualities that make the rupturing movements a formal consequence of other movements can then be picked up to place the new within a seamless narration. It is the artificial need for an unbroken linear development in the history of art that brings about the compromise between rupture and consequence. A new movement breaks away from the past, presents a new and unexpected paradigm, but, oddly enough, also manages to continue a heritage as an inevitable predictable development. This feat is achieved by rearrangements and the smoothing of categories with strange tools like the labeling of some forms of expression as "protomovements."

The word "protomovement" allows the exclusion of some artists from a group into which they might fit thanks to form or intention for the sole reason that their inclusion might upset some other ideas. For instance, it could upset the date structure of the storytelling. In line with this, both Yoko Ono's *Instruction Paintings*, the earliest of which are from 1961, and some even earlier works by George Brecht are classed as "protoconceptual."[5] It is not completely clear why, but it has been decided that conceptual art started in 1965. Consequently, Ono's and Brecht's work don't fit the narration, and it would be terrible to simply affirm that conceptual art started much earlier. These mental hoops jumped through to accommodate a chauvinistic (i.e., of country or ism) writing of history are further complicated by the presumptuous naiveté that leads to classifying the re-creations of previous work by other artists, made many decades later, as original. Depending on how far removed in time, these re-creations are accepted as a new beginning or politely referred to as *post* or *neo*.

Conceptual art was placed within the limits defined by hegemonic history writing once it was perceived as an art style equal in rank with other isms. In itself, this is not something totally bad, even if it cannot fully account for some of the works (e.g., by Gordon Matta-Clark, Hans Haacke) usually claimed for the movement. The placement brings with it some focus and a form of identity that can generate new artistic thoughts and forms. And when nothing new is generated, the placement at least can validate some existing thoughts and forms with a coherent theory. However, conceptualism, not being a formalist movement, is much broader than conceptual art or any preceding artistic style. It was not simply one more aesthetic movement to be neatly fit into the development of the Euro–North American avant-garde. Conceptualism started in a blurry form, and

much earlier, and it was a huge grid of historical, cultural, political, and economical influences and forces. Metaphorically speaking, different regional roads passed through it at different times and following regional clocks. That is why any search for coincidences using the standard mainstream attempts at a definition of conceptualism is irrelevant, and a comparative study of the many versions of conceptualism seems a much better way of approaching the subject matter.[6]

4 *Conceptual Art and Conceptualism in Latin America*

I will now try to sift through some of the differences I see between mainstream conceptualism, particularly as developed in the United States, and Latin American conceptualism by looking at four areas that, more often than not, are placed in a political context. Thus, even in those areas where common ground exists (dematerialization and textualization), there is still a difference. The four areas are: the function of dematerialization, the role of pedagogy, the use of text, and the literary analogue used as a model for art.

The term "dematerialization" was introduced to the mainstream by North American art critic Lucy Lippard in 1967 and now seems to be permanently welded to conceptualism. It is ambiguous in its meaning, and its use isn't even consistent. In mainstream art history, the term has been the subject of many philosophical speculations, including its impossibility—the case being made that the most elusive projects still need some material support to exist.[1] Even Lippard shows changes over time. In her first statements, the idea of dematerialization in art appears as a response to an excessive dependence on crafts. Three years later, in her prologue to the show 2,972,453 (1970, Buenos Aires), she politicized the concept, pointing out that "social change, radical politics, . . . lack of faith in existing cultural institutions and economic systems, have all affected the emergence of dematerialized art."[2] Today the mainstream views dematerialization as a logical consequence of reductionism. However, to understand Latin American conceptualism, it is important to make a clear differentiation between these two terms.

In the art historical discourse, "dematerialization" has been a way of "reducing" material, which has been part of the formalist reductionism typical of the very early 1960s. Formalism, in turn, generally excludes politics. In the Latin American context, dematerialization was not a consequence of formalist speculation. Instead, it became an expedient vehicle for political expression, useful because of its efficiency, accessibility, and low cost. When reductionist movements have a utopian, political, or metaphysical objective, the message is not carried by the art, but in separate manifestos that try to explain the intentions of the cre-

ators. Manifestos define enemies, sometimes straw men, through which one's own identity can be affirmed at the expense of the target.[3] Messages are avoided in the artwork itself and are therefore placed in a parallel vehicle that permits the artist to be explicit.[4] Many Latin American artists concerned with finding formal equivalents to their political visions without falling into illustration also used this device, often to separate themselves from imported visions or to add political views that could not be expressed formally. Thus, the Uruguayan painter Joaquín Torres-García (1874–1949) wrote extensively to theoretically frame his constructivist paintings within a Latin American tradition, and the Group de Recherche d'Art Visuelle (GRAV) gave political reference to their kinetic installations through elaborate proclamations that would not have been readily visible in their constructions.

Generally, however, those constraints that in the mainstream relegated political expression to manifestos in order to leave the art pure were not as active in Latin America. Although this did not necessarily diminish the quantity of manifestos, it did have some effect on the messages they carried. Manifestos were more typical of literary movements, but when used in art, they were not carefully separated from the artwork. It was acceptable to read art in the context of property ownership, political power, and consumer behavior, and the importance and purity of material support was of secondary concern.

In the cases where dematerialization took place, it was for ideological, practical, and economical reasons. The manifesto was integrated into the making or creating of the object and appeared through it. There is no point in mystifying a low level of material support when it is driven by necessity and not by choice. In fact, in Latin America, dematerialization was explicitly suggested as a strategy in 1966, in an article by the influential Argentinean critic Oscar Masotta, where he wrote: "After pop art we dematerialize."[5] The question of who came up with the term first became an issue of contention in Argentina after the term entered art history's lingo and led to a long elucubration by Roberto Jacoby in the publication *Ramona*.[6] In his book *Conciencia y estructura*, Masotta published his lecture and included a quote from El Lissitsky's text "The Future of the Book," which had been reprinted in the *New Left Review* in 1967. In his essay, El Lissitsky wrote: "The idea that moves the masses today is materialism: however, it is dematerialization that characterizes the times."[7]

The occasion for Masotta's text was Eduardo Costa, Raúl Escari, and Roberto Jacoby's "anti-happening" that same year in Buenos Aires, an action in which Masotta was also involved. It was an event that had not taken place in real life, but had sprung to life in newspaper reports and reviews the same as a real event. It

was the information about the piece that became the piece. Masotta saw this work as a perfect answer to the object-oriented pop art, and, being a prominent theoretician at the time, his ideas had great influence on the art then produced in Argentina. Another work in this vein was organized the same year on the occasion of (and against) the Third Biennial of American Art in Córdoba, Argentina. Artists invited the public to witness a happening that used Gandhi's quote "There is room for everybody in the world" as the title. With the public gathered in the gallery and waiting for something to begin, the artists nailed the door shut from outside. The space was reopened an hour later with the staging of a protest rally against the recent police killing of student leader Santiago Pampillón.[8] A related piece was staged in Rosario, Argentina, in 1968 by Graciela Carnevale in the context of a Cycle of Experimental Art. The public was locked in the gallery space, causing such a scandal that the police prohibited any further exhibition in that venue. Increasingly, there was an attempt to let the message, or the content, exist on its own, without being trapped in material confines.

Figure 4.1. Graciela Carnevale, *El encierro* (*The Confinement*), 1968, Ciclo de Arte Experimental Rosario. Photograph belonging to the digitalized document about the "Grupo de vanguardia de Rosario," collection of contemporary art of the Museo de Arte Contemporáneo de Rosario, Argentina; donation of Graciela Carnevale, 2004.

The trend toward dematerialization in the United States had a different foundation, and "antimaterialism" may have been a more appropriate word for it. Many of the artists had a fascination with "essential" ideas, with a wish to isolate some core of an idea. Such a search did not have the same resonance on the periphery. Artists who produced conceptual works on the periphery—with the exception of those who limited themselves to mimicking the mainstream—"downgraded" the material vehicle, but without any particular dedication to having it eliminated.

In 1967, or thereabouts, Venezuelan artist Claudio Perna (1938–1997) set up still lifes, then photographed them and named them *Objetos como conceptos*

Figure 4.2. Claudio Perna, *Objetos como concepto* (*Objects as Concepts*), ca. 1967, silver print, 20 3 24 cm. Courtesy of Fundación Claudio Perna, Caracas, Venezuela.

(*Objects as Concepts*). From the point of view of mainstream conceptualism, such work was heterodox and lacking in rigor, and Perna would be excluded from any consideration as a contributor to conceptualism. However, if we examine his work carefully, we discover some useful things about conceptualism in Latin America. Perna's work adopted a conceptualist strategy in that he first set up his own readymade and then appropriated it into another context. Therefore it can be said that what Perna did was to determine the importance and value of the visual image literally by what he said in naming it. The text bore the meaning. From the mainstream's point of view, he had an excessive material presence. What he really did was to *recontextualize*.

It is important to note that both directions in conceptualism have a common concern that was never made sufficiently explicit. With hindsight, it is easier to see now that this concern was the erosion of information. In the process of realizing a work of art, there is always a distance between initial conception and final result, something that for the longest time has made me ironize that the history of art is an accumulation of errors. This distance is the first step of the

erosion process. When the work is read, viewed, or in any way consumed, there is a distance between the creator and the receiver. This is the second step in the erosion of information.

In 1969, Argentinean artist David Lamelas (1946–) partially analyzed some of these issues:

> Once we have the idea, the next step is to consider the means required for its materialization. Automatically, everything tends to *disregard* this executive phase that exists between *idea* and the *finished work.* All subsequent reasoning is aimed at concealing this intermediate step, therefore succeeding in producing a work fit for consumption. . . . The resulting "work of art" is thus completed, static and tantamount to itself—an artistic object that will remain forever intact. This is invariably the case, even if those works *change* or comprise *motion,* for what is displayed is the result of an idea transformed into a concrete fact.[9]

While Lamelas applies these ideas to traditional parameters of art and thus speaks of "concealing this intermediate step," what conceptualist artists share is a step beyond. Whether in the orthodox mainstream or on the periphery of conceptualism (and Lamelas himself was an active participator at the time), the concern is to minimize the erosion, not to hide it. Hiding leads to finding forms of packaging. In conceptualist work, the task is usually about revealing the intermediate step, hence so-called process art, which is one form of avoiding erosion. The real search was for something we can call (if we like jargon-fitting neologisms) "demediatization," a way of conveying everything to the viewer.

In terms of communication, conceptualism wanted to find ways to send messages through no-loss information systems. Theory of information, as presented by Claude Shannon and Warren Weaver, among others, was as important and influential to the artists both on the periphery and in the mainstream of the sixties as was semiotics and structuralism. Obviously, the diminution of the material presence was of great help in this. When considered in relation to ideas, material is something rather crude and rough. If one then adds the clumsiness provided by a craft, the distance between what the artists wants and what the viewer gets becomes quite notable.[10] In the search for ways to reduce the loss of information (*demediatization*), using context to give meaning (*contextualization*) appears to be a subtler tool than reducing material (*reductionism*).

In both mainstream and Latin American conceptualism, there was a very heavy emphasis on theoretical speculation. In some cases, artists were compelled to leave enormous amounts of documentation, too often unreadable or unbear-

ably boring. This outpouring was partly demanded by the need to explain and justify the nature of the rupture their work was supposedly producing, but it also served to explain things that were not that self-explanatory because of the lack of material presence. At the time, nonmaterial work seemed to have a smaller chance of staying in the historical record, so many artists felt the need to use their explanatory writing to make sure that they got registered. In later stages, in the United States and England, that theorization in text form slowly crept into the art itself and became one with the production of art. In an extreme tautology, the theory of the work of art became the work of art. In Latin America, artists theorized less about art than about politics, so it was politics that slowly crept into the production of art and became one with art. In 1968, Argentinean artist Pablo Suárez wrote a letter politically reasoning his refusal to participate in an exhibition and then, in turn, declared his letter to be his contribution to the show.[11]

The merger of politics and art not only gave identity and purpose to the role of art in society but also served as a strategy to effect change. It is primarily on this level where didactics entered conceptualist art in Latin America.

"Didactics" is generally considered a dirty word in the art shown by high-culture galleries. It is the primacy of formalism and the promotion of *art for art's sake* as a symbol for individualistic freedom that led to a very simplistic definition of didactics and to its blacklisting. In formalism's dismissive definition of "didacticism," explicit messages are viewed as *dumbed down,* a move that was considered unacceptable for any self-respecting gatekeeper of the arts.[12] But besides adopting a patronizing attitude toward the viewer, because of this primacy of formalism, the term "didactic art" is also intended to evoke negative things like propaganda, authoritarian manipulations, and totalitarianism. It is equated with indoctrinating simplifications. This snobbery, however, hides the fact that didactic qualities are unavoidable when one deals with any form of purposeful communication, regardless if one is in the center or on the periphery. The real question to be discussed is not so much the importance of avoiding didactic intent, but rather how effectively the intention is veiled. By definition, any form of art is manipulative, and the refusal to assume responsibility for this fact is disingenuous.

It is no accident that the written word occupied a disproportionate presence in the conceptualist art of both the mainstream and Latin America. Rightly or wrongly, text seemed a much more direct way of communicating an idea with clarity than any form of rendering. In the world of ideas, rendering always had the danger of appearing to be a servant to text and thus becoming an illustration. Text also seemed to be potentially less ambiguous and, therefore, short of telepathy, more accurate and less subject to erosion of information. Not only was text

overwhelmingly present, but, thanks to Ferdinand de Saussure, it also became a structural model for the work. Everything became a form of language and thus, ironically, the polysemous quality of visuality was somewhat preserved. Text was a metaphor from which one drew conclusions for the shaping of the piece, no matter the degree of dematerialization. And suddenly text wasn't enough and subtext came into the picture as well. However, it wasn't the presence of text that determined differences between the mainstream and Latin America, but rather the manner in which it was used in each case.

Shortly after both de Saussure and Claude Lévi-Strauss (semiotics and structuralism, respectively) became fashionable in the United States, it struck artists that visual art consists of signs and therefore can be "read."[13] It soon followed that textual analysis merged with the work repeated itself, and, subsequently, the analysis was allowed to become the work.

In Latin America, where close ties with French culture and language had existed since the late nineteenth century when positivism was in vogue, all this became clear earlier. By the time structuralism reached prominence in the United States, it had already existed for many years in the broader Latin American intellectual public domain. Thus (as in Europe with lettrism), the interest in text preceded minimalism, whereas in the United States the reverse occurred. Paradoxically, when minimalism was used as a formal device, it was done as an applied form.

In Brazil, much of concretism in visual arts was a consequence of concrete poetry, and the theoretical writings of some poets, particularly those of (José Ribamar) Ferreira Gullar (1930–), prefigured minimalist reasoning. When Mathias Goeritz (Mexico, 1915–1990) used his version of minimalism, it was not self-referential, but mystical in purpose. In Argentina, speculations about information, meaning, and representation during 1965–1966 preceded the relatively late appearance of Argentinean minimalism (the Estructuras Primarias II exhibition in Buenos Aires took place in 1967).[14] Already during the 1930s, Argentinean painter Xul Solar (1887–1963), a close friend of writer Jorge Luis Borges, created a linguistic structure into which he wanted to merge all of his art.

In the United States, the fact that the interest in reading signs took place shortly after minimalism came on the scene meant that reading signs became part of the same project. Analysis of language in art was tautological (as in Kosuth's, some of Ed Ruscha's, and Larry Weiner's work). In Latin America, because the interest in *text* preceded minimalism, there was no pressure for a connection with that project. Text was open to many other possibilities, free to become a vehicle for other ideas within the art context.

The use of language in visual art forced the Latin American artist to make a choice. Those artists who were addressing the international market did not hesitate to use English for their works, no matter where they were living.[15] Some chose English not out of an expectation to sell, but rather to develop an international audience for what they had to say. Others pursued their interest in language to rediscover the subject of communication with a local audience. That raised the issue of priorities in regard to local versus external audiences. For those of us in diaspora or exile, the issues became even trickier. In my own case, thinking of Uruguay and living in New York, I remember being painfully torn. I didn't know what language to use, and I often made the same piece twice, only to then ponder about whether, legally speaking, this constituted an edition of two or if I had made two originals.

Besides the above considerations, there is yet another area of difference between conceptualism in the mainstream and in Latin America, and it is closely related to the role of text and the use of literary analogues to advance the understanding of art. In writing about the visual arts in the mainstream and the literary values and analogues used in art criticism, Joshua Taylor noted that over the last couple of centuries, these have shifted between history, poetry, psychology, and metaphysics.[16] Taylor is not interested in the narrative content of the analogue, but rather in the way literature as text is used as a model. For example, he notes that by the end of the nineteenth century, "much critical writing on art was a form of poetizing. To describe a painting one had to be taken into its spell and write within its special poetic aura."[17] It is evident that the analogue of poetry appeared at the same time in the mainstream and in Latin America. However, it continued much longer in Latin America and supported a not very rigorous and quite sentimental school of cultural and sociological ideas well into the 1950s.

Taylor's analysis, while useful, falls short by at least two categories: politics and philosophy of art.[18] The political reading of the work helps us to understand the political impact and relevance in the Latin American arena. Philosophy of art, meanwhile, seems to be the vehicle with which to read mainstream conceptualism.

5 *Simón Rodríguez*

As an artist, I often feel that an excessive preoccupation with art can interfere with the production of art. One reason Simón Rodríguez is so appealing is that he was oblivious to any art issues, and he delivered an aesthetically inspiring body of work. Further, this body serves as a template for this book, since it is an early and vivid example of one of the arguments submitted here: that in Latin America, art, education, poetry, and politics converge, and do so for reasons rooted in the Latin American experience. As in the case of the Tupamaros in the 1960s–1970s, Rodríguez in the early 1800s resorted to aesthetic strategies to deal with issues of concern to him in education and politics. Usually, neither Rodríguez nor the Tupamaros are studied from the perspective of art; rather, they are analyzed within their respective disciplines: teaching/politics for Rodríguez; guerrilla warfare for the Tupamaros. Because both are relatively unknown outside their countries, I will put an inordinate stress on their biographical facts and on anecdotal information in this chapter and the next.

Simón Rodríguez, born in Caracas, Venezuela, in 1769, became interested in both teaching and politics. As early as 1794 he made a critical analysis of the school system and demanded equal education for black, mulatto, and white children.[1] Rodríguez had to flee into exile for having joined a conspiracy against Spanish rule soon after he began serving as the childhood tutor of Simón Bolívar (from 1792 until 1797). He never returned to Venezuela. He first went to Jamaica, where he learned English by playing with children. He then continued north to Philadelphia and worked in a print shop where he learned typesetting, something that later helped him in the layout of his own pages. He then proceeded to Europe, which presumably had been his initial destination. There he accidentally met Bolívar in Paris, in 1804. They decided to walk to Rome together, and it was this trip that made Rodríguez the sole witness and reporter of Bolívar's famous oath to liberate Venezuela from Spain. On August 15, 1805, Bolívar and Rodríguez went to the top of either the Monte Sacro or the Aventino (depending on which account you read), where Bolívar yelled his promise into the Roman air. These vicarious achievements gave Rodríguez his initial and lasting fame.

But long before these events, Rodríguez had laid out his own life by becoming obsessed with teaching and with the development of his personal pedagogical theories. Jean-Jacques Rousseau's *Emile* and Daniel Defoe's *Robinson Crusoe* were his biggest influences, and based on these texts, he elaborated ideas that were close to those of Johann Heinrich Pestalozzi and went beyond those of Joseph Lancaster.[2] Lancaster acquired some importance in Latin America because Bolívar, who had come into contact with his ideas while studying in London, had invited him to Caracas to introduce his system.[3] Lancaster was an unsavory character who eventually was let go from his own school in London on account of his sadistic tendencies. The interesting aspect of Lancaster's method, however, was that he emphasized peer help through a monitorial system. Concerned with the education of "the poor," he had classrooms built to accommodate three hundred students. Thirty monitors were trained to help, picked from the "few intelligent students." To these he added one master. Rodríguez didn't like Lancaster, partly because Lancaster had devised his system around the study of the Bible and Rodríguez was strongly anticlerical. He accused Lancaster of using peer teaching purely to force students to memorize the Bible ("To order to recite from memory what is not understood is to make parrots, so that for life they'll be charlatans").[4] Things were probably made worse because of professional jealousy and the importance Bolívar attributed to Lancaster. However, Rodríguez's anticlericalism was very real, and it went so far that he named his two sons and his daughter (born during his stay in Ecuador) Choclo, Zapallo, and Zanahoria (Corn, Squash, and Carrot). It was his form of protest against the Church's expectation that children be christened according to the register of saints.[5]

It is not clear how much Rodríguez knew about Swiss reformer Johann Pestalozzi, but there is a broader overlap of ideas and beliefs with him than with Lancaster, especially with regard to respect for the student and the search for a connection with real life.[6] Pestalozzi stressed spontaneity and freedom in the use of art implements by children. He believed that "human nature" should follow its course, aided by study and practice.

Rodríguez was as much interested in methodology as he was in ideology. He developed his own shorthand version of a socialist ideology outside the usual influences. In his book *Sociedades americanas*, written in 1828, Rodríguez says that "collective property should be the rule and private property the exception," and, in his personal form of layout and typesetting:

TO DEAL WITH THINGS
is the first part of Education

TRATAR CON LAS COSAS

es la primera parte de la Educacion

i TRATAR CON QUIEN LAS TIENE

es la segunda

Figure 5.1. Simón Rodríguez, "Tratar con las cosas" (To Deal with Things), *Obras completas,* 1:356

and TO DEAL WITH THOSE WHO HAVE THEM

is the second.[7]

He summed up the plight of fighting colonization and underdevelopment by declaring: "Either we invent or we fail," a phrase that only as recently as the 1990s has become something of a Latin American slogan. Rodríguez wrote extensively, but only a small part of his work has survived. On his last trip, shortly before his death, his ship sank, taking with it a trunk containing his writings.

What is left is still enough to fill two volumes that show the part of Rodríguez that makes him a paradigm for me. Most of his texts are written in a broken form of layout. Sentences rarely flow linearly as in ordinary texts, but are subdivided by means of big brackets that accommodate options of ideas or subcategories. The typeface changes frequently for emphasis, sometimes even within the same line, and the text may follow geometrical shapes or be organized by a central axis. The result creates pages akin to calligrams, a form popular during the eighteenth and nineteenth centuries, in which an image described is rendered by the layout of the words. But whereas calligrams are a formalist game, Rodríguez's only concern when he used his form of layout was clarifying ideas. His compositions could be described as mental flow charts that increase the speed of understanding. They are visual as well as textual aphorisms, with beauty an unintended byproduct. Thus, in his own way, Rodríguez addressed the issue of erosion of information and tried to convey his thoughts in a no-loss format.

Like Stéphane Mallarmé in *Un coup de dés jamais abolira le hazard* (*A Throw of Dice Will Never Abolish Chance*), published in 1895, Rodríguez used his devices for emphasis. But while Mallarmé was interested in a paramusical structure that

helped the sound of the poem, Rodríguez was only concerned with clarity. Mallarmé wanted ambiguity, plurality of meaning, and formal arrangements to articulate possibilities. Rodríguez wanted to re-create his thinking process in the reader's mind.

Far from naive, Rodríguez was aware that his way of writing was unorthodox, and he prefaced his 1828 edition of *Sociedades americanas* with a note that stated:

> This project will seem as exotic, as strange as the orthography in which it is written. In some readers, maybe, it will excite laughter. In others—... disdain. This shall be unfair, since neither are there falsities in the observations, nor is there nonsense in the propositions. In regard to laughter, the author may claim (better in French than in Latin) "He who laughs last laughs the best."[8]

The note, consistent with the rest of the work, is broken up into short, centered parts, with changes in typography. Later, in *Tratado sobre las luces y las virtudes sociales* (*Treaty on Social Lights and Virtues*; 1840), he wrote about his approach while discussing "the shape given to discourse."[9]

> Form given to the discourse: Painting the elemental ideas in paradigms; the thoughts, in synopsis. The tongue and the hand are the most cherished attributes of man (as Buffon observes). Be it here understood in regard to the intention to instruct.
>
> It is not the importance of the word, which everybody knows. The importance of its painting is well known by a few, and many don't even think about it. However, one can paint without talking, but one can't talk without painting.
>
> Gestures are a sketch of what the hand is unable to draw for lack of means or time. To gesticulate is to paint in the air ...[10]

Later in the same essay he says: "Without painting there is no memory, but [only] dispersed or piled-up ideas."

After discussing the order needed for a good lecture, Rodríguez applies his findings to writing:

> The writer has to organize his pages to obtain the same result: therefore the art of writing needs the art of painting.
>
> The ideas that connect to form a thought don't have the same importance as the thoughts put together in a painting.[11] Each of the components is an abstraction, and the composition is an abstraction of abstractions.[12]

Figure 5.2. Simón Rodríguez, "Forma que se da al discurso" (The Shape Given to Discourse), *Obras completas,* 2:151.

FORMA que se da al DISCURSO

Pintando { las Ideas elementales=en *Paradigma*
{ los Pensamientos =en *Sinópsis*

La **LENGUA** y la **MANO**

son los dotes mas preciosos del hombre
(*observa Buffon*)

Entiéndase aquí con respecto á la
INTENCION DE INSTRUIR

No se trata de la Importancia de la Palabra
porque
no hay quien no la conozca

La Importancia de su PINTURA
la conocen pocos bien
muchos....ni piensan en ella

no obstante

Se puede PINTAR sin HABLAR
pero nó HABLAR sin PINTAR

Los **JESTOS** son un **BOSQUEJO**
de lo que la *mano* } { de *medios*
no puede dibujar } por falta { ó de tiempo

JESTICULAR es pintar EN EL AIRE

Mallarmé, instead, introduced his *Un coup de dés . . .* with a preface in normal prose explaining the reasons for his formal breach:

> I don't transgress against the system, but simply disperse it. The paper intervenes every time an image on its own ceases or retires within the page, accepting the succession of the others, and it is not a question, unlike the usual state of affairs, of regular sound effects or verses—rather of prismatic subdivisions of the idea, the instant when they appear and during which their cooperation lasts, in some exact mental setting. The text im

poses itself in various places, near or far from the latent guiding threat, according to what seems to be the probable sense. . . . Let the genre become one like the symphony, little by little, beside the personal declamation, leaving ancient verse intact—I venerate it and attribute to it the empire of passion and of dream—while it would be the time to treat, preferably, as it follows naturally, subjects of pure and complex imagination or intellect, not to exclude them from Poetry—the unique source.[13]

Both authors imply inevitability in their choice of form, but Rodríguez was not a modernist and didn't bother to analyze the limitations of the traditional format. He dispensed with it, though he anticipated some irritation on the part of the public. Mallarmé, however, sweetened his criticism by reasoning his departures from the norm, and by reassuring his audience of his continued faithfulness to poetry. It is also interesting to see Mallarmé's reference to music compared with Rodríguez's only concern with the absence of falsity and nonsense. While Rodríguez used his layout to pinpoint his truth, Mallarmé wanted to stop the traditional eye movement used for reading, because "otherwise we will miss that ecstasy in which we have become immortal for a brief hour, free of all reality, and raise our obsessions to the level of creation."[14]

In one of his comparisons of language with government, Rodríguez made an antiformalist statement that is worthy of Latin American conceptualism:

To put the idea of Republic into practice, they took it from the head into the hands, and in the hands it stayed: It is necessary that the idea return to the head. The forms are discrediting the idea. It should not be called Republic because it isn't. And it isn't because there isn't a people.[15]

Rodríguez lived in poverty most of his life, refusing to compromise his ideals. The schools he created on his travels through Chile, Perú, Bolivia, and Ecuador never gathered enough pupils, so he had to earn money through other activities. More than once he combined teaching with candle making in the same building. Appropriately, he carved above his door: "AMERICAN LIGHTS AND VIRTUES, that is, candles [made] of grease, patience, soap, resignation, strong glue, love for work."[16]

During his stay in Bolivia, he was branded as an eccentric and strongly opposed for his ideas. Among other ideas of his that were unpopular among the ruling classes was one in which he had proposed a subsidy of parents in the hope of thus eliminating child labor, one of the factors that was keeping children out of school.[17] At one point, Rodríguez was rumored to have organized a festive din-

ner in honor of General Sucre, who at the time was ruling the country within the Bolivarian structure. To discredit Rodríguez, the rumor included that he had served food in hospital bedpans instead of dishes. With this action, he supposedly had expressed his disagreements with the general in regard to planning an education system. When the rumor finally reached Rodríguez, he celebrated the story and helped to actively further its circulation. This incident may very well have been the first entry of urinals into the history of art.

However, what interests me most in Rodríguez is the tight relation of the form of his writing with the content of his communication. Rodríguez's page structure lacked the strict formalist and tautological qualities of calligrams, but then, had he used calligrams, the power of his messages would have seriously suffered. His writing lacked any aesthetic drive and, instead, fit the visionary he accurately perceived himself to be. His urgency was not that of an artist, but of a preacher. In today's post-Beuys art context, in which the artist as a shaman seems to have become a popular notion, it may be important to separate Latin American artists into their own category. "Preacher" offers a more precise description, and one that bears less affectation than that of a "shaman."

Thanks to the processes of colonization and the widespread belief among emerging nations that joining modernity is a condition for independence and progress, Mallarmé's name has always been much better known in Latin America than that of Rodríguez. However, Rodríguez represents an attitudinal foundation that, even when not explicit, is latent in most Latin American cultural expressions. Partly this is due to the social role and social awareness of the artist as a helper in the construction of a culture whose development seems to be continually interrupted. It is here where artists are not only preachers but also teachers, and where I find Simón Rodríguez to be an example and an antidote.

Coupled with the fetishist attitude toward the art object, mainstream art always focused on the aural quality of the product. The object is anointed and irradiates its "artness." Even in the case of Duchamp's work, one could interpret the effect of his readymades as a consequence of transferring that quality to the everyday object. The precedent set by Simón Rodríguez points to the danger of that aura interfering with a communication intended for social change. As a teacher, it is his clarity, not his status or aura, that elicits thinking. That is why, in Rodríguez's writings, preaching and teaching go in a different direction than shamanism or any pursuits of self-contained aesthetics. Rodríguez's strength in this tradition is that he never would have defined himself as an artist. He was an artist by default, possibly only in my own hindsight.

6 *The Tupamaros*

The Uruguayan guerrilla group known as the Tupamaros certainly meddled more directly in reality and everyday life than Simón Rodríguez, but then again, it was this meddling that actually defined them. If there is a line that separates art from politics, there are two events in Latin America that touch this line from their separate areas. The Tupamaros exemplify politics coming as close as possible to the art side of the line. Some years later, in 1968, the Argentinean group Tucumán Arde (Tucumán Is Burning) is an example of art coming as close as possible to the political side of the line. Yet, it should be clearly stated that the Tupamaros never declared themselves to be artists or as doing art. They were clearly a guerrilla movement, albeit an idiosyncratic one. By analyzing their actions as an aesthetic phenomenon, and therefore minimizing the unpleasantries of day-to-day guerrilla warfare, there is the danger of excessive romanticizing (in their time they were often characterized as "Robin Hoods" by the foreign press) and of a historical distortion of events.

The Tupamaros started to organize during 1962, but it was two years before they identified themselves by that name.[1] Also known as the MLN (Movimiento de Liberación Nacional), the group was started by people from different political sectors, but mostly by members of the Socialist Party and dissidents of the Anarchist Federation.[2] The organization also drew heavy support from the student population, and though there were art students among them, the Tupamaros did not develop overt artistic ambitions. Their main role was to become the "people's prosecutors" and, as such, to uncover corruption in the government, banks, and industry. Uruguay had been, until then, a model of stability in Latin America. However, the agricultural production that had provided the country's wealth until the Korean War had not updated its methods and had become noncompetitive. The economy suffered, and the oligarchy was unwilling to share its wealth in order to keep the progressive social system functioning. What had been a primarily middle-class society became increasingly polarized. The crisis started to become visible during the beginning of the decade of the sixties with an enormous strengthening of the police.

Figure 6.1. *Bala* (*Bullet*), 1969, graffiti on the wall of the University of Uruguay pointing out bullet holes. Photo Luis Camnitzer.

The movement originated as a voice against all of the above, but also as a reaction to the activities of right-wing gangs that were acting under the protection of the police. Starting in 1960, these gangs terrorized left-wing militants through kidnapping, scarring bodies with swastikas drawn with razor blades, and occasional murders. One of the deaths, that of high school teacher Arbelio Ramírez, was particularly poignant.

It is presumed that the bullets that killed Ramírez were actually intended for Che Guevara, who, on August 17, 1961, was giving a lecture at the university. The bullets missed Che and hit Ramírez instead.[3] It was ironic that in his remarks that day, Che had gone to great pains to explain why one should not use weapons when legal options are still available.[4]

The group started organizing shortly after this incident, but only became public in 1967, with the publication of an "Open Letter to the Police" in one of the daily newspapers. In it they stated:

. . . For these reasons we place ourselves outside the law. This is the only honest solution when the law is not applied equally, when the law exists to defend the false interests of a minority in detriment of the majority, when the law functions against the progress of the country, when even those who created the law depart from it with impunity whenever it is convenient for them.[5]

At the time, Uruguay was a country with roughly three million inhabitants, half of whom lived in Montevideo, the capital. The ensuing urban culture that marked the country led the Tupamaros to operate primarily in an urban environment, something that had no precedent for successful guerrilla activity. Moving constantly in densely populated areas led them to develop a strategy that would not only avoid alienating the public but would also make them instantly attractive and persuasive in the eyes of the people.[6] The axiomatic quality they gave to these ideas separates the Tupamaros from most of the other Latin American guerrilla movements. In 1969, for example, Brazilian guerrilla leader Carlos Marighela proclaimed rather bluntly:

The urban guerrilla's reason for existence, the basic condition in which he acts and survives, is to shoot.[7]

In this schema, according to Marighela, guerrillas are distinguishable from outlaws because they eschew personal gain, and the public is expected to see and understand this difference between revolutionary heroes and exploiters.

Given the particular situation of Uruguay within the Latin American context, schematic positions of this kind were of no use to the Tupamaros. They were keenly aware that no blood had flowed in Uruguay since 1904, and they believed that the fight now required was a bloodless one, since Uruguay was a country whose population took pride in a long tradition of civility. For both practical and ideological reasons, they believed this was the only way to move the public to support their cause. Although this policy unfortunately was not sustained during the life of the movement, it certainly informed its beginnings. To this effect, the Tupamaros, unlike many other guerrilla movements, ignored the use of "focalized" war violence (Che Guevara's term) to generate wildfire opposition to the system. Instead, they resorted to a pedagogical process of image building. During its earlier stages, the movement had notably passed on several opportunities to kill high-ranking enemies.[8] The humane character of their operations was designed not only to elicit sympathy but also, it was hoped, to elicit, promote, and encourage collaboration from the public. Their operations were scrupulously or-

Figure 6.2. Tupamaros, *Subversión, Las Fuerzas Armadas al Pueblo Oriental* (Subversion, The Armed Forces to the Oriental People), 1971, blueprint for an operation at the Coca-Cola plant in Montevideo, Uruguay.

ganized, and they often had a medical doctor on hand to take care of any persons, whether friend or enemy, who might be harmed if violence broke out.

Among the things the Tupamaros sought to achieve with their operations was a lasting effect on the memory of the public. They wanted the public to see beyond any functional results of a given operation and to build something less tangible but more powerful in the long run: a mythical image. Publicity and communication, their primary goals, governed and hybridized all other actions. In one of their strategy papers, they spoke of "armed propaganda" and noted that it

becomes particularly important under certain conditions, like becoming [publicly] known in the beginning of the guerrilla's development. It also is important in the moment of clarifying positions toward the people during those periods in which drastic measures have to be taken that do not

clearly illustrate the guerrilla's aims and that might be difficult for the popular mind to comprehend.[9]

Some years later, in 1977, the armed forces published a self-promoting book in which they evaluated this strategy with unexpected and surprising objectivity:

> Surrounded by great publicity, these actions try to present the methods of the Police and the Government as clumsy and inefficient, so that the organization may appear, [while] ridiculing them, installed on the cusp of imagination and ingenuity.[10]

The general theory of the Tupamaros was that "it is the revolutionary actions that lead to revolutionary situations." It was premised on a completely different understanding than that of the traditional "*foco*," or spark action, employed by other militant groups.[11] Analyzing the movement in relation to other Latin American guerrilla groups, French writer Régis Debray pointed out the absence of any prejudgments in the organization. In his comments, he sounds as if he is describing creation rather than strategy:

> There is no traveling dogma, no revolutionary strategy independent of the conditions determined by the place and time; everything is to be reinvented every time on location.[12]

Debray's comment reminds me of Richard Huelsenbeck's introduction to the *Dada Almanach:*

> The dadaist is the freest man on Earth. An ideologue is every man who falls for the lie presented by his own intellect: that an idea, that is, the symbol for an instant of perceived reality, is absolutely real.[13]

Debray's admiration is particularly remarkable, because the Tupamaros had acted against his own wisdom as expressed in his *Revolution in the Revolution?* where he had written that

> armed propaganda follows military action but does not precede it. Armed propaganda has more to do with the internal than with the external guerrilla front. The main point is that under present conditions the most important form of propaganda is successful military actions.[14]

With his statement, Debray had endorsed the traditional strategy of hit-run-and-hope-for-wildfire, a position shared by most of the other guerrilla movements. Marighela, for example, discussed armed propaganda as "the coordination of

urban guerrilla actions, including each armed action."[15] The assumption was that the accent had to be on "armed," based on the aura this word had thanks to the success of the Cuban Revolution. The Tupamaros, more deeply rooted in the student movement and in intellectual circles, shifted the accent to "propaganda."

It was the design of the operations that stood out and that led observers like Régis Debray to refer to the Tupamaros as a "cultural phenomenon."[16] It prompted descriptions of their use of time and timing more likely to be found in discussions about filmmaking.[17]

The Tupamaro leadership clearly wished to affect the media, but they didn't theorize about it, and to some extent were not self-conscious about this aspect of their actions. In response to a question I asked him, one leader of the movement, years later, speculated that there probably were two factors that influenced their use of "creativity." One was a deep distrust of all stereotypes, a distrust that led them to break from traditional political groups in the first place. The other was the hard fact that most of the leaders of the movement were taken off to prison before the movement had a chance to plan any major operations. During their imprisonment, they befriended many of the nonpolitical prisoners and discovered unusually creative thinking and resourcefulness among them. These insights were translated into political methods once they broke out of jail, and led to one of their most famous capers, the "Operación Pando," discussed below.[18]

Operations generally were conceived of as "theater" and planned accordingly. Every "player" or "actor" rehearsed not only his/her own role but also that of somebody else as well, so there was always an understudy prepared to take over if events took an unexpected turn.[19]

The first couple of events organized by the Tupamaros did not at all qualify for aesthetic consideration. They consisted of plain money-and-arms gathering through simple break-ins. One of these actions led to the jailing of Julio Marenales, the fired sculpture teacher I referred to in Chapter 1. When interrogated by police after being caught, he simply told the truth, that he had held up a bank not for personal gain but to finance revolution. The idea seemed so far fetched that he was suspected of insanity and set free three months later.[20]

Over the years, the Tupamaros were able to seriously improve their bank-robbing operations. Between September and November of 1968, they took money thirteen times. One of the banks was successfully targeted twice in the span of two weeks. But the more interesting operations were not directly bank related.

In 1963, the group engineered its first major plot involving food distribution. Guerrillas posed as members of a neighborhood political club and ordered a

truckload of goods from a major food supplier. Given the proximity of Christmas, they made sure that a large supply of sweets was included in the shipment. The truck was directed to an address close to a shantytown and then was kidnapped upon arrival. The food was then distributed among the local people. Though the operation was successful, the Tupamaros did not develop this format into a general tactic. They decided that the actual help provided to the people did not justify the risks taken and was not commensurate with the investment of time and energy by the guerrilla movement. [21]

The Tupamaros also resorted to such debatable actions as kidnapping, although this was mostly for interrogation and sometimes also to embarrass the government. They had a "People's Jail" for this purpose, from which the prisoners were released as soon as it was deemed feasible. One exception to this policy was the case of Dan Mitrione. Mitrione was a former chief of police in the United States who had been sent to Montevideo to instruct police personnel in torture techniques. Caught by the Tupamaros, he was imprisoned, and his possible release was used to negotiate the freedom of jailed guerrilla members. The discussions went well until the last moment, when the government pulled back from any deal. The guerrilla cell that held Mitrione and had threatened to execute him if the negotiations fell through kept their promise against the better judgment of the majority of the movement. Although there was no question about the criminal status of Mitrione, the execution, in August of 1971, seriously damaged the image of the whole movement.[22] Subsequently, other acts of violence more typical of armed warfare followed and further tarnished the early image of the movement.

Meanwhile, during the same period, 106 prisoners died in government jails. According to regulations, prisoners in government jails

> may not have books with underlined text or handwritten comments. May not have books of Marxist ideology or related tendencies or other forbidden topics. . . . It is forbidden to produce crafts containing tendentious drawings such as: a rose, a bleeding rose, the Aztec sun, a five-pointed star, a dove, a fist, hands united to make the shape of doves, a mosquito, a fish, a pyramid, a couple, a woman with child, a pregnant woman. One may not make standardized crafts that may be identified as made in the Establishment.[23]

Punishment for any infraction was solitary confinement.

It should be said that the Tupamaros used no torture with their prisoners; they offered qualified medical service when needed, and interrogation—when used—

was generally polite. In one of their operations during 1971, the Tupamaros kidnapped both the director of the Public Energy Department and a former minister of agriculture and held them in the People's Jail for a whole year. For the director, it was actually a second experience. Ulysses Pereira Reverbel, a very unpopular character accused of being profoundly and irredeemably corrupt, had been taken in once before, in 1969.[24] Claude Fly, an American Agency for International Development (AID) adviser, spent seven months (August 7, 1970, to February 27, 1971) imprisoned in the People's Jail. After his release, he refused to give any information to the police and maintained friendly correspondence with some of his captors. It was a relation that cannot be easily dismissed or explained as a case of Stockholm syndrome.[25]

During that same year (1971) and for short periods, the Tupamaros also took over movie houses and used the captive attention of the public to project slides in which they showed the prisoners and their well-being, added to slogans about the movement.

Both the Tupamaros' initial emphasis on bloodlessness and the conditions provided by the urban environment as a theatrical stage may have unconsciously led them into this aestheticization of operations. And although they were armed and increasingly subdivided into autonomous cells that took part in military encounters that sometimes produced unnecessary and unjustified casualties, by the time they ceased their underground operations, the total body count was relatively small. Over the period of eleven years in which the Tupamaros were active in the underground, their operations led to the death of forty-nine guerrillas and fifty army and police members.[26]

The year 1969 proved the most fertile in actions with a spectacular staging and aesthetic appeal. During that year, the movement performed eleven highly publicized operations and eighty others that lacked publicity. Even if not all the operations were a media success, the sophistication of the use of propaganda kept increasing, and it is clear that the Tupamaros had chosen to give this primacy. The military component in the operations worked only as a supporting instrument, flying in the face of favorite models like the Cuban and Vietnamese experiences. And years earlier, Fidel Castro had expressed his condemnation of any urban-based guerrilla movement when he proclaimed that the city was "a cemetery of revolutionaries and resources."[27]

On January 1, 1969, while a trial was in process against the Tupamaros, members of the movement entered the rooms of the district court and reclaimed forty-one weapons. The weapons had been found earlier by police in a Tupamaro hiding place and were kept in storage in the court building. On February 7, some

A LA INJUSTICIA DEL REGIMEN
SE OPONE LA JUSTICIA DEL PUEBLO

Frick Davies y Ulysses Pereira Reverbel, detenidos en la Cárcel del Pueblo

Por la libertad de todos
los presos politicos ★ ★ ★ ★ ★
Habrá patria para todos o
no habrá patria para nadie

CLOACA MINADA

Figure 6.3. (left) Tupamaros, *Subversión, Las Fuerzas Armadas al Pueblo Oriental,* 1971, slides for movie theaters.

Figure 6.4. Tupamaros, *Cloaca minada* (Mined Sewer), 1972, sign left to disconcert the police during an escape through a specially dug tunnel, news clipping.

Tupamaros deposited a package with 220 pounds of explosive gelignite in front of the house of an army official known to be a bomb expert. The material was initially taken from an army depot, but the group decided later that it was too dangerous for the use they had in mind. They returned the package with a note containing detailed explanations about how and why. On February 19, dressed as policemen, they took the equivalent of 220,000 dollars, which was an enormous amount of money for Uruguay at the time, from the Casino San Rafael in Punta del Este. San Rafael is the fanciest state-owned gambling house in the country. Too late, they realized that the money taken included the tips for the employees. The Tupamaros immediately offered (unsuccessfully) to return the corresponding percentage. On May 15, they took over a major radio station during the broadcast of an important international soccer game. With most of the population of the country listening, they read a political message six times over the next half hour. On July 16, a faction called the OPR 33 stole the original flag used by a group of thirty-three patriots who had entered Uruguay in 1825 to free the country from Spain. The flag was on permanent display in the Museum of National History. After the national flag, this one is ranked second as a civic symbol. On it is an inscription proclaiming "Freedom or Death." In a public an-

nouncement, they promised to return the flag to the museum once the political situation deserved it. At the time of this writing, it has yet to be returned.[28] On December 30, 1969, a box was left on the grounds of the Feria de Libros y Grabados (Book and Print Fair), a very public and popular event that takes place once a year. At that time, the fair was held in the front plaza of the municipality building. Activated by clockwork and to the delight of most of the public, the box broke open and started spouting propaganda leaflets into the crowd.[29]

The most elaborate and spectacular of the public events performed by the Tupamaros was "Operación Pando," and it involved about one hundred guerrilla members. On October 8, pointedly coinciding with the second anniversary of Che's death, they hired cars for a funeral procession. The excuse given for the occasion was the reburial of a relative who had died in Argentina several years earlier. The entourage included five cars and a van. The reburial was to take place in Pando, a city of twenty thousand people about twenty-five miles from Montevideo. On its way, the procession stopped at several points to pick up more "relatives," all of whom bore an appropriately funereal demeanor, most of them crying. The coffin was full of arms intended for the operation. Once the group was assembled, they overpowered the hired drivers and the real work started. What followed included the takeover of the police headquarters, the fire station, the telephone building, and, finally, the four banks in town.

From a practical point of view, the operation was a big failure. During the return to Montevideo, a confrontation with police took place, and three guerrillas died and eighteen were arrested.[30] However, from an aesthetic point of view, especially with regard to the narration of the sequence of preparations—the takeover of each station constitutes a complex subplot—the operation was a memorable achievement. It set the tone for further theatrical staging of events for which the city and its inhabitants played a role in the script designed by the guerrilla "actors."[31]

The Tupamaros may not have had aesthetic ambitions, but they certainly were eager to establish a good and efficient communication system. To achieve this, one would presume that they needed some kind of iconography, but they didn't use any, at least not in the form of literally illustrative images about the movement or their cause. Unlike the case of many other guerrilla movements, the publications by the Tupamaros were mostly without pictures. They were also dry and boring. Their effort was invested in the public relations image they projected. This projection required the use of mass media, and it is here where some actions by Latin American conceptualists, U.S. Yippies, and the U.S. war resistance movement may come to mind. However, while the U.S. examples

catered to the media format, the Tupamaro operations did not. Or, if they did, it was in a much-reduced form.

With their own mobile radio station and print shop, and the occasional takeover of public airwaves, the Tupamaros were relatively independent and immune to any manipulation of their image. The feat mentioned earlier, the use of a popular radio station to beam their messages during a soccer game, did more for the Tupamaro image than the actual content of their proclamation. The design of their operations did not have to be compromised by unfriendly "mediation." Instead, the operations made use of a very direct and sympathetic rumor mill that exploited the mechanisms of folklore more than those of advertising.[32]

With all these actions, the movement became successful enough to provoke the government (in 1970) into officially prohibiting the use of six words (or terms) in the press. "Extremist cells," "commandos," "political delinquents," "ideological delinquent," "subversive," and "terrorist" could not be printed by any newspaper in the country. The government issued a list of permissible words to be used in their place, among which were "evildoer," "delinquent," "criminal," and "offender."

Figure 6.5. Tupamaros, "Messrs. Policemen, This time it was a simulation; the next time it will be for real," 1969. Mimeographed flyer, collection of Luis Camnitzer.

Figure 6.6. Uruguayan government's six prohibited words, 1970 news clipping, Montevideo, Uruguay.

This step was followed by further and unprecedented acts of censorship. Even the "*murgas*," the popular groups that perform during the Carnival season on open stages in the different neighborhoods of Montevideo, felt the repression. Their songs are always topical, and they humorously and critically refer in their lyrics to events of the previous year. In one incident, the word "captain" had to be taken out of a reference to *Peter Pan*'s Captain Hook, since the context was

deemed offensive to the armed forces.[33] Temporarily, the war had shifted to the field of language. It was something of an orthodox conceptualist dream.

During April of 1972, the Ministries of Defense and the Interior joined in issuing a declaration in which they not only reasserted that the use of public force was a prerogative of the executive branch of the government, but they also rejected "any private organization that presumed to usurp any competencies of the State." What amounted to a government's recognition of its own weakness was embellished the following year, when the government/army climaxed with an oxymoron of classic proportions. In the same decree in which the Parliament was abolished and dictatorship was officially instituted (1973), it was declared that

> it is forbidden to divulge . . . any type of information . . . that directly or indirectly attributes dictatorial intentions to the Executive Power because of the present decree. . . ."[34]

By then, the Tupamaros had already been defeated (the army coup was not connected with any ongoing warfare), but there were other and more immediate reasons than those predicted by the skeptics that led to their demise. One was

Figure 6.7. Army communiqué, 1974 *Marcha* news clipping, Montevideo, Uruguay.

the excessive and rapid growth in their ranks. The result of their success in affecting public opinion proved fatal once this combined with a lack of appropriate screening systems. What had started as a relatively unified strategy became a fragmented one, with units taking it upon themselves to engage in unneeded violence. Another factor, although linked with the first one, was enemy infiltration in the higher ranks. The third cause was a general improvement of the Uruguayan intelligence service, including a remarkable sophistication in the use of torture, which was being aided by heavy U.S. financial support, as well as by technical training through "advisors." Finally, an increase in internal dissention caused lateral defections, secessions from the movement on strategic grounds that, although not based on ideological discrepancies, weakened the movement's overall structure.

In 1984, after the withdrawal of U.S. support, the army abandoned its support of the government and allowed for the reinstitution of democracy. As of 1985, the Tupamaros are organized as a legal party and have members in the Uruguayan Senate, the Chamber of Deputies, and the City Council of Montevideo. Their main function for the moment is to be ombudsmen.

······

The Tupamaros developed, if one were to use artistic terms, a new form of theater. To accommodate what he called "environmental theater," U.S. critic Richard Schechner offered a diagram that goes from public events (demonstrations), to intermedia (happenings), to environmental theater, ending in traditional theater.[35] The range went from "impure" (life) to "pure" (art). The Tupamaro operations subverted this diagram because they were nearly as rigidly structured as traditional theater, but functioned under unpredictable conditions. Therefore, one would presume a need for total improvisation.

In this context, one remarkable feature of the Tupamaro operations was their utilization of time. In our modern culture, time has acquired a sacred status that rules how we look at things as much as it controls the rest of our lives. A work of art usually requests our time for contemplation in a polite manner, and the spectator grants it at his or her own discretion. We can leave whenever we want to. Part of the subversion instituted by the Tupamaros relied on the fact that they completely appropriated the viewer's time, either as a witness or through direct involvement. One could not leave whenever one wanted to. They also managed to take over time under nonmatrixed conditions, that is, uncontrolled by constraints of space or structure.[36] They were able to force decisions after the fact,

decisions that ranged from sympathy/antipathy, to the need for change or lack thereof, to just evaluating the success or failure of an operation. That is, there were conditions that, although not pegged to traditional patterns of consumption, could not be ignored. This way of dealing with time is usually reserved for disciplinary actions by armies and governments (whether democratic or regimented), including schooling and jailing. In fact, several years later, Nicos Poulantzas described the capitalist state in relation to time and space, a description that actually applies to any state structure with a central government:

> What is specific to the capitalist state is that it absorbs social time and space, sets up the matrices of time and space, and monopolizes the organization of time and space that become, by the action of the state, networks of domination and power.[37]

Poulantzas's description complements what Anthony Giddens wrote during the same period about the nation-state and its claimed monopoly of violence:

> The nation-state, which exists in a complex of other nation-states, is a set of institutional forms of governance, maintaining an administrative monopoly over a territory with demarcated boundaries (borders), its rule being sanctioned by law, and direct control of the means of internal and external violence . . . only in modern nation-states can the state apparatus generally lay successful claim to the monopoly of the means of violence, and only in such states does the administrative scope of the state apparatus correspond directly with territorial boundaries about which that claim is made.[38]

Political-military rebellions usually address the issue of enemy power in a straightforward manner and try to change the balance of power to their own advantage. In doing so, they justify their actions by invoking the monopoly and misuse of the administration of violence. Since the field of art concerns itself with changes in the representations of time and space, it is expected that artists have the clearest ability to subvert the monopoly of the state. It is here where the Tupamaros unwittingly come close to art.

The line separating liberating activities from crime, always blurred by changing definitions of legality, was even more confusing under dictatorship. It became, then, even more urgently a subject of attention for the artist and for the creative fighter.[39] What words were allowed, what was offensive to state and armies, what constituted a "crowd"—all were unpredictable variables that changed almost daily. Art therefore became a tool for liberation, and an even

celebrated by both Romero Brest and Samuel Paz (then assistant director of the gallery). What I had hoped to do was to contextualize an otherwise mostly apolitical exhibit in the rooms of the Institute. Ultimately, of course, I was the one being contextualized and drawn into a traditional frame of reference. Needless to say, I didn't see it that way at the time, and what stands out for me now in retrospect is that the Institute was then the only regular exhibition space in Argentina that would even have considered my piece.

Throughout this time, the authors of *Tucumán arde* saw themselves as removed from any artistic "style," to the point that former members of the group still resent any association with mainstream conceptualism. León Ferrari explains:

> But those who connect *Tucumán arde* with conceptual art forget that this is a new "avant-garde" [belonging] to the same elite that the people of *Tucumán arde* abandoned, not only because they were serving and ornamenting it, because they were making weapons for the enemy, but also because the elite contaminated their work, because the language invented for and from the elite was useless for communicating with the new public that was sought. *Tucumán arde* used art to make politics. The greatest part of conceptual art and of some expressions of contemporary political art use politics as a subject matter to make art.[24]

Ferrari makes the point that traditional art forms dull political action when they limit themselves to a reference to ideas rather than to their implementation. Later in the same paper and still talking about *Tucumán arde*, Ferrari continued:

> Art was measured within different parameters: what serves revolution, what does not serve revolution, and what serves counterrevolution.

Rather than connecting with the avant-garde, Ferrari prefers to establish a link between Tucumán Arde and the Grupo Espartaco, founded in 1959 and led by Argentine painter Ricardo Carpani (1930–1997). Espartaco tried to create a figuration that was a militant alternative to Soviet socialist realism, sort of a Trotskyite socialist realism as opposed to a Stalinist one. The artists used distortion of the figures with some indigenous flavor and formal solutions inspired by Mexican muralist painting. They saw themselves as going out to the masses by painting murals in workers union buildings. Ferrari's link made sense if one left out formal analyses and focused on goals and on the wish to avoid art-institutional venues. In that sense, a definition of art was abandoned for the sake of a political definition of the effect of art.

Consistent with this position, Renzi resented any connection of his work with mainstream conceptual art, and accused both Lucy Lippard and Jorge Glusberg of erroneously linking him and his group to that movement. He states:

Bourgeois culture always tended to remove content from any art creation, and this conceptual art of today is no more than a content-less (and sense-less) variation of our efforts to communicate political messages.[25]

He then gives the reasons that separate his and his colleagues' "messages" from mainstream conceptual art:

(1) We are not interested in having them considered as aesthetic. (2) We structure them according to their content. (3) They are always political and not always transmitted through official channels like this one. (4) We are not interested in them as works per se, but as means to denounce exploitation.[26]

It is obvious that a clear solution to the question of how to erase the art/politics borderline was not found by the Tucumán rebels, but at least the contradictions were sharply revealed. Art-as-object serves preestablished interests, and art-for-revolution tries to break down the power of those same established interests. The problematic aspects of the enterprise became clear. "Revolution" is the product of a political definition; art has not yet been seriously accepted as an activity capable of producing its own definition of revolution. Art is only expected to define and refine its own formal rules, and not to redefine itself as political activity. In a letter to Jorge Romero Brest as director of the Instituto Di Tella, artist Pablo Suárez (Argentina, 1937–) wrote of his frustration with this limitation, and of the loss of power the artist suffers once a piece or an action is exhibited in an artistic context:

If it occurred to me to write LONG LIVE THE PEOPLE'S REVOLUTION in Spanish, English or Chinese, it would be exactly the same. Everything is art. Those four walls bear the secret to transform everything that is within them into art, and art is not dangerous. (The fault is ours.)[27]

Tucumán arde was an example of art fully going into the political arena, whereas the Tupamaros represented an aestheticization of politics. The merger of political zeal and art thinking had reached its peak. The Tupamaros continued their aestheticized operations for a few years, until their demise. Art returned to its more formal path and the traditional gallery showcase. Nevertheless, in Latin American conceptualism, however much reduced, politi-

cal content and the dream of subversion of exploitative and repressive regimes continued to be important, at least for a while.

On balance, one can say that Latin American conceptualism emerged as an aesthetic more concerned with reality than with abstraction. The fact that this distinctive characteristic has been overlooked by mainstream U.S. commentators on Latin American art denotes a narrowness of interpretation that has been applied to conceptualist strategies in general and particularly to those that took effect on the periphery.[28]

8 *The Aftermath of* Tucumán arde

The activities that followed the *Tucumán arde* "silence" in Argentina were, if political at all, mostly restricted to protest demonstrations. It took some years for visions of radical social change to revive and follow the points made in 1968. One exception, but without a public dimension, was a piece by Jorge Carballa. In 1969, he secretly contracted several churches in Buenos Aires to celebrate mass in honor of Che Guevara on the anniversary of his death.

It then took four years for a piece with a political edge to appear. In 1973, a group of artists created an installation called *Proceso a nuestra realidad* (*Process toward Our Reality*) in the Museum of Modern Art of Buenos Aires for the Salón Acrílicopaolini. It was a cement block wall, seven meters long and two meters high, covered with graffiti and posters, just as one would find on the street. The main inscription was "Ezeiza es Trelew" (Ezeiza is Trelew). Ezeiza refers to the international airport of Buenos Aires, and Trelew is an airport in the south of Argentina. Both places provided a stage for mass killings under the military dictatorship. As already mentioned, a shoot-out took place when former president and dictator Juan Perón returned to Argentina and arrived in Ezeiza in 1973. Thirteen people died and 365 were wounded in the gunfire exchanged between right- and left-wing Peronists. In 1972, political prisoners who were held in the nearby Rawson naval base escaped and took over Trelew airport. Nineteen were brought back to jail, sixteen of whom were machine-gunned a week later by the dictatorship.

Proceso a nuestra realidad was accompanied by an invitation card. On one side it had a drop of blood made with acrylic paint. This material detail justified the presence of the piece in the exhibition that had been organized for the promotion of plastic products. The drop was accompanied by a text that referred to the massacres. On the other side of the card was a second text that started with:

No/For a nonelitist
nonselective
noncompetitive
nonnegotiable art.[1]

Ten years later and fifteen years after *Tucumán arde* (September 21, 1983), a more ambitious project took place when the center of Buenos Aires was covered with silhouettes of corpses. They were chalked on the streets or cut out of paper and glued to the walls of buildings and had, stenciled inside, the names of the *desaparecidos* (disappeared), or missing people. The main concentration of the silhouettes was located on the central Plaza de Mayo, where the images accompanied the Third March of Resistance organized by the Mothers of Plaza de Mayo.[2] The event, known as *El siluetazo*, was conceived by three artists: Julio Flores, Guillermo Kexel, and Rodolfo Agueberry.[3] It was financed by two organizations, the Mothers of Plaza de Mayo and the Grandmothers of the Disappeared. The idea was to put up 30,000 silhouettes, which was estimated to be the number of people imprisoned and killed by the dictatorship between 1976 and 1983. The operation became a major popular event, and the silhouettes were a regular presence at subsequent rallies.[4]

The movement of the Mothers of Plaza de Mayo is an aesthetic action of its own, although its source is grief, not art. On April 30, 1977, fourteen mothers of disappeared victims went to the square in front of the Casa Rosada, the presidential palace. They protested not only the disappearance of their children but also the secrecy and lack of information they faced. Headed by Azucena Villaflor, who herself was to be kidnapped and "disappeared" eight months later, they wore white kerchiefs over their heads, symbolizing the diapers used for their children. The ceremony extended to all the provinces of Argentina. In Ledesma, Jujuy, there is one mother who, as of 1999, was still making her individual procession in the central square. From 1981 onward, the movement appropriated the square on a regular and organized basis, staging "Marches of Resistance" and enduring police harassment. They were threatened with machine guns and attack dogs. The slogan for these actions was "Appearance Alive," as opposed to "disappearance," which meant "presumed dead."[5]

El siluetazo generated a sequence of activities. In 1984, enlarged photographs of the "disappeared" were affixed on the walls around Plaza de Mayo in celebration of the International Day of the Woman. In 1985, an event with the title *450 Thursdays That Restored Dignity* had everybody wear white masks. In 1989, under the catchword "social readymade," several art actions were organized in support of the victims of Tiananmen Square.[6] The most notorious was *Bicicletas a la China* (*Bicycles, Chinese Fashion*). The organizers gathered dozens of cyclists in the center of Buenos Aires and had them construct "heroic sculptures" with their bicycles.[7] The rally also involved patients from the insane asylum where the organizers worked. The event alluded not only to Tiananmen but also to a cam-

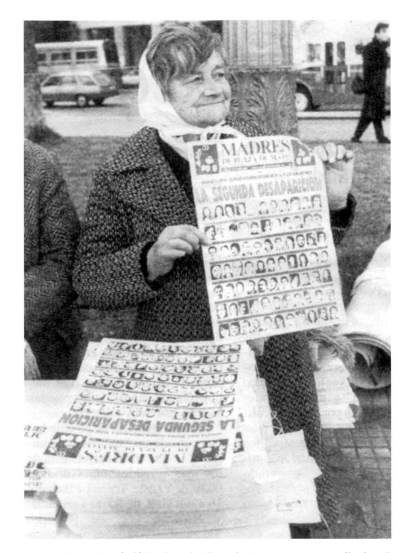

Figure 8.1. (left) Madres de Plaza de Mayo, 1977, news clipping, Buenos Aires, Argentina.

Figure 8.2. (top right) Graffiti on the Plaza de Mayo, Buenos Aires, Argentina, 2004.
Photo Selby Hickey.

Figure 8.3. (bottom right) Path of the weekly procession of the Madres de Plaza de Mayo,
Buenos Aires, Argentina, 2005. Photo Selby Hickey.

paign of then president Menem, who, in an effort to save gas, was promoting the use of bicycles. Over all, the whole affair was to be seen as a Sino-Argentinean political collage that included the memory of *Tucumán arde*.

The weight of the political situation in many of the countries of Latin America during the two decades from the midsixties to the mideighties was such that, in 1986, Uruguayan conceptualist Jorge Caraballo (1941–) published a pointed *Breve historia del arte en Latinoamérica* (*Brief History of Art in Latin America*) as a

Figure 8.4. Jorge Caraballo, "Hidrocinetismo" (Hydrokineticism), *Breve historia del arte en Latinoamérica* (Brief History of Art in Latin America), 1986. Courtesy of Jorge Caraballo.

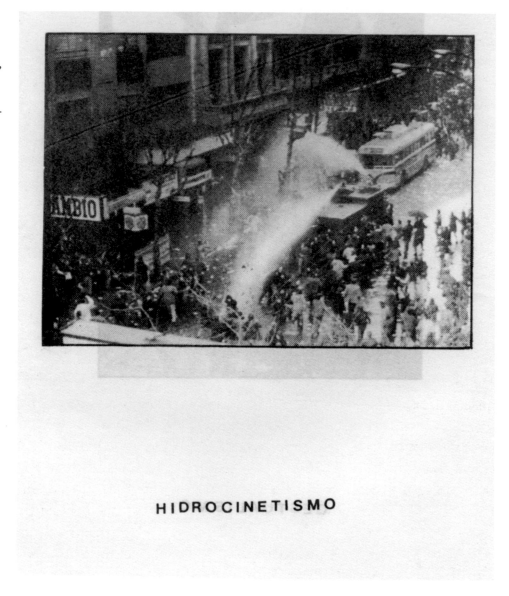

HIDROCINETISMO

work of art. It consisted of titles of several art movements ("Gestualism," "Hydrokineticism," "Realism," etc.) and not much more than that. However, instead of the expected pictures, the movements were illustrated with photographs taken of incidents of repressive actions by the government and protest actions by the people of Montevideo. Hydrokineticism, of course, showed a crowd being dispersed with water cannons; Realism was represented by a view through the bars of a jail window; and the U.S. School, by armed antiriot police. In January 2002, a new group was created in Argentina. It bore the broader name Argentina Arde (Argentina Is Burning).

It is not clear how pointed the influence and repercussions of *Tucumán arde* were in the rest of the continent, but it is a fact that, at various times since then, politically motivated collective movements sprang up in different places. One of the bastions of politicized conceptualist activities still in existence during the seventies was a continental movement of mail art. It was inspired by the early work in the field by U.S. artist Ray Johnson, who had already started during the early fifties and founded his New York Correspondence school in 1963. The movement included both poets (generally inspired by concrete poetry) and visual artists. Meanwhile, a second attempt to go from art into politics was taken up from the midseventies onward, this time mostly by groups in Mexico, Chile, and Peru. Mexico was particularly fertile. So many groups were organized there that at one point the term "Los Grupos" (The Groups) became the popular title for the movement. While some of these started earlier in the decade, their political engagement appeared later.

Mail Art

The epidemic of dictatorships that spanned Latin America from the sixties to the mideighties made the use of mail a perfect vehicle to allow for the communication between isolated artists and the rest of the world. The network became important enough to justify the organization of international exhibits in Uruguay (1974), Argentina (1975), and Brazil (1976), and in Mexico and other countries shortly thereafter. The notoriety of these efforts had two consequences: the number of mail artists increased greatly, and censorship became more sophisticated and intense.

In Latin America, mail art was immediately used for politicized art and was considered subversive enough to lead to the imprisonment of several artists. In 1976, Paulo Bruscky and Daniel Santiago were jailed for some days in Brazil.[8] The following year, in Uruguay, Clemente Padín and Jorge Caraballo went to prison for several years. In 1981, Jesús Romeo Galdamez Escobar was kidnapped by the Salvadorian military.[9] The indictments of Padín and Caraballo were for "anti–North American convictions, moral offense, and offending the army's reputation."

The new network created a "parallel, alternative, and marginal" distribution circuit, which didn't really threaten the dictators, but certainly did attack them.[10] It also served to keep artists in exile in the loop, exchanging work and ideas. As Guillermo Deisler (1940–1995), a Chilean artist exiled in Bulgaria, wrote: "For the Latin Americans—and we are already many creators who have gone into exile voluntarily or been forced by political circumstances—mail art becomes a

Figure 8.12. Carlos Finck, *El hombre atropellado* (*Runover Man*), 1973, Grupo Proceso Pentágono ("A nivel informativo" [On an Information Level]) installation. Photo Víctor Muñoz, Archivo del Grupo Proceso Pentágono, courtesy of Víctor Muñoz.

Figure 8.11.(left) Lourdes Grobet, *Hora y media* (*Hour and a Half*), 1974. Photo Víctor Muñoz, Archivo del Grupo Proceso Pentágono, courtesy of Víctor Muñoz.

a wall to which he added bullet marks. Lourdes Grobet enlarged "the four orifices of the body" to the size of photomurals. The images of the orifices had openings, and members of the public were encouraged to put their hands through them. Their action was rewarded with the unexpected feeling of the animal guts stacked behind the photographs. In *Hora y media* (*Hour and a Half*), a 1974 installation, Grobet filled a darkened gallery space with unfixed photographs. The lights were turned on after the public assembled, causing the immediate blackening of the photographs.

Some of the Mexican group projects expressed a radical militancy that turned out to be short-lived. In early 1978, various Mexican artists who belonged to Los Grupos tried to create a "Mexican Front of Cultural Workers' Groups" with the (unsuccessful) aim of "joining proletarian and peasant struggles, and gaining control of the means of production and circulation of work."[18]

The groups affiliated with the Front espoused a wide mixture of leftist ideologies and also included a variety of disciplines. The Taller de Arte e Ideología (Art and Ideology Workshop), or TAI, created in 1975, sponsored panel discussions on ideological aspects of art and communication.[19] Their goal was to achieve "the increase of the possibilities of rupture with those ideas, feelings, and perceptions ruled by the ideology of the dominant class."[20]

The No-Grupo (No-Group) primarily challenged the bourgeois art market by analyzing its mechanisms using irony. In one of their performances, they presented a price list for the different handshakes available during an opening (scaled upward from artist to critic to museum director).[21]

A most unexpected feature within the Mexican context was that the groups and the Front promoted pan-Americanism. Preceding movements had primarily focused on Mexico itself and on nation building; this continental focus was a radical departure. The artists wanted to fight the same battles that inspired the original muralist movement, but were eager to do so from different formal premises and without the muralists' dogmatism that now was viewed as obsolete and counterproductive. As it happened, the artists of Los Grupos often focused so much on the didactic functions of their work that the expressive aspect seemed neglected and excessively weakened. Their main contributions were the collective approach they practiced and their effort to bypass conventional artistic venues, something that later got lost. In 1977, four of the groups accepted an invitation to represent Mexico in the Tenth Biennial of Young Artists in Paris. One of them, Grupo Proceso Pentágono, was an enlarged version of the Grupo Pentágono that assembled especially for this occasion. In a public relations coup, they persuaded Colombian writer Gabriel García Márquez to write an introduc-

Figure 8.13. Installation by the Grupo Proceso Pentágono for the Tenth Biennial of Young Artists, Paris, 1977. Photo Lourdes Grobet, Archivo del Grupo Proceso Pentágono, courtesy of Víctor Muñoz.

tion for the catalogue. García Márquez defended the artists in what could be seen as a political concession: the participation in a bourgeois exhibition dedicated to reviled forms of art. García Márquez used the old argument that withholding participation would, by default, have turned over the space to their reactionary adversaries.[22]

In their defense, it should be said that, in Mexico, both Los Grupos and the "reactionary adversaries" were operating in the same social space. Meanwhile, in Chile, the situation was quite different. Thanks to the bloody regime of Augusto Pinochet, that social space was clearly divided, and thus the group CADA had an oddly clearer panorama in which to work.

CADA: *Colectivo de Acciones de Arte*

As Chilean critic Nelly Richard observes, the artists from the Chilean Left had used Salvador Allende's tenure to "illustrate geographical or socio-political con-

text." The art produced later, during Pinochet's regime, would "objectify" these issues and use fragmentary quotes from both the international and national repertoire, transplanting from one into the other.[23] Thus, Carlos Leppe, in his *Acción de la estrella* (*Action of the Star;* 1979), follows Duchamp's example with a tonsure in the shape of a star, but then displays it as taking the place of the one star on the Chilean national flag by sitting behind the corresponding open square.

It is interesting that, compared to the primarily male group of artists who were involved in individualized Latin American conceptualism, both Los Grupos and the Chilean collective CADA (Art Actions Collective) had a balanced-gender membership. And, paradoxically, in Chile it took Pinochet's dictatorship to generate and give shape to the more interesting and militant artistic expressions. Previous artistic events, like *El quebrantahuesos* (*The Bonebreaker*) or the actions by Alejandro Jodorowsky and Enrique Lihn, did not seem to have much influence. There were some other precedents, among them the work of Juan Luis Martínez (1942–1993) and Cecilia Vicuña (1948–), that perhaps dated to the midsixties. Martínez was a poet who also explored visual poetry. His poems are broken up with imagery, and his objects bring to mind the work of both Joan Brossa and Joseph Cornell. Vicuña's early work is poorly recorded and mostly reconstructed at much later dates, thus giving more of an insight into her own trajectory than into the development of conceptualism in Chile. Juan Pablo Langlois (1936–) made *Cuerpos blandos* (*Soft Bodies*) in the Museum of Fine Arts in Santiago in 1969, and Vicuña's *Otoño* (*Autumn*) installation was shown in the same museum in 1971. *Cuerpos blandos* was a one-thousand-foot-long piece made of garbage bags filled with newspapers that went through the building and out to the street. *Otoño* consisted of a room full of dried leaves three feet deep. But there was no clear tradition leading to the actions of the late 1970s. In part, this may be due to the fact that immediately before and during the Allende period, artists were less concerned with artistic "rupture" than with the development of a more "popular" aesthetic, something equivalent to that of Mexican muralism and Mexican popular graphics.

During the second half of the 1960s, Vicuña, a poet and a figurative painter, started creating disposable mini-installations that she called "*Precarios*" (*Precarious States*). At the time, however, they were private activities, and they are mostly known today through her recent reconstructions. With six other poets and artists, in 1967 she integrated the Tribu No (No-Tribe). Tribu-No's members had decided that the only option left for South America was to say *no*, and, accordingly, they performed some street actions to spread their message.[24] In spite of their nihilist title, the group mostly advocated love, solidarity, beauty, and social-

ism, and wrote graffiti like: "Read Henry Miller." The actions were classed by some as a symptom of derivation from the U.S. hippy movement rather than as events having local impact.[25]

None of this activity seemed to have a very long-lasting effect, and neither did later imported input during the seventies. Kosuth had visited Chile in 1971, but with no major consequence for the Chilean artists. In a lecture, he made it a point (maybe because of Allende's Chile) to extol conceptual art's "potential revolutionary nature." But then the talk also described conceptual art as a "reflexive critical practice perpetually overviewing and recontextualizing its own history."[26] German happening artist Wolf Vostell (1932–1998) had a major exhibition in 1977, and that seems to have had a much more lasting effect, although it reflected giving a more prominent role to the spectacle format.[27] This very particular panorama may explain why Mari Carmen Ramírez and Chilean critic Justo Pastor Mellado propose José Balmes (1927–) as a protoconceptualist in the Chilean context. Balmes is a painter whose work during the 1960s was closely associated with informalism, and who gave his paintings a political bent by integrating graffiti-like words in his canvases and directing them against different actions of U.S. imperialism.

Censorship during Pinochet's dictatorship was applied much more harshly to the publicity for events than to the events themselves. The dictatorship turned out to be rather unpredictable in its aesthetic judgment. There was no discernible official line. The regime's tolerance in art ran all the way from the most trivial and uninformed taste of the army hierarchy, suddenly self-appointed to make cultural decisions, to the sophisticated cosmopolitan taste of the politically conservative oligarchy. It was a complex situation in which artists had to negotiate a "safe" language. The solution they found was to employ avant-garde formats that were internationally validated. With these formats, they appealed to the snobbery of the more informed factions of the regime, who they hoped would successfully intercede with the philistines in the military. Within the safer formal boundaries, they then developed and codified ambiguity to both disguise and promote their content.[28] The work was acceptable as long as the regime believed that it was elitist enough to be inaccessible to the masses. One of the recipes for success was to avoid any formal solution employed in the popular art created during the Allende period. The big challenge for the artists was to achieve and maintain a level of "clandestine" reading within this very elaborate and complex set of rules.

The group that operated under the name CADA brought all this to fruition. CADA was the more militant group in what was known as the Escena de Avan-

zada (Advance Scene) artists, active during the late 1970s and early 1980s in Chile. The acronym CADA stands for Colectivo de Acciones de Arte (Art Actions Collective). In Spanish, the word "*cada*" also means "each," an example of the ambiguity they favored. The members of this diverse group were the artists Lotty Rosenfeld (1943–) and Juan Castillo (1952–), the sociologist Fernando Balcells (1950–), the poet Raúl Zurita (1950–), and the novelist Diamela Eltit (1949–).

The group started in 1979 and tried to work outside the existing art institutions. It sought to make direct appeals to the public at large. When they did use public exhibition spaces, they did so in a format that tightly conformed to their own program. One of their most typical works was their first, called *Para no morir de hambre en el arte* (*Not to Die of Hunger in Art*), performed on October 3, 1979. As a first step, the artists distributed milk in a shantytown, later reclaiming the containers to use for works to be exhibited. Then they secured a page in the magazine *Hoy*, which they left blank except for a few captions. They had wanted to leave the page completely empty, but had to bow to the magazine's demand for at least some text. The text they used was:

> imagine this page completely blank
> imagine this page white like the milk daily consumed
> imagine every corner of Chile deprived of
> daily milk like white pages to be filled [29]

The reluctance to include the text came from a fear of redundancy. The whiteness of the page was to lead the reader/viewer to imagine milk and shortages (and, of course, the hand of power present in censorship). A second component was the reading of a text, "No es una aldea" (It Is Not a Village), in front of the United Nations building in Santiago, and ideally also in Bogotá and Toronto [30] in the five languages used by the United Nations. [31] Finally, in a gallery in Santiago, they exhibited one hundred reclaimed milk containers stamped with "1/2 liter milk," in reference to a slogan of the Allende government to guarantee a minimum of nutrition for every child, and worked on by other artists. [32] The milk containers, together with the tape of "It Is Not a Village" and the page from *Hoy*, were exhibited in a sealed acrylic display case, which prevented the smell of the rotting milk from entering the gallery space. On

Figure 8.14. CADA, *Invasión de escena* (*Scene Invasion*), 1979. Courtesy of Lotty Rosenfeld.

Figure 8.15. CADA, *Invasión de escena* (*Scene Invasion*), 1979. Courtesy of Lotty Rosenfeld.

October 17, eight milk trucks paraded through town, going from the dairy to the Museum of Fine Arts along a planned route. The trucks were then parked in front of the museum. When the trucks arrived, the entrance to the museum was blocked with one hundred square meters of white fabric, its whiteness also a reference to milk.[33] After the event, realizing the nature of the project that had taken place, the company that supplied the trucks, Soprole, changed the logotype on its vehicles in an effort to distance itself from the event's message.[34]

The milk event was extended to other countries, not only with the reading of the text in front of UN buildings, but with Chilean artists living in exile who were invited to join by performing related activities in their new countries of residence. CADA's plan included "a glass of milk spilled under the blue sky." Thus, Cecilia Vicuña, who at the time lived in Bogotá, spilled a glass seemingly containing milk onto the street by pulling it down with a red cord. The action was announced all over the city with posters set in bullfight-poster typography. The opportunity also served to denounce corruption in Colombia, where milk given to children in areas of extreme poverty had allegedly been adulterated. To this effect, Vicuña used white vinyl glue instead of real milk. In Canada, artist Eugenio Téllez drank a glass of milk while he read a text in front of Toronto's city hall.[35] For the group, the international networking of these relatively slim activities was much more important than the events themselves.

In 1981, the group performed another action, *Ay Sudamérica* (*Oh South America*), during which six planes were used to throw 400,000 flyers over the poor neighborhoods of Santiago "as a quote of the bombing of the government palace that signaled the fall of the democratic government headed by Salvador Allende . . . [and] to reconstruct the political trauma of 1973."[36] The flyers had a text that finished with: ". . . every man who works for the enlargement—even if only a mental one—of his living spaces is an artist."[37] Surprisingly, the group was granted permission for their project by the government. One of the packages of flyers didn't open, and when it fell on the roof of a police station, it made a big hole. The group had to pay for the repairs, but didn't suffer any further consequences.

The members of CADA did not limit themselves to collective work. Lotty Rosenfeld tampered with road markings using broad white tape to design plus and minus signs that confused drivers (1982–1985), and Raúl Zurita used an airplane to write his poems in the sky (1982). Zurita, together with another member of CADA, Diamela Eltit, also did performances that involved acts of self-mutilation. Chilean critic Nelly Richard noted that these actions were "as if the self-inflicted marks of chastisement on the artist's body reflected the marks of suffering on the national body, as if pain and its subject could unite in the same scar."[38] What Richard is remarking on is something that distinguished CADA's work from earlier mutilation/flagellation pieces by Gina Pane, Chris Burden, the Viennese artists, and others. In their work, self-mutilation, even if geared toward social shock (or, in the case of Burden, social participation), remained a mostly personal and artistic expression. In CADA's work, the mutilation seems to have become a metaphor for collective experience.[39]

CADA's attitude was summed up in an interview conducted by critic Nelly Richard in 1982. The words they used, once again, sound familiar: "Our aim is to dissolve art through everyday creativity. We do not want any opposition between art and life. The future we desire for art is life itself, the creation of a different society as a great work of art."[40]

Their last piece, before the group decided to cease doing collective work in 1983, was "*No +*." It coincided with the tenth anniversary of the regime, asked for the collaboration of artists who did not belong to the group, and consisted of graffiti with "No +" as the text. In Spanish, the word for the sign "+" is "*más*," which can be read as "more," so that soon the walls of buildings around Santiago had signs saying things like "no more dictatorship," "no more poverty," and so on. The public assimilation of the work was considered a transmittal of the activity and determined their decision to stop their projects. In retrospect, this

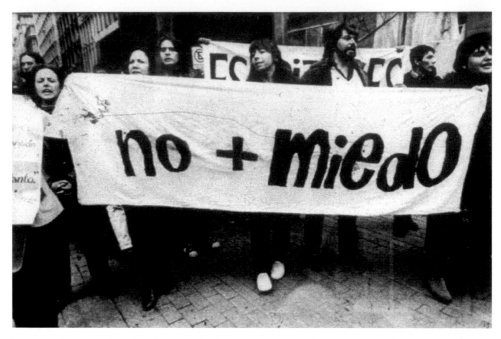

Figure 8.16. CADA, *No + Miedo* (*No + Fear*), 1983. Courtesy of Lotty Rosenfeld.

seems like an unfortunate decision, since this point might have served to further empowerment as a continuing process.[41]

In 1980, and in the same vein of having the public complete thoughts hinted at by an artist, Alfredo Jaar (1956–) filled Santiago de Chile with billboards asking "Are you happy?" Given the atmosphere of terror imposed by the dictatorship, the question was an extremely loaded one and was a good example of "contextual" art. In the Museum of Fine Arts, viewers were stopped and invited to answer the same question for a poll, and this was recorded on videotape. They were given mints that were to be placed into clear plastic containers marked with the possible answers to the question. People also had the choice to abstain, in which case they were allowed to keep the mint and eat it.

EPS *Huayco*

Meanwhile, in Peru, insurgency prevailed during the same time frame as CADA and Jaar's billboards, 1979–1980. "Shining Path" was the best known of Peru's guerrilla movements, but there were many others, spanning a whole spectrum of leftist ideologies, mixed to different degrees with indigenist causes. Conceptualist strategies were not common in Peru, but one art group, EPS Huayco, did stand out during this period as coming relatively close. This group, though short-lived, made an impact with two actions.[42] EPS stands for "Estética de Proyección

Social" (Social Projection Aesthetics) and plays on the name of a cooperative created by the government of Juan Velasco Alvarado called Empresa de Propiedad Social (Social Property Company).[43] The word "*huayco*" is Quechua for "avalanche." EPS Huayco members gathered ten thousand empty cans of evaporated milk and used them as a composite canvas on which they painted a huge dish with french fries and sausages that was visible from the highway. In a second phase, a year later, they added another two thousand cans and repainted the whole piece with a portrait of Sarita Colonia. Sarita, born Sarita Colonia Zambrano (1914–1940), is a popular cult figure claimed to have performed many miracles among the poor, although there is no concrete information about what those were. At some point in her life, she was apparently stopped by robbers, who, upon finding nothing to steal from her, tried to rape her and discovered that she was like a doll, with nothing between her legs. In spite of the claimed miracles, the Catholic Church did not accept Sarita. She apparently died of malaria and was buried in a common grave. However, as the myth surrounding her grew, the Church made an about-face later and thought it prudent to adopt her as an unofficial saint.

Sarita's portrait was placed on a hill that faces both the city and a heavily traf-

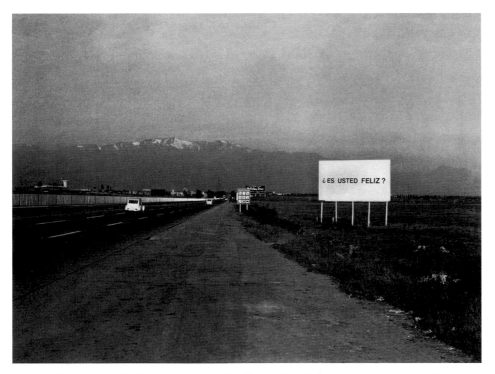

Figure 8.17. Alfredo Jaar, from the *Studies on Happiness* series, 1979–1981: *¿Es usted feliz? (Are you happy?)*, 1983, billboard. Courtesy of Alfredo Jaar.

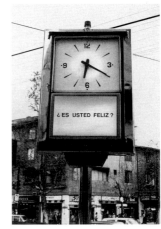

Figure 8.18. Alfredo Jaar, from the *Studies on Happiness* series, 1979–1981: *¿Es usted feliz? (Are you happy?)*, 1983, advertising space on street clock. Courtesy of Alfredo Jaar.

Figure 8.19. EPS Huayco, *Sarita Colonia,* 1980, enamel on tin (ca. 12,000 cans of evaporated milk, 60 square meters). Photo Marianne Ryzek, Archivo de Micromuseo; Gustavo Buntinx, *EPS Huayco: Documentos,* Lima: Museo de Arte de Lima, Instituto Francés de Estudios Andinos, Centro Cultural de España en Lima, 2005.

ficked route used by migrant workers. Gustavo Buntinx, who wrote extensively about the work of EPS Huayco, points out that what could aesthetically be classified as a derivation of pop art, here became an icon returned to the people. Offerings to Sarita were brought to the site of the painting, and the work, in Buntinx's words, linked "Andean migrants and radicalized sectors of the middle class in a shared bid for revolutionary power."[44]

One of the influential figures in Huayco ESP was Francisco Mariotti, who was born in Bern (1943), but did his grade school and secondary education in Lima. Later, after studying art in Hamburg and Paris, he participated (together with Klaus Geldmacher) in the Documenta IV international exhibition in 1968. Back in Lima, under the Left-leaning government of Velasco Alvarado, he helped organize silkscreen workshops for peasants. In 1980, Mariotti exhibited his *Reciclajes* (*Recyclings*), installations using materials found in garbage dumps, a show that inspired subsequent actions by Huayco ESP.[45] However, the idea of using empty cans of evaporated milk had been raised a year earlier in a group that partially overlapped with Huayco. Their idea was to make curtains to interfere with traffic in Lima in an operation supporting a general strike.[46]

EPS Huayco also did some poster work, which relied heavily on pop imagery. Soon after, they stopped making collective creations and then disintegrated, completely plagued by internal dissension.

9 *Figuration, Abstraction, and Meanings*

In *An Anecdoted Topography of Chance* (1966), Daniel Spoerri (1930–) refers to Israeli artist Yaacov Agam (1928–) as somebody "who invented everything earlier."[1] In 1970, Argentine artist Eduardo Costa (1940–) proposed making "a piece that is essentially the same as a piece made by any of the first conceptual artists, dated two years earlier than the original and signed by somebody else."[2] While Spoerri's comment was a joke or a critique applicable to a single artist, Costa was defining an ideology.

Costa's statement is revealing because what he wrote is a *piece* and not an essay. He used a work of art to make an ideological critique. In that sense, it is a didactic and militant piece, out of synch with Western formalism. If there is a difference with traditional political art, it is that, while actually spelling out the critique, he was not making a programmatic piece. It is a straight art piece, but comes from a different, unexpected ideology. It is this point that characterizes rupture produced in Third World conceptualism. There is no need for a separate program to spell out a pedagogical strategy for art when the ideology from which work is generated is itself pedagogical.

Costa's critique is remarkable because in three lines it vividly captures a complex analysis of the obsession with uniqueness and ownership that is in the conventional definition of artistic "genius." He addresses originality as a quality based on historical origin and comparisons. He questions the presumed necessity of placing all art events into the "history" as written by the mainstream. And, beyond that, he sums up the dangers that shadow attempts to write local versus mainstream accounts. While researching dates, one is driven to "beat" other histories, thereby participating in a race defined and conditioned by mainstream history. One of the challenges when analyzing the whole picture, however, is to see the role that formal styles play in this and their true relevance for cultural development. Condemned styles may end up having a stronger impact than initially perceived, whereas other styles may dissolve in the fashions of taste.

One of the big controversies in art in Latin America during at least half of the twentieth century was the conflicting ideologies of abstraction and realism, and,

more precisely, the role of socialist realism. It is surprising to see how often the socialist realist rhetoric envisions an aesthetic so alien to the ghastly Soviet paintings produced in its name. An introductory text to the Soviet Pavilion at the 1939 World's Fair has at least one paragraph that is actually refreshing for its other reverberations:

> To the outré cult of form in pre-revolutionary art, which in the final analysis resulted in negation of the descriptive quality in art, Soviet artists oppose profound content and imagery. To pretentiousness, art for the few, Soviet artists oppose art for the millions, for the masses, for the people. To formalism Soviet artists oppose realism.[3]

If one ignores the paternalism and demagogic concessions that made socialist realism a form of artistic baby talk, and if one overlooks its fascist idealist ingredients, one could see in it a fitting platform for Latin American conceptualism that goes way beyond simple agitprop. If we focus on the accessibility of content—particularly when related to ethical and political concerns—we may find relationships and correspondences between works and movements that in a formal sense are quite dissimilar. We can see, for example, a connection between Mexican muralists and the work of Uruguayan Joaquín Torres-García (1874–1949). The work of Torres-Garcia in his constructivist period and that of Diego Rivera (1886–1957) in his muralist phase both contain what Shifra Goldman calls "indigenous utopias." Both artists are interested in a future based on progress and derived from a local tradition. And both are interested in art as a symptom of a broader and more collective culture than the gallery circuit may provide. Yet, they are portrayed as two different faces of Latin American modernism that are at odds with one another.

Latin American conceptualists should be placed in this shared "matrix" of abstractionism and message-oriented art. Across the formal boundaries, they really have much more in common than we are accustomed to accepting. The matrix was traditionally obscured in Latin America by the abstraction/figuration controversy that had started during the forties and climaxed during the fifties. It was an imported formalist discussion that created a false opposition. Following the example of the United States, the enmity between the two factions became even more distorted and exaggerated with the introduction of Cold War politics. The anticommunist West identified extreme realism with totalitarianism, and abstractionism with democracy. The communist camp, on the other hand, saw socialist realism as the true depiction of a developing utopia, whereas abstrac-

tionism was a decadent bourgeois aberration. Meanwhile, of course, Adolf Hitler, Dwight D. Eisenhower, and Winston Churchill all made their own realist art of sorts in their free time, and in 1976 Andrew Wyeth's show at the Metropolitan Museum had the highest public attendance to date. Albert Speer and Joseph Goebbels, on the other hand, had expressionist sympathies, and Benito Mussolini and some of General Franco's people were not averse to abstractionism, and sometimes even promoted it.

Nevertheless, the abstraction/figuration clash was fairly international and became more exaggerated on the periphery, perhaps because there it was even more irrelevant. There were no rational alignments, only fanatical and religious ones. Both positions became simplifications of semidigested directives and, carried away by a belief in the infallibility of taste, went far beyond the discrepancy in dogmas to the point that the despised opposed aesthetic was perceived as incapable of having even the most minimal trace of quality. The raising of these aesthetic strawmen allowed taste to triumph over mind and prevented those who were paying attention to this "debate" from realizing that many artists of both persuasions actually shared beliefs about art's social functions.

Abstractionists, in accusing those artists who used political ideas as pamphlet makers who were misusing art, were giving unwarranted significance to the mere absence or presence of content in it. Meanwhile, the realists and figurative artists, in accusing the abstractionists of meaningless ambiguity and empty decoration, were emphasizing rather superficial issues of iconography. However, the range of political ideologies among the artists in both aesthetic camps was very broad, which made it obvious that what was happening was a war between different artistic fundamentalisms and not a genuine political confrontation.

Given the intensity of the polemics, it is difficult, even today, to recognize that Latin American conceptualism was a perfect alternative to what seemed to be an intractable polarity. From a formal point of view, conceptualism can be viewed as the consequence of some of the processes characteristic of abstractionism. At the same time, and in all other respects, it includes concerns from the whole range covered by figuration, including interest in the immediate context, commitment to liberation from categorical constraints, and choice of extroverted forms of expression.

Conceptualists did not engage in the controversy between realists and abstractionists. It was, in any case, identified with older generations, and by the 1960s, the issue didn't seem overly interesting or relevant anymore. This was partly because of fissures in the "communist bloc" due to the challenges to dogmatic recipes reflected in developments in Czechoslovakia, Poland, and Cuba. The ver-

sions of socialist realism or "committed figuration" expressed by many of their artists did not offer any real artistic reason to despise them.

In the United States, the abstraction/figuration gap was closed by pop art, which was so culturally specific—a form of U.S. vernacular—that, with the possible exception of Cuba, it never had any major stylistic consequence in Latin America. In some sense this is surprising, since, unlike previous isms in the mainstream, pop art was an encompassing movement formally open to synthesis and also interested in "reflecting" reality. In a politicized version, it could have provided a methodology for some of the purposes for art embraced in Latin America.[4]

Perhaps pop art failed to influence art styles in Latin America because of its disregard for politics, and because consumer products, other than those connected with religion, never inspired any art of relevance in Latin America.[5] Whatever icons of consumption there may have been were derived from imported items, so that to the extent that they appeared in art at all, it was usually with sarcasm. The consumer icon in the Latin American context would only work as an acknowledgment of the consumer as a victim of market expansion within economic underdevelopment. It never occurred to any Latin American artist to adopt a Coca-Cola bottle as a friendly taken-for-granted fetish.

The use of the market icon for resistance is exemplified in the practice of "insertion" and "reinsertion," terms used by Brazilian artist Cildo Meireles in his 1969–1970 pieces. Meireles, in fact, used the icon only as a stepping-stone to reverse the flow between the consumption of everyday commodities and the consumption of art. In U.S. pop art, both the consumer item and the celebratory art piece only circulated in one direction, with both landing in the consumer's lap as their final destination. In Latin America, the circulation process initiated by the commodity was appropriated by the artist and then redirected for the transmission of information. Meireles achieved this by using a rubber stamp to send political messages on money bills or by using Coke bottles with decals as message carriers. The stress, however, was no longer on the object but on the circuits of information.[6]

One could say that it took a "conceptualist" stance to generate works that had an iconic value parallel to that of pop art in the United States. It was pop art that somehow brought the idea of "thinking in terms of problems" into U.S. art. In Latin America, it was conceptualism's role to do the same thing.[7] Once art was formulated like a set of problems to be solved, it stopped being a vehicle for illustration or a tool for hedonism. In the United States, this shift into problem formulation led to a revision of the painterly repertoire. With pop art, layout took

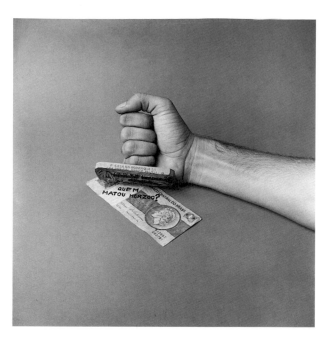
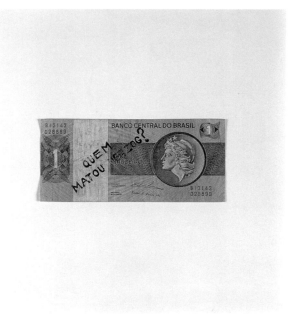

Figure 9.1. Cildo Meireles, *Inserções em Circuitos Ideologicos: Projeto Cedula* (*Insertions into Ideological Circuits: Cedula Project*), 1970–1973, rubber stamp on banknotes, dimensions variable. Copyright © Cildo Meireles, Courtesy of Galerie Lelong, New York.

the place of composition, and the painterly atmosphere was abolished. The presentation of the object became as "cold" as possible. Nonetheless, Andy Warhol (1928–1987) managed to push these trends into a conceptualist stance. His work took the shape of existing objects, and his creations, in turn, were successful in the market. The importance of his contribution, however, was not the creation of the object, but the conceptualist move to identify and proclaim as his own an already existing aesthetic. The most unadorned example of this in his production occurred with his signing of actual Campbell's tomato soup cans (1964). He capitalized on his own strategy that was based on the fabrication of tangible objects, and then dematerialized the whole thing. The real soup can became a readymade of a complexity that Duchamp had not envisioned. It seemed to be the appropriation of a commercial product, but was the symbol of an appropriation that had already taken place with his previous work. Thus, the new readymade was like one of his own works transferred to the object that had started his creative cycle and was now closing it. After completing this full cycle, the actual soup can could only be seen as a tautology on the level of symbols, bypassing any need for manufacture.[8] Thus, it wasn't pop art as a style that had an impact in Latin America but rather its "conceptualization."

Yet, the term and the imagery of U.S. pop art was pervasive and made every-

Figure 9.2.
Waldemar
Cordeiro, *Popcreto*
(Subdesenvolvido)
(Popcreto [Under-
developed]), 1964,
102 × 82 × 54 cm.
Courtesy of Ana
Livia Cordeiro.

body aware of its existence and, without necessarily influencing the creative process, redirected the gaze of some artists. Thus, Waldemar Cordeiro (1925–1973) even used the word by naming his work of the early 1960s "*Popcretos*." They were made with pieces of disassembled furniture reassembled on a canvas. But instead of using pop art strategies, he applied ideas used in Brazilian concrete poetry to manipulate everyday objects. In the process, he downplayed the image itself and underlined the structure of his constructions or assemblages. At some point these objects also dealt with text, creating pop/conceptualist hybrids.

Conversely, Colombian artist Antonio Caro, one of the more important conceptualists in his country, did not hesitate to accentuate visual iconic features. Both his *Colombia*, in which the name is written in Coca-Cola-style script, and his use of typography from popular bullfight posters to make political slogans during the mid-1970s are examples of the use of the vernacular toward this effect.[9]

Hélio Oiticica's work with the Schools of Samba, from 1964 onward, also used the power of vernacular imagery. The dancers' capes became a vehicle for the circulation of ideas. *Tucumán arde*, appropriating the aesthetics of "display," was in one sense a meta-exhibition serving these same purposes. Display techniques and the act of exhibition were recontextualized, creating, in effect, a new icon.

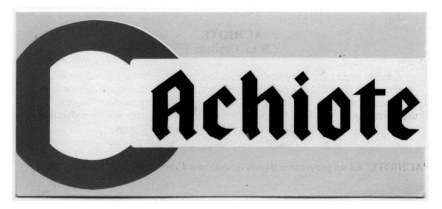

Figure 9.3. (above) Antonio Caro, *Coca-Cola*, 1976, enamel on tin, 70 × 100 cm. Courtesy of Antonio Caro.

Figure 9.4. Antonio Caro, *Achiote*, 2001, digital print, variable dimensions. Courtesy of Antonio Caro.

The only point related to resistance that mainstream pop art ever came close to making was to question the role of the consumer. The conceptualist stance in Latin America went further and also took into account labor issues by underlining commodification and exploitation. Thus, in Latin America in the 1960s, it was an entirely different set of questions than those raised by pop art and other movements that seemed pressing. Something that sounded much more interesting than strict form or content, for example, was the exploration of the possibilities for controlling ambiguity in the communication with the public. Neither abstract nor representational artists had until then adequately addressed the role of the viewer vis-à-vis the work of art. Both factions had developed murals and public art, but had failed to answer in-depth things such as: How could the public be prompted to participate with the work of art? How could decision making be shared without losing "artistic quality"? How much ambiguity could remain in a work to ensure mystery and other artistic imponderables, without deviating from its political mission? How could one have both a search for mystery and an education of the uninitiated in the same piece, and still avoid being either hermetic or obvious?

Some artists plunged into this in a more straightforward manner than others, but the questions persisted beneath the surface of most of the work produced along conceptual lines in the 1960s. Argentinean artists León Ferrari and Juan Pablo Renzi confronted them very directly in the preparatory papers for *Tucumán arde.*

Ferrari decided to classify art by its meaning. He differentiated between "Rorschach art," an art open to the public for any interpretation—an unplanned voyage so to speak—and art with a closed and inescapable meaning determined by the artist. He then went on to affirm that it is not just meaning that defines art; how it is organized has an equally important role in the definition.

> Art shall not be beauty or novelty; art shall be efficiency and perturbation. Successful art will be the one with an impact somewhat equivalent to a guerrilla attack in a country that is freeing itself.[10]

Ferrari, of course, was aware that not only is there no total "Rorschach art" representing an idealized freedom, but the freedom offered to the viewer is always restricted. His option, then, was to try to find and eliminate the specific restrictions that prevent the viewer from reaching freedom—one of the points pursued in *Tucumán arde.*

Renzi, on the other hand, talked about ethical and aesthetic consciousness in the context of collective deliberation:

We know, roughly, what not to do, but how will we realize artistically the acquired consciousness? The answer belongs to the realm of individual creation, but maybe we need a group reflection about the problem. Because if something is relatively clear, it is that, politically, our attitude will have a cultural weight while we act as a group and while our activity is clearly defined within the limits of our specific work: aesthetic creation. Otherwise there is the danger of falling into ambiguity and losing efficacy.[11]

According to him, the artist is both an individual and a freelance agent and producer and, as such, is opening the way to an ideological-cultural process. In this activity, the process should have more impact than the particular object produced. The object as a product here becomes an ideological point for decision, either to be pursued or to be abandoned. Accordingly, the ideology places the emphasis either on consumption or on creation, an alternative that plagues every artist and that forces his/her placement vis-à-vis society. It is a choice that also reflects on the artist as a teacher and on his/her views on the function of pedagogy, a discipline that in Latin America has been closely linked to all these ideas.

10 *The Intellectual Context*

Two major events shaped much of the Latin American thought of the 1950s–1980s: the Cuban Revolution and the emergence of the Theology of Liberation movement, and both should be discussed briefly to better understand the context in which much of conceptualism operated.

The Cuban Revolution strongly marked at least two decades of Latin American thought. It was an event that galvanized Latin American intellectuality as much as the Spanish civil war had during the late thirties, with its ripple effect that lasted several decades. The Cuban Revolution served as a consciousness-raising tool, bringing ideological issues to the fore and honing attitudes about the use of the intellect.

Nearly too much has been written about the Cuban Revolution and its consequences, both by friends and foes. Still, it should be said here that from its very beginning in 1959, the revolution served to demonstrate—at least temporarily—not only that the development of strategies to challenge institutions made sense, but that utopia had a chance. Socialism without bureaucracy and repression seemed possible. Nutrition, shelter, schooling, medicine—all of these could be available as innate rights and not just as castles in the air. Somehow, it seemed that permission was given to be oneself if one was willing to fight for it. Cuba gave Latin American revolution a hemispheric rather than a narrowly national quality, and it clarified even more our ideas and awareness about dependency, whether economic or cultural. In a more strict artistic sense, the revolution challenged traditionally held notions about "form." So it is no surprise to hear statements like the one made by Argentinean artist Juan Renzi when he declared that the life of Che Guevara was a work of art of greater importance than that of the majority of the objects collected by museums. This position led to a particular blend of art and politics that can only be understood with the knowledge that, at the time, both art and revolutionary politics were in the hands of the educated middle and upper classes. As Mexican author Jorge Castañeda explains, in discussing Latin American intellectuals:

To a large extent, they have served as mediators between two sets of separate actors that often proved incapable of communicating directly with each other. Intellectuals are frequently situated right at the seam between Latin America and the rest of the world, and between a strong state and a weak civil society.[1]

Castañeda also points out that of those who died as a result of repression between 1964 and 1978, 33 percent were manual laborers and 64 percent were intellectuals (half of them students).[2]

The writings of Jorge Luis Borges, as we will see, had given us an education in creativity: he had shaped our vision of the cosmos as a great tautology, while underlining both the power and the inanity of naming. The Cuban Revolution gave us a political backdrop for our stage on which we could move consistent with Borges's inscrutable symmetries and vicious circles.

Somewhere between literature and politics appeared the engaged thinking embodied in the Theology of Liberation. Though Catholic in origin, it became influential among most Latin American intellectuals of the 1960s and 1970s regardless of their religious beliefs or disbeliefs. In many respects, Theology of Liberation had a parallel development to that of Latin American conceptualism, but it also had a reinforcing effect on conceptualist artists with an ideological commitment. Theology of Liberation certainly came from the same political roots as the art of the time; it reflected the same concerns and, just like conceptualism, also aimed at an encompassing cultural structure. Further, its thoughts were very much in tune with the renewal of pedagogy, such as the theories of Paulo Freire, who was strongly connected with the progressive factions of the Catholic Church in northeast Brazil. A leading figure of the Theology of Liberation movement, Hélder Câmara (1909–1999), came from that region as well. Freire was often misconstrued as a radical leftist by the anticommunist dictatorship, but he based his theories within the ideas of Theology of Liberation on an antisectarianist antiradicalism of either Right or Left. His goal was to foster dialogue between humans, between humans and the world, and between humans and their Creator.[3]

Ivan Illich (1926–2002), another important pedagogue, was a defrocked priest active in pedagogical thinking, theological ethics, and ecology. Like Freire, he was very critical of the establishment's school system. He referred to it as the "Universal Church of Our Decaying Culture." The university graduate was described as having been "schooled to fulfill a recruitment service among the rich on Earth."[4]

One of the more prominent guerrilla heroes in Latin America was the Colombian priest Camilo Torres (1929–1966), who started his career as a very influential sociology professor at the Universidad Nacional in Bogotá. Although he left the Church to become an active guerrilla fighter (and died in battle), Torres was constantly anguished about his relation with it. For a long time, he tried to balance militancy with piety and allegiance, until it proved untenable:

> Although his [a priest's] mission is specifically supernatural, there is also the imperative of charity, for "the charity of Christ impels us." The measure of charity is determined by our neighbor's need. That is why there were bishops possessing the temporal powers of judges and princes. And for the same reason the missionary must practice medicine on many occasions. The law exists for man, and not man for the law.[5]

Torres, like most of the other Liberation Theologians, used *Pacem in Terris*, Pope John XXIII's encyclical of 1962, as a platform for action. In one segment picked up by Torres, the encyclical differentiates between philosophies of nature and initiatives to ameliorate the economic and political order. According to John XXIII, the priority of the goal of social justice overrides and invalidates textual orthodoxy that is at odds with reform. Torres writes not about religion being invalid, but about postponing some issues: "When the popular class takes power, thanks to the collaboration of all the revolutionaries, our people will discuss their religious orientation."[6]

The coincidence in timing between the appearance of the Theology of Liberation and the Latin American version of conceptualism signals the same mode of thinking in two apparently unrelated fields. The Theology of Liberation leveled a challenge at those religious ascetics who denounced the needs and favors of the flesh. There is, to quote Argentinean theologian Enrique Dussel, a "morality of domination" over "corporeal ethics."[7] With some license, the following quote from the Theology of Liberation could be read as a description of the difference between conceptualism in the mainstream and conceptualism on the periphery:

> Accordingly, nothing transpiring on this negative level—the realm of the body—is of any importance: daily manual labor, torture at the hands of a Latin American dictator or CIA trainee, and so on. Nothing is of any worth except in the light of eternal values, or from the perspective of the "spiritual" and cultural virtues of the soul. This is the morality of domination.
>
> The ethics of liberation is "fleshy"—if by "flesh" we understand the

whole human being in his or her indivisible unity. Thus there is no such thing as a human "material body"; there is only "flesh." Nor is there such a thing as incorporeal soul; there is only "flesh." "The Word became flesh"—neither body nor soul separately.[8]

Not surprisingly, Theology of Liberation tried to deinstitutionalize the evil parts of society. It did so by carefully separating morality from ethics (the first being a body of rules aimed at control, the second consisting of relationship activities and addressing the needs of other persons). Morality was seen not only as institutional but also as protective of institutional interests. Ethics, instead, was seen as protective of the needs of people. Thus morality was not a set of regulations that articulated ethics, as institutions wanted to make it. Morality was a distortion of ethics, one that could even contradict ethics. The challenge raised by Theology of Liberation was not played out exclusively at the theological level. Latin American bishops also entered the political arena, making denunciatory declarations and staging acts of defiance.[9]

There was a general communion of ideas and sympathy for the causes espoused by the Theology of Liberation, even among nonreligious artists, but that did not reflect in a new form of religious art. Aesthetically speaking, Santería had a much bigger impact, particularly in Brazil and Cuba. Theology of Liberation was mostly disconnected from the aesthetics of any ritual. There is only one artist I can think of as being relatively connected to this movement, at least in spirit, and that is Mexican artist Mathias Goeritz. Although his scope as an artist is markedly broader, there was such a preoccupation with ethics and mysticism in both his behavior and his work that this seems the right place to discuss him. What may have separated him from the movement was the isolation of ethics from politics. This may also explain why there was no direct link with the later appearance of Los Grupos.

Mathias Goeritz

Mathias Goeritz (1915–1990) was one of the most inquisitive artists of his generation, not only because of his ethical concerns but also because of how he dealt with formal issues. He was born in Danzig/Gdansk, a place that was never fully certain what country it belonged to, and settled in Mexico in 1949. Some of his pieces that now seem closest to later conceptualism were completed in the context of his private correspondence during the 1950s. Two of the best examples are *Doblado en cuatro* (*Folded in Four*; 1957), a folded sheet of letter paper, and *OK,*

homenaje al papel (*OK, Homage to Paper,* 1965). In *OK, . . . ,* he placed measurements of a larger paper, or rectangles with enlarged measurements, on new sheets of paper. In his work, Goeritz's quest for essences both formal and ethical led him to produce reductionist works as early as 1953. Though I see him as a precursor of conceptualism, in the history books he is designated solely as a precursor of minimalism. With his radical approach, Goeritz served as a catalyst for those Mexican artists who were neither politically doctrinaire nor aligned with the muralists, but who despaired about the state of Western contemporary art.

Expressing his displeasure and disillusionment with decadence, Goeritz founded the group of artists known as Los Hartos (The Fed-Ups) in 1960. The group denounced the "emptiness in contemporary art" during a one-day exhibit in December of 1961. It was held in the Galería Antonio Souza in Mexico City, profusely spiced with manifesto-containing flyers bearing the title "Estamos hartos" (We are fed up).[10] Goeritz exhibited "monochromatic messages," and José Luis Cuevas, a prominent neofigurative artist, installed a piece called *Visiones panorámicas del harte* (*Panoramic Views of Art*). In Spanish, the word "art" (*arte*) was misspelled by preceding it with *h* to play on "*harto.*" Cuevas's piece consisted of a white panel defined by four lines, with no other information. Water ran on the

Figure 10.1. Mathias Goeritz, *OK, homenaje al papel* (*OK, Homage to Paper*), 1965, 14.4 × 19.8 cm. Courtesy of Ida Rodríguez Prampolini and Daniel Goeritz Rodríguez.

Figure 10.2. Mathias Goeritz, *Doblado en cuatro* (*Folded in Four*), 1957, 64.5 × 49.2 cm. Courtesy of Ida Rodríguez Prampolini and Daniel Goeritz Rodríguez.

floors and walls of the gallery, and the rest of the exhibit included collided cars and mutilated paintings, as well as a number of nonartistic activities and objects, among them a dish prepared by a housewife and fruits from a farmer.[11] The only apparent condition for participation was that the profession of the participant had to begin with a vowel. This permitted the attachment of an *h* to it, an important factor for the purpose of the show. Thus, there was "*hama de casa*," instead of "*ama de casa*" (housewife) and "*hagricultor*" instead of "*agricultor*" (farmer). The show also included a chicken ("*have*" instead of "*ave*") that laid an egg ("*huevo*," already with an *h* in Spanish). The egg was the only piece sold in the exhibition (at market value), and was bought by architect Luis Barragán.[12] At some point during the opening, somebody got hold of the now-work-of-art egg and aimed it at Goeritz's head. It missed him and was destroyed against the wall. Initially, the plan had been to hold the exhibition for a full month, but the opening was judged a scandal, promptly causing the closure of the show that same day. The manifesto distributed during the opening explained that "the Hartos do not want to be confused with Neodadaists, who ignore that Dada is eternal. The Hartos are also fed up with Dada. The nature of their realism is moral."[13]

The show and the expression "fed up" came from Goeritz's self-examination during previous years. His pondering had led him to a kind of early-Christian mysticism applied to art, which he called Arte-Oración (Art-Prayer). He used French terms for the elucidation: "*art-prière*," as opposed to what he called "*art-merde*." The latter meant fashionable art: "conscious or unconscious egocentrism, gratuitous expressionism, . . . the conquered moon, . . . cruelty, bluff." The praying art was to be "a fight against the ego and for God, the rebellion of DADA against incredulity." He wanted to work on "the modest line that creates the world of spiritual fantasy, the absurd beauty of Gregorian chants, service, and absolute surrender, ART, PRAYER."[14]

Among the places Goeritz chose to "preach" his message was New York's Museum of Modern Art. The occasion was the March 17, 1960, opening of Swiss artist Jean Tinguely's Homage to New York exhibition. Tinguely (1925–1991) had built a huge and noisy mechanical contraption that, once in operation, had as its only mission its self-destruction. Possibly because of where the action was taking place, Goeritz took Tinguely's piece to be a cynical statement, one that was incompatible with his own mysticism, and not as a self-deprecatory expression mocking art. He decided to picket the event and to distribute flyers.

Goeritz's mystical tendencies had been demonstrated as early as 1958 with his golden monochrome nailed works *Meditaciones* (*Meditations*). After 1960, he pushed further, trying to reach the humble station of the anonymous artisan. In

1961 he found himself pained nearly to the point of self-destruction. There were discrepancies between his various motivations and also between his intentions and the actual physical presence of the work. In the end, he couldn't resolve either. He published a letter addressed to a friendly reviewer of his work:

> As soon as I execute a dreamed work I have to destroy it, at least with words, by mocking it. Of course I realize that my work, even when agitated by artistic motivation, is fundamentally ethical in nature. Do you understand me? Me neither.[15]

Some months later, for an exhibition in the Carstairs Gallery in New York, he prepared a statement explaining that the exhibit was

> a protest against myself as an artist. Art has been violated and is dead. No transcendental artistic problem exists anymore. But there is a philosophic one. Aesthetics without an assured ethical background may produce interesting results, even beautiful ones, but not art.[16]

Goeritz seemed to internalize what at the time was leading other artists in England and in Argentina to express themselves with aggressive externalized destruction. In his personal form of religious dadaism, Goeritz played with many of the limits of traditional media, and beginning in the early 1950s, he also ventured into concrete poetry. His experiments informed later sculptures, and he used three-dimensional letters, as in his *Oro* (*Gold,* 1965). However, he never was able to transcend the limitations posed by formal constraints. He tried to do so with ethics, but couldn't bring himself to fully consider the erasure of material borderlines.

Goeritz's predicament is not unusual. Allan Kaprow once wrote, in relation to "happenings": "The line between art and life should be kept as fluid, and perhaps as indistinct, as possible."[17] And then he proceeded to leave politics out of the picture. Kaprow tried to break down formalist art by creating a new form.[18] Goeritz tried to break down art using ethics, but without totally challenging art. His shortcomings may have been based on the fact that he ultimately did believe in art as one separate activity and in himself as a producer of it. Thus, he couldn't find a bridge that totally connected his ethical concerns with his production.

11 *The Input of Pedagogy*

The most radical social intervention during the 1960s was the extreme abuse of power and use of violence by various Latin American states and other countries on the periphery. It was this form of political and social "rupture," a rupture executed by those in power, that art and alternative pedagogy sought to resist. Every component of state power severed completely any connection to popular control in a process that continued into and climaxed in the seventies. Revising this development, in 1968, Nicos Poulantzas asked and answered (with his own italics) this question:

> What is to be understood by repressive force and violence, which are vague notions and useless until they are made more specific? *The term* force *in fact covers the functioning of certain institutions of organized physical repression, such as the army, the police, the penitentiary system, etc.* This repression is socially organized and is one characteristic of *all power relations . . .* In this respect, this state's characteristic is *that it holds the monopoly of organized repression* as opposed to other social formation in which institutions such as the church, seigneurial power, etc. have, parallel to the state, the privilege of exercising power.[1]

Poulantzas did not expand his insight to address either education or art, but he could have, since both are activities with an institutional base in society. In any case, under conditions in which the institutions of the state were completely devoid of accountability to the public, any conceptualist aesthetic is virtually, and by definition, utopian in its implications. Boundaries are critical to the police state, even more so than to a state that is democratic and porous. In crossing boundaries, even effacing them, conceptualist art poses a threat regardless of the message it carries, since it is able to ignore and invalidate the power structure. The political implications of conceptualism were even more pointed in so far as conceptualism in Latin America intended to educate the public. With this in mind, one can insert conceptualism into the long tradition of revolt that higher education has produced in the twentieth century. It was a process that started

with the Córdoba Reform in 1918, in Córdoba, Argentina, and then spread across the continent during the decade that followed.

The Córdoba Reform was a student-initiated movement that began the reorganization of the Latin American university system into an autonomous structure. The reform was inspired by the news that arrived about the Russian Revolution of the preceding year. Those events led to a reevaluation of the function of the university system, its social impact on society, and the rules that determined access to its instruction. The students proposed the organization of the university as an autonomous state within the state; students, alumni, and faculty were to have majority decision-making power on university councils; and social commitment and action was made to be a part of the institutional mission.

During the late 1950s, the Córdoba Reform was updated by a second wave of university reforms. Students all over the continent were brought together in their opposition to military treaties with the United States that secured the building of U.S. military bases in their countries. The unity of the militancy against the treaties was also used to reanalyze the university structure and led to efforts to update it. Students reaffirmed the need to broaden access to education to wider segments of the population and the importance of finding the best methodologies with which to address social issues. The student body, but also faculty and intellectuals at large, agreed that, as Lola Cendales puts it:

> To understand an education system we begin not from that system itself but from the analysis of the type of society in which it is located. A type of education corresponds to each determined "mode of production," to each concrete social formation. In the dependent capitalist system, education is logically a bourgeois and pro-imperialist system that functions to maintain, reproduce, and develop the social system.[2]

Teaching in universities was revised once more at this time, but now the revision also affected the political communication tools used by the Left. The development of a new political teaching became clear in the continent thanks to the dissemination of several publications. One was a series of "letters" to the Brazilian peasants, written in 1960 and 1961 by Francisco Julião, leader of the Ligas Campesinas (Peasant Leagues) in northeast Brazil. Julião managed to describe voting rights in the simplest terms, yet without any trace of condescension. His writing counteracted the baroque meanders and party talk into which political rhetoric had digressed all over Latin America:

You are part of the majority already. The majority that doesn't vote. You

have to build the majority that votes. It is only then that you will be part of the majority inside and outside. But while you don't conquer that right, take your alphabet, get a free hour and go, tired, hungry, and in rags, to the home of your brother who knows how to read, and learn with him how to spell and how to sign your name.[3]

Coinciding with Julião in time and place, Paulo Freire was developing his own teaching method under the aegis of the Brazilian Catholic Church and reflecting on ideas of the Theology of Liberation. The word "teaching" may not be totally appropriate. While there is no record of any conscious reference to Simón Rodríguez's thought, Freire's thought clearly fits into the same tradition that stresses learning over teaching. Already in 1849, Rodríguez had written:

HERE IS BEING TAUGHT

(Supplied) What family parents want, and how they want
it to be taught. It is true.

HERE IS BEING EDUCATED ... NO
The family parents would be offended, and rightly so.
One should offer the owed respect to privileges.
Schoolteachers have been, ... and shall remain under monarchy ...
(which will continue until the end of the world) poor dependents or under-
paid tutors, like horns that sound according to how they are blown:
their task is ...

To fool the boys by order of their parents.[4]

Forced into exile to Chile by the Brazilian dictatorship in 1964, Freire published his *Pedagogía del oprimido* (*Pedagogy of the Oppressed*) three years later, in which he gathered his experiences in the impoverished Brazilian northeast. The premise developed in Brazil was that teacher and student should participate equally, and that a central function of education is to help people understand how power is used to block decision making by the oppressed. According to Freire, pedagogy was not to be developed *for* the oppressed as a small gift of power, but *with* the oppressed as a form of empowerment. Freire recognized that even when illiterate, the student is immersed in a culture with both a language and a history, and therefore should be treated as a subject of that history. The culture of domination was to be fought culturally by aiming for the generation of a

of the most intractable problems facing the development of socialist pedagogy within bourgeois institutions, namely, that students of first world nations by and large represent one of the most empowered constituencies on earth, one whose disempowerment is a necessary prelude to global transformation.[12]

Under the ideological constraints of the mainstream, it was only logical that prominence was earned by those philosophical and art historical speculations aimed at and consumed by a narrow peer audience. Even the British/U.S./Australian Art & Language group, one of the more politically lucid groups in the mainstream, got carried away into taking stances that were essentially elitist, if not outright antipublic. A 1999 retrospective exhibit, full of references to Lenin and "proletarian-friendly" art, was nevertheless one of the most indigestible shows I had seen in a long time.[13] The exhibit required abundant background research to make any sense of the display, and it had to be helped by a map to distinguish the separate units within an all-encompassing mosaic that grouped unrelated works in a massive wall display. A map to it was only available at the entrance desk, but the need for the map only became apparent in the faraway room where the installation was. The lucidity typical of many of the texts produced by the collective was scrambled and generally inaccessible even to the more informed public. The curators seemed to have been aware of this, for they offered the following as one of many explanations for the hermetic quality of the display:

> The installation is meant to work against a facile (or tendentious) historicization of Art & Language. This sort of hanging yields a mosaic of chronological dislocation and play in a travesty of linear causality.[14]

In contrast, one could say that conceptualist art in Latin America tried to remove art from its normally expected place, that is, the field of cultural symptoms. Its new place was to be one step up, in the field of the everyday practice that supposedly causes those symptoms. Art was meant to be a way to allow the audience to participate in a decision-making process that it was hoped would lead to social and economic liberation. Didactic approaches therefore were welcome, although this didn't mean that one had to embrace the traditional simplistic transmission of a political message. This kind of transmission, typical of the old pedagogy, is classified as indoctrination. The new aim now was not brainwashing, but equipping people with creative tools.

Mexican muralism set down a model for didactic art that had currency in

Latin America until the late 1950s. Art with political content was prominently placed in public spaces, and passersby had no way to escape it. Later, during the early 1960s, the Group de Recherche d'Art Visuelle (GRAV) changed the model and provided a first example of sharing creative tools rather than images. Although multinational and working in Paris, GRAV had a heavy Latin American presence with Julio LeParc (1928–), Horacio García Rossi (1929–), and Hugo De Marco (1932–), all of whom came from Argentina.[15] The group's manifestos were somewhat more radical than the work they produced, insofar as they called for the elimination of the category "work of art" and aimed to create a "new visual situation based on peripheral vision and instability."[16] Trying to create *participatory art*, they demanded interaction with the public, and a work of art was considered completed only when this interaction occurred. Though the artists rigidly predetermined the parameters for decision making by the public (for example, the viewer was not allowed to introduce radical changes or to destroy the piece), there still was ample opportunity for the viewer to share the process of production of the group's sculptures and environments by moving parts and pieces.[17]

Ultimately, however, all these manifestations, from Mexican muralism to GRAV, as well as some of the conceptualist works that followed, were guided by the idea of creating art *for* the people rather than fully assuming the responsibility of completing a task of empowerment by generating an art *by* the people.

12 *The Importance of Literature*

As mentioned, Latin American conceptualism was nourished as much by poetry and literature as it was by politics and precedents in the visual arts.[1] In fact, with the possible exception of Mexico in the 1920s, during the twentieth century, literature seemed to be a culturally stronger medium in the high arts than the visual arts. This was reflected in the international response to the "literary boom" that had long preceded international acceptance of Latin American painting and sculpture. Before discussing more general issues, I want to focus here on Max Aub and Jorge Luis Borges: Aub in particular for his novel *Jusep Torres Campalans*, and Borges for his more general influence on Latin American intellectuality. In that sense, Borges may have been of more consequence in preparing the general ground for conceptualist thought, and Aub, less known in Latin America at large, one of the symptoms of a spread-out way of thinking.

Max Aub

The Spanish/Mexican writer Max Aub (1903–1972) took Giovanni Papini's *Gog* to an extreme by fully and complexly creating a fictitious artist who started living a life of his own. Aub could, in effect, be called a meta-artist. Max Aub was born in Paris in 1903 of a German father and a French mother. In 1914, he was taken to Spain, where he received the bulk of his education. As a member of the government of the Spanish Republic, he became the Spanish cultural attaché in Paris from 1936 to 1938. There, representing his government, he was in charge of paying Picasso 150,000 francs for his *Guernica*, which had been produced for the Spanish Pavilion at the 1937 World's Fair. After the destruction of the Republic, Aub went into exile and arrived in Mexico in 1942, where he took citizenship. He died in 1972 while playing cards with his friend Luis Buñuel.

Aub wrote *Jusep Torres Campalans*, first published in Mexico in 1958, under the guise of a completely researched biography.[2] *Jusep* . . . is a hybrid piece, difficult to place or analyze in the context of this book. In fact, there is a great temptation to include Torres Campalans in my listing instead of Aub. Mexican critic Cuauhté-

moc Medina places Aub's work, along with Borges's story "Pierre Menard," as one of the Latin American avant la lettre contributions to hegemonic postmod ernism.[3] Borges limited himself to describing a writer who, from scratch, tries to create an original but identical version of Cervantes's Don Quixote. Aub, however, assembled a complete and credible character with both life and work. Torres Campalans became Aub's alter ego with such intensity that it is difficult to keep them apart except by referring to their respective biographies.

The launching of Aub's book was preceded by an exhibition of paintings claimed to be by Torres Campalans (Aub did all the artwork and documentation himself), for which a group of well-known Mexican personalities, ranging from Octavio Paz to David Alfaro Siqueiros, wrote complimentary reviews and planted them in the press.[4] (This was similar to the 1966 action of Argentineans Eduardo Costa, Raúl Escari, and Roberto Jacoby in their *First Work of an Art of Communications Media*.) Siqueiros, with untypical humor, pointed out that Torres Campalans is an example of "semi-non-objectivism," a movement that Siqueiros claimed to have been hoping to found on his own. His plans for this movement supposedly would have included the writing of a book titled *The Monocle of Socialist Realism vis à vis a Possible Marxist-Inspired Normalist Realism*.[5]

Aub portrays Torres Campalans as a close friend of Picasso, an admirer of Mondrian, and an enemy of Juan Gris ("a little orderly man who only went into Cubism when he saw an open and easy road" [*Jusep*, 161, 166]). Through remembrances of friends, quotes, and some interviews (alleged to have been done when Aub found Torres Campalans in Mexico), the author not only demystifies the artistic scene of the beginning of the twentieth century, but also introduces a wonderful confusion into it.

In the novel, Aub "reproduced" credible work by his painter and included photographs of friends and family, all of them manufactured by Aub himself. Picasso, still Pablo Ruíz in Barcelona, discovers that Torres Campalans is still a virgin at age eighteen. To correct this deficiency he takes him to a local whorehouse called Viño. Later, when Viño becomes Avignon, the experience will be glorified for both the sake of the demoiselles and art history.

Torres Campalans is a character full of contradictions, deeply anarchistic and ethical throughout, but at the same time cynical and misanthropic. He decides that in order to depict the "essence" of art, someday he will make a painting bearing only his signature, and it will be two hundred feet long.[6] But he also dreams of other, more threatening kinds of art:

> What I would like is a *direct action* painting, a series of actions[7] that tell
> humanity that we exist, that we want a more just world.

Mixed with sardonic remarks ("Modigliani is a great Japanese painter") and trivialities ("Another sauerkraut and to bed"), Torres Campalans's notebook contains some interesting ideas. Examples of his "quotables" are: "Art is creation, not reproduction. Art is not life, but death which produces life"; "Art: to transform truth in a lie, so that it won't stop being the truth." Denouncing interclass artistic tourism, he announced: "All those who paint peasants as if they were saints shall go to hell."

Once he reached Mexico, the fictional Torres Campalans stopped painting. He lived there with the Indians and taught them to eat certain mushrooms formerly believed to be poisonous. He also helped them understand the celestial messages

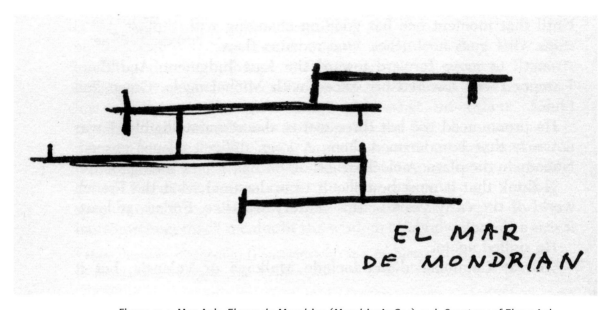

Figure 12.1. Max Aub, *El mar de Mondrian* (*Mondrian's Sea*), n.d. Courtesy of Elena Aub.

of raindrops hitting roofs and leaves. He died in 1956. One of his most wonderful sketches immortalized in the book is *El mar de Mondrian* (*Mondrian's Sea*). It is a crude pen-and-ink drawing with some horizontal lines and vertical fragments that look like an incomplete staircase in a pathetic effort to portray fluidity. Death did not end the production of Torres Campalans, and some pieces continued being signed as late as 1971.

Aub created two other works worth mentioning here. One is *El correo de Euclides* (*Euclid's Mail*), the other, a deck of playing cards. *El correo de Euclides* is a series of yearly posters that he described as Christmas stories, which were produced between 1959 and 1968. With the format and typography of bullfight

posters (a device later used by several artists), they really are "news" announcements of the *National Inquirer* variety. Examples are: "Paradise Open for Everyone as of Next Week," "We Are Not Children of Our Parents," "Terrible Mistake: Men Were Not Destined for Earth," and "God Created the World Due to a Mistaken Report by the C.I.A."

The deck of cards is an Aub-created blend of Spanish and French playing cards. Very sketchily drawn, they are vehicles used to randomize text. The idea was to have minichapters that fit the cards and then be able to shuffle the argument, which would be useful

> as long as one was looking for the portrait of a character, since it is equivalent to see him in the center of my game of mirrors or, what is the same, through other eyes.[8]

The mixture of card styles helps reduce the possibility of playing any of the normally intended games, thus underlining the abstractness of Aub's own game.

Jusep Torres Campalans was not Aub's first exercise in apocrypha. In 1934, while still in Spain, he had invented a poet. His name was Luis Álvarez Petreña, but his poems, according to Aub, "don't contribute any meaningful information conducive to an intimate knowledge of the author."[9]

The creation of fictional characters along the lines of Aub's example was not unique in Latin America. Borges, with his friend Adolfo Bioy Casares (1914–1999), created the author H. Bustos Domecq, who started publishing in 1942. In 1987, an activist group in Mexico created a superhero, Superbarrio, who went to court to defend people from eviction. And in 1966, without any knowledge of Aub's work about Torres Campalans, the New York Graphic Workshop (NYGW; José Guillermo Castillo, Liliana Porter, and myself) created its own artist named Juan Trepadori. Born in 1939 in Asunción, Paraguay, Trepadori was a former concert pianist who was orphaned and confined to a wheelchair by a car accident. Trepadori turned to printmaking, having learned his new skills through a correspondence course from the Atelier Friedlander in Paris.[10] Since 1953, Trepadori had lived on the outskirts of Lisbon. He served as a cover for needy Latin American artists who created "his" work and sold editions to publishers. Part of the income went to the creators for their artwork and labor, and a percentage went to the Fandso Foundation,[11] a nonprofit organization created by the NYGW and registered in New Jersey. The foundation's funds were used to create fellowships for other needy Latin American artists. On a very modest scale, the Fandso Foundation paid tuition for artists to study printmaking at the Pratt Graphic Arts Center in New York, which had matching funds for this type of donation. To our great

erary sensibility and experience into the visual arts—an interpenetration of space and text.

Many of the elements that give character to Latin American conceptualism, particularly the "spatialization of language" as developed in concrete poetry, had appeared in poetry before they made their way into the visual arts. *Content* is the common link, and it often defines the precise frontier where image crosses into text or text crosses into image to justify each other in the final work. With the term "content," I intend to encompass not only the idea of "argument," but also the awareness of neocolonialism and its impact on peripherality. Latin American visual artists, as was also observed about Borges earlier, aware of their distance from the center and from what the center perceives as primary information, use what can be called peripheral vision to make art. It would seriously diminish the work if we fail to factor this into our analysis.

Tautology is also relevant to Latin America conceptualism, but with a twist that is different from its use in the mainstream. Joseph Kosuth and his peers used tautology to search for the ultimate truth of the art process by enclosing it in a noise-free package, sterilized from any nonartistic interference. In *Titled (Art as Idea as Idea) [meaning]* (1967) and related pieces, Kosuth limited his work to dictionary definitions. These definitions in self-enclosed formats and rigid limits became the foundation for his theories about conceptual art as a language-based style.

In its artistic extreme, tautology is a secondary tool that gives the artist an opportunity to analyze the art process while being part of it. It is the conceptual equivalent of a painting talking about itself. As Argentinean artist Liliana Porter (1943–) described a 1966 tautological piece of hers: "It is like pretending that I am me."[21] When Kosuth used tautology (also clearly in pieces such as *One and Three Photographs* or *One and Five Clocks* [1965]), the works showed that the equation matches the result, and the result solves the equation. In León Ferrari's case and that of others, the use of tautology promotes imagination more than analysis. The resonance is different; the result is a different pedagogical model.

It is the influence and presence of poetry that makes Latin American conceptualism an impure hybrid, without any scruples about the inclusion of narratives in their different shapes—something conceptualists in the mainstream had frowned upon.[22]

León Ferrari

As a counterpoint to Kosuth's work, Argentinean León Ferrari (1920–) worked with language and meanings as a starting point to explore the limits that were

Figure 12.4. León Ferrari, *Cuadro escrito* (*Written Painting*), 1964, ink on paper, 67 × 48 cm. Courtesy of León Ferrari.

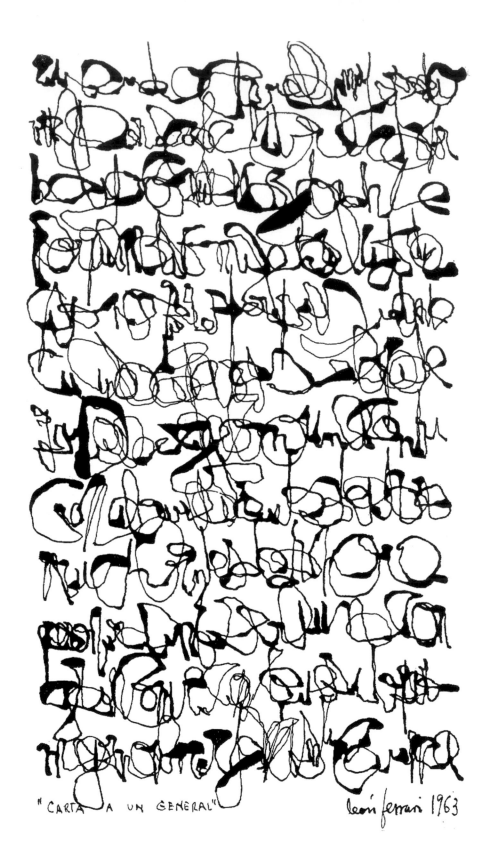

Figure 12.5. León Ferrari, *Carta a un general* (*Letter to a General*), 1963. Courtesy of León Ferrari.

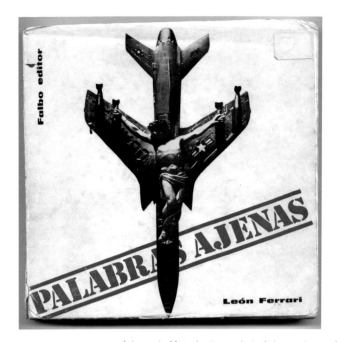

Figure 12.6. (above left) León Ferrari, *Palabras ajenas* (*Words of Others*), 1967, cover. Courtesy of León Ferrari.

Figure 12.7. León Ferrari, *Palabras ajenas* (*Words of Others*), 1967, sample inside page. Courtesy of León Ferrari.

encircling art—as he saw it at the time—and the ways of destroying them. In 1962, Ferrari had scoured the dictionary to compile endless lists of interesting-sounding words, disregarding their definitions. *Cuadro escrito* (*Written Painting*, 1964) is a detailed description of how and what he would paint if he were to use that medium.[23] The decision-making process applies to an extremely baroque and symbolic painting. The writing, as in many of his works from the mid-1960s, is that of a quasi-outsider in an artlike calligraphic scribble. It is not only the dictionary definitions that fall by the wayside, but also any possible expectations one might have about the role of image and text.[24] Dot Lauer interprets Ferrari's use of writing/unwriting as a play between the "ignorance of the colonized" and the "literate/civilized colonizer," and thus as a symbol of periphery/center relations.[25]

Another work by Ferrari is even more embedded in literature, this time removing authorship completely and raising editorship to the level of ultimate filter. In *Palabras ajenas*, a 233-page string of quotes, Ferrari accumulates carefully cited material from the Bible, magazines, newspapers, books, and documents, quoting disparate characters like popes, chiefs of state, government ministers,

that could be interpreted either as Mikhail Bakhtin's description of resistance to unification and authority, or as the digestion of values and forms by Brazilian locality symbolized by Carnival. De Andrade, though, went much further than "carnivalization" does in either interpretation. If there was a challenge to authority, it was the one born of cultural colonization. In fact, he surpassed his own famous notion of *anthropophagia* (which, after all, is a form of consumption), explored in his manifesto of 1928, by defining what later came to be called the "periphery" as an arena for creative action rather than a place consigned to the passive consumption of imported devices. De Andrade's importance in Latin America derived from the fact that he inserted international avant-gardism into national politics and national politics into international avant-garde form.

Simón Rodríguez, Vicente Huidobro, and Oswald de Andrade represented three distinct phases in the intellectual history of Latin American poetry/art. Rodríguez's formal decisions were in some sense aesthetically naive, but he grasped the importance of giving predominance to ideas and concepts and subordinating form to them, a point that later dominated Latin American thinking about art. Huidobro's work had a formalist importance and was relatively separated from his own political life. De Andrade, distinguishable from both, made an effort to synthesize formalism and politics within a Brazilian context.

De Andrade articulated his ideas into two widely circulated manifestos. The first appeared in 1924 and was titled "Manifesto of Pau-Brasil Poetry." In it, he advocated "language without archaisms, without erudition. Natural and neological. The million-fold contribution of all errors. Like we talk. Like we are." And further: "Let us divide: Poetry for import. And Pau-Brasil poetry for export."[22]

For de Andrade, poetry became a raw material from which Brazilian products were tooled for internal use and for external influence. In that sense, de Andrade was not at all oblivious of the mainstream; instead, he tried to argue and compete with it. It was a position later carried forward by the concrete poets, who were eager to claim an "equal standing" in the mainstream and adopted the "export" policy of Pau-Brasil.

In 1928, four years after his first manifesto, de Andrade published a second statement titled "Manifiesto Antropófago" (Cannibalistic Manifesto).[23] This particular piece continues in active circulation today among the newer generations of Brazilian intellectuals and Latin American art critics, and it has become a prime tool for separating Latin American eclecticism from mainstream postmodernism.[24] In this manifesto, de Andrade spoke about the appropriation of everything. In Entry V, he writes: "I am only interested in that which is not mine." In Entry III, he asserts: "Tupí or not Tupí. That is the question." The two

entries should be read together. The Tupís are a Brazilian Amerindian people, and, in a trivial pun, Portuguese pronunciation of "Tupí" is "to pee." De Andrade is questioning the great icon of Anglo literature while simultaneously appropriating it to underscore a cultural blindness to locality.[25]

It can be argued that de Andrade is clearly more important as an advocate and exemplar of *deinstitutionalization* than as a poet. Absolutely everything for him, and not just found objects, became a readymade target for appropriation. This links him strongly in attitude and objective to later Latin American conceptualists who also practiced art with a culturally subversive intent.

De Andrade's poem "amor/humor" (love/humor; the two words are the full poem, not the title) was considered a seminal piece by the Brazilian concrete poets of thirty years later, who honored it for being the shortest poem in the Portuguese language.[26] Nearly as concise, but more pointed is de Andrade's 1925 "América do sul / América do sol / América do sal" (South America / Sun America / Salt America), in which the salt refers to the tears produced by oppression.[27] The pristine enumerative clarity of this piece reflects reaction to the artificial process in Brazil of accelerated urbanization and the affectation of modernity. In the 1920s he had written:

> Skyscrapers
> Fords
> Viaducts
> a smell of coffee
> In the framed silence.[28]

It is remarkable and endearing that de Andrade, whose theoretical texts are baroque and hermetic, achieves in his poetry such striking precision and simplicity.

In time, de Andrade got more and more involved in Brazilian politics. In 1931, with Patricia [Thiers] Galvão, he founded the magazine *O Homem do Povo* (*The Man of the People*). The publication hoped to be "from the people for the people."[29] It lasted through eight issues in which fascism, exploitation, and repression were the prime targets. It advocated unionism, taxes for the rich, and feminist causes. In spite of what were popular causes, the magazine never achieved widespread popularity. On the contrary, the last editorial of the publication proved to be too radical and provoked the ire of law students, who appeared at the door of its offices to rally against it. Patricia Galvão went after the students with a gun (and then to jail as a consequence) while de Andrade proceeded to kick them in the rear, at least as many of them as he could reach.

The platform de Andrade provided to other Brazilian artists was an unstable one. His successors tended to emphasize either art or politics rather than fulfilling the dream of full synthesis. A group of poets who followed de Andrade in spirit ended up being more connected to European developments than to Latin American poets like Huidobro, Tablada, or Oquendo. It was the work of these latter authors and their notion of "visual poetry," with an emphasis on the use of space as a poetic device, which turned out to be the immediate formal antecedent of the Brazilian visual conceptualist art of the midsixties and after. More than any other poetry movement in Latin America, their work blurred the borderline between art and poetry.

The Noigandres and the Neo-Concretes

Visual poetry was developed by the Brazilian group Noigandres[30] with what they christened *poesía concreta* (concrete poetry). The movement was directly indebted to de Andrade, but also to the work of international figures like Mallarmé, Apollinaire, e.e. cummings, and Ezra Pound. Pound was followed solely on his aesthetic merits and was spared any political judgment in regard to his fascist allegiances. Meanwhile, Huidobro seems to have been completely ignored. The way the cultural circuits were operating at the time placed Paris (or the French in Paris) much closer in influence on São Paulo than Santiago de Chile (or the Chileans in Paris). And the existence of Simón Rodríguez simply wasn't known.

Noigandres started in 1956 and was led by the brothers Augusto and Haroldo de Campos and by Décio Pignatari.[31] Along with several offspring and splinter groups, it is a movement that could still be considered alive today. Its first public presentation was a manifesto written by Augusto de Campos and published in the Sunday supplement of the paper *Jornal do Brasil* (November 11, 1956). With the title "Pontos-Periferia-Poesía Concreta," it contained the following declaration:

> The truth is that the "prismatic" subdivisions of the ideas of Mallarmé, the ideogrammatic method of Pound, the verbal-vocal-visual presentation of Joyce, and the verbal mimicry of cummings converge into a new concept of composition, a new theory of form—an organoform—where the traditional notions like beginning, middle, and end, syllogism and verb, tend to disappear in order to be improved by a poetic-gestaltic, poetic-musical, poetic-ideogrammatic structure: CONCRETE POETRY.[32]

In another article, "Poesía concreta," published shortly thereafter, Augusto de

Campos claimed that "the concrete poet . . . goes directly to the center [of the words] to live and vivify their facticity."[33] Unwittingly, he had turned around one of Huidobro's phrases.

The main tools used to do this were the space occupied by the words as recorded and the manipulation of both words and space so as to interrupt the linearity of the discourse.[34] Following Mallarmé, spaces on the page acquired status as units of meaning and served to compose a visible structure. A concrete poem was chiefly a formal and somewhat tautological exercise that

> communicates its own structure: structure-content, the Concrete poem is an object in itself, it does not interpret external objects.[35]

The words chosen often reflect a minimalist economy of letters. Consonants and vowels create a pattern with a visual and aural character that is independent of the meaning of the sentence. Self-referential concerns are also apparent and precede their fuller exploration in mainstream art of a decade later.

Although concrete poetry claimed to be concerned with Brazilian national identity, the primary goal seemed to be to compete within the international scene, and not merely to interrogate it. Access to the mainstream was seen as crucial, to the point that the search for a nationally rooted movement was placed second to the presentation of an identifiable formal system. A Bolivian-born visual poet of Swiss ancestry, Eugen Gomringer, helped the concrete poets succeed in launching their movement abroad. In 1955, Gomringer met Pignatari, one of the leading concrete poets, borrowed the idea of concrete poetry for his work, and used his connections with European artists (he was the secretary to Swiss sculptor Max Bill) to bring the Noigandres poets to European attention.[36]

It is puzzling that even today the Noigandres movement is not given its due credit by the mainstream. U.S. critic Peter Frank, for instance, in describing the tradition of "expanded poetic" experiments, beginning with "Marinetti, Hausmann, Schwitters and other phonetic poets," follows his theme into different countries and then, in a telling slip, adds the word "even" when he writes: "and even in Brazil by the Noigandres group."[37]

The concrete poets created an important base for other groups that followed, including those whose insights were at odds with concrete poetry or whose political commitments were stronger and more explicit. A notable example was the group of neoconcretes founded in 1959 by poet and art critic Ferreira Gullar. Ferreira Gullar had been a former contributor to the early issues of *Noigandres* magazine. His new group was critical of the excessively mathematical and graphic foundation of concrete poetry ("rationalism robs the autonomy of art")

and advocated the "non-object" and a "nationality of language." The neo-concretes favored the void over any rational connections between words, and Ferreira Gullar was seeking the disintegration of the discourse. He described his poetic process as follows:

> I ended by disintegrating the discourse and reducing words to obscure conglomerations of phonemes and screams in an attempt to find a less abstract, nonconceptual, nonmanipulated language as close as possible to the sensorial experience of the world. . . . After that came Concrete, Neo-Concrete, and, finally, my commitment to political poetry when Brazil was agitated in the turmoil of struggle for social reform.[38]

The "non-object," an ill-defined entity, was to be both "pure appearance" and "transparent to perception, . . . waiting for a human gesture to be actualized."[39] Following the path of dada, painting was declared dead, and whatever was non-object was to be disconnected from any indication of use and from any verbal significance. The goal of the poem was to be:

> not a representation, but a concrete presence perceived in the World's real space and not on the metaphorical background of abstract expression.[40]

It could be said that there was a greater connection in poetry than in art with what became mainstream minimalism. In effect, Ferreira Gullar was proposing the ultimate stage of dematerialized information in which only the informative essence remained, and nothing else. This represents not only an overlap with the arguments Donald Judd and Robert Morris would later use for their own minimalist works, but also a possible reference to the work and thought of Spanish sculptor Jorge Oteiza. Oteiza had received the international prize for sculpture at the Biennial of São Paulo in 1957 and at the time had interacted and disagreed with the concrete poets.

The importance of Oteiza in Latin America has been seriously and unjustly overlooked until now. I would like to start redressing that here, though it may be an odd place to do so. But minimalist tendencies in Latin America seem to have been stronger in poetry than in the visual arts, and Oteiza was an important forerunner of minimalism. Oteiza's version of minimalism, as explored in his sculpture of the 1950s, did not have much stylistic influence except in the work of Colombian constructivists.[41] But his theorizing did, and during his extended stays in Latin America he strongly interacted with the intellectual world. In his contact with the concrete poets, Oteiza expressed his disagreement, anticipating the arguments later expressed by Ferreira Gullar. He felt that the concrete

poets were working with a simplification of Mallarmé's poetry and producing work he saw as "marred by a limited formalism that might hold them back dangerously."[42] Oteiza also dabbled in poetry, but the real body of his work was sculptural, a medium in which he zeroed in on space and absence. He tried ways of emptying the cube and the cylinder to find the void as an active center from which the sculpture would become a shell on the way to dematerialization. Although he was a rabid atheist, his work reveals a constant quest for spirituality in ways that make him a Spanish counterpoint to Mathias Goeritz.

Oteiza had lived in South America from 1934 to 1947. He went to Chile; Argentina, where he taught; and Colombia, where he had a great effect. He particularly marked Colombian constructivist sculptor Edgar Negret (1920–), who in turn became responsible for the development of many of the Colombian abstract artists. It was in Buenos Aires where, in 1947, Oteiza published his first speculation about "empty space":

> The empty space is revealed to us in our analysis as the key concept of a logic for formal renovation. [It is] spiritually equivalent to the reappearance of the sense of tragedy at the climax of the legacy of a classical morphological system.[43]

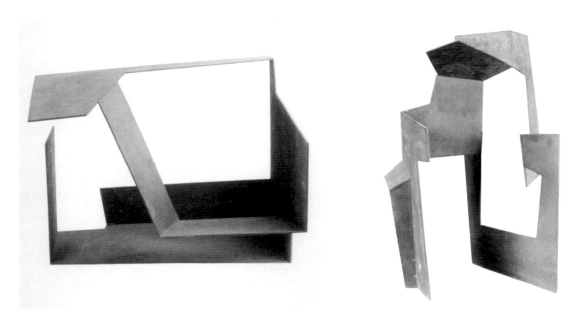

Figure 13.5. (above left) Jorge Oteiza, *Formas lentas* (*Slow Forms*), 1957. Courtesy of Pilar Oteiza San José.

Figure 13.6. Jorge Oteiza, *Caja abierta* (*Open Box*), 1958. Courtesy of Pilar Oteiza San José.

massive consumption. The counterstyle turns to the conquest of information, not to the manipulation of knowledge.[50]

For de Sá, knowledge can and should be disregarded, for it has already been manipulated in terms of place and time. In their concern for the conquest of information, by its handling and organizing, the neoconcretes are in line with artist Waldemar Cordeiro, who, shortly after 1967, started working with computer languages. And in their focus on participation, they are linked to both Hélio Oiticica and Lygia Clark.

Nicanor Parra

In Chile, the "Antipoemas" of Nicanor Parra (1914–) explored linguistic solutions that prefigure later work of some conceptualists in the visual arts. Parra, after Huidobro and together with Pablo Neruda, is the best-known Chilean poet of the twentieth century. His "Antipoemas" and his "Artefactos" are particularly relevant because of their formal synthesis and pointed use of information. The "Artefactos," a series of one-line poems, downplayed poetic construction and claimed an identity as an art object. Although published in 1967, their origin can be traced to 1957, when he used a form of this device in the poems "Versos sueltos" (Loose Verses). They included lines like: "Bargain crucifix, for sale." Among the complex one-liners of "Artefactos" are "U.S.A. / where liberty is a statue"; "To milk a cow / and pour the milk over its head"; "Look, even in the sewers there is a little shit"; and "The automobile is a wheelchair."[51] The "artefactos," according to Parra himself, are the product of the explosion of his antipoems. An "artefacto," he wrote, "is a self-sufficient linguistic configuration . . . which has its own laws, let's say, that it sustains itself . . . It has the same efficacy that a newspaper advertisement has."[52]

With these works, Parra endorsed the headline format with its ability to transform itself into instant memory.[53] His "Noticiero 1957" (Newscast 1957) is loosely built around found headlines.[54] At the time, this was less an indication of conceptualist thinking than a sign of the spirit that would later be formalized in pop art. Some years later, Chilean-Mexican author and filmmaker Alejandro Jodorowsky (1929–) used the same format to write aphorisms, such as "Eat crumbs and they shall take you for a pigeon," and also to create sensationalist-sounding news headlines like "Ubiquity resolved."[55] But the origin of this should be traced to a joint project with Parra, *El quebrantahuesos* (*The Bonebreaker*) in 1952.

During a year, and based on an idea of Parra's, Parra, Jodorowsky, poet Enrique Lihn (1929–1988), and some others who formed the editorial staff organized a

poetry mural installed in two places in the center of Santiago de Chile. Changing headlines cut out from newspapers made humorous and absurd statements like: "Héroes de la paz / Atentaron contra la vida de Pío xii" (Peace heroes / made an attempt against the life of Pius xii), and "Misterioso / concurso de poesía organiza / Para envenenar la República" (Mysterious / poetry competition organized / To poison the Republic). At the time, based on Marinetti's statements about "poetry as an action," Jodorowsky and Lihn would also stage protohappenings on the street. They carried a cardboard box with holes in it that was full of coins that would slowly fall to the pavement and make passersby pick them up. They would stand on the street ready to play a guitar and a violin, only to break them into pieces once enough of an audience had gathered, and to then give a coin to every onlooker.[56]

Parra's general concern in regard to the form of the text is much less intense and poetically more traditional than that of either Rodríguez or Huidobro. Rodríguez represented the shape of his thought on paper and created a didactic form of transmission based on a calibration of graphic emphasis. Huidobro made a tautological use of form to visually and redundantly underline and illustrate his content. In both Rodríguez's and Huidobro's work, the reader is the recipient and mirror of the finished work. Parra, however, works less explicitly. In his poems, he provides very little information, ensuring that if there is to be an impact, it will result from reverberation within the mind of the reader. Like the Russian poet in Papini's *Gog*, Parra adopts a dematerialized version of a poem. Its presence on paper is materially minimal; the poetic act is in the stimulation of experiences by the reader.

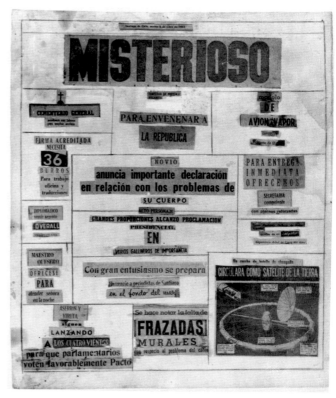

Figure 13.7. Nicanor Parra and Enrique Lihn, *El quebrantahuesos* (*The Bonebreaker*), 1952. Courtesy of Nicanor Parra.

Parra's dematerialization process seems contradictory (or at least dialectical), inasmuch as it tries to destroy and create poetry at the same time. We can read the title "Antipoem" as a poetic death wish or as an antimaterial solution to the problem of communicating poetic ideas. Parra himself was ambivalent about tra-

ditional poetry: "I have nothing left to say / Everything I had to say / Has been said, I don't know how often."[57] Fortunately, this did not prevent him from continuing to write.[58]

The way Parra engages the mind of the reader is closely related to Magritte's strategy. He invites the audience to derive new systems of order by making unexpected connections. The images used are relatively unimportant; it is the link that provides the new life. In certain ways, during the late 1950s and 1960s, Parra laid out a model for a sociopolitical approach to art. Creation was to be shifted from artist to audience. Argentinean artists in the Group de Recherche d'Art Visuelle in Paris were also actively pursuing this concern in the late 1950s by using playful interactive situations. Their aim was "to limit the work to a purely visual situation, . . . to look for the NON-DEFINITIVE work, but—indeed—exact, precise, and intended."[59] Artists were coming to see themselves as fulfilling a role somewhere between catalyst and stage director. In the case of Parra, the headline as a poetic readymade transferred skills from the act of making to the act of finding, making the creation of poetry accessible to all. Anyone can "find."

Ricardo Carreira

Of the poets discussed here, Ricardo Carreira (1942–1993) was the one who most clearly had his feet in both poetry and visual arts. He was active in and crucial for the development of many projects during the 1960s in Argentina, including *Tucumán arde*, for which he participated in the preliminary discussions. Soon after that event, he faded from the scene and remained relatively ignored until his death.[60] Only recently has he been brought back to the foreground, in connection with a systematic reevaluation of the decade of the sixties in Argentina. A collection of his poems, originally distributed in mimeographed sheets, was published in 1996, and some of his work—destroyed after being used in their original settings—has been reconstructed.[61]

In his time, Carreira was perceived more as a lively character given to impromptu performances on the intellectual scene of Buenos Aires than as a disciplined artist. However, his work had consequences for the production of Argentinean conceptualism, and today he is credited for much of the mind-set in the art scene of Buenos Aires after 1966. His most well-known art piece is a blood puddle made out of plastic resin (1966). It was placed on the floor of a gallery during an exhibition organized against the war in Vietnam. A typical "contextual" piece, it was designed to change the purpose of the room by appro-

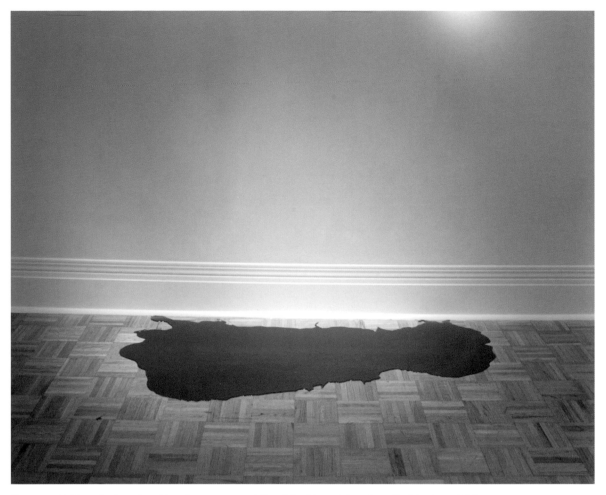

Figure 13.8. Ricardo Carreira, *Mancha de sangre* (*Blood Stain*), 1966, as installed in the exhibition Inverted Utopias: Avant-Garde in Latin America, 2004. Copyright © Museum of Fine Arts Houston. Courtesy of Adrian Carreira.

priating all the other artists' work hanging on the walls. The pieces in the exhibition were politically consistent in their antiwar message, but individually they paid homage to conventional art traditions. Carreira's puddle, in its subversion of form and by constructing a situation that could be read as a context, brought all of them together into one powerful collective expression.

Also in 1966, Carreira produced some pieces that addressed the relation objects have with the information given about them. He divided a gallery space by stretching a rope from wall to wall, low enough to obstruct the circulation of the public. The installation was completed with a separate sample piece of the rope

Figure 13.9. Ricardo Carreira, installation in Experiencias 67, Instituto Torcuato Di Tella, still from video by the artist. Courtesy of Adrian Carreira.

and a photocopy of it. In another project, he covered a staircase with a plastic sheet that took the molded shape of the steps. On the occasion of exhibiting one of these pieces (*Ejercicio sobre un conjunto* [*Exercise on a Whole*] in the Instituto Di Tella in 1967, he wrote: "Maybe it is as important to run, to kill, to organize genocide, as it is to make a sample of chalk powder (of course from an aesthetic point of view and as an argument structure, right?)."[62] It was an effort to underscore the problems formalism may run into when it is left to its own devices and in the absence of any other consideration.

In spite of Carreira's awareness and warnings, his pieces became a model for many self-referential pieces made by other artists who also used information as the subject. Most of them, however, then left it at that. The inclusion of projections, video, and other forms of representation, which until then had been uncommon in Argentina and other Latin American countries, can be traced to his works.

Overall, Carreira is primarily known for his poems. Very simple, direct, and consistent with his informational pieces, they always finish with the same poignant device: The final lines enumerate all the important words used in the preceding text. For example:

A woman takes off her clothes which wrinkle and cool down on a chair.
woman, clothes, chair.
takes off, wrinkle, cool down."

The opening lines of his poems are always evocative, but they don't really give much beyond a straightforward and relatively trivial description. The drama is provided by the repeated words at the end. These seem to ensure that what at first reading appears to be a fleeting, casual observation becomes a powerful image in the mind of the reader. As with Parra's work, Carreira's poems are realized only after reaching the reader. The words, once repeated, become more than a poetic trick; they are clues to the structural process of imagination, the same as the layout devices in the work of Simón Rodríguez. The single words of the poem bear eroded information from the bigger picture, just as a photocopy does from reality in Carreira's installations.

Carreira's focus on information as an independent entity allowed him and the artists that worked like him to discover a new opening for politicization. Many of them initially were interested in media-for-media's-sake, but then switched to a more militant media-for-message strategy. It began with pieces similar to contemporaneous or later work produced in the United States and then evolved into something more distinctive. In this evolution, surprisingly, the Argentineans were closer in feeling to the work of Arte Povera's Giulio Paolini's works of 1965 and those of William Anastasi, a lesser-known artist compared to the more famous Robert Morris or Kosuth.[63]

In Carreira's case, his poetry remained a constant throughout his life. Even when speculating about art and politics, he maintained his style:

What art should we make, then? [Art with] more conscience, that it shall not be avoidable, and that one should be unable to bear that conscience. The more massive and present, the better. Present, like my shoes, but with one being too big and the other one being too small . . . I don't mean to say that [thought and art] are simple signs that always mean the same, but that when the named object or the named situation is revolutionary, "words" grow with their object.[64]

form. This stability had the advantage of making it easier to introduce a "program." The socialist realist artists, for example, worked within a programmatic extension of the academicism of the nineteenth century. Their artwork did not start with the material execution, but with the illustration or visualization of a program, in this case an ideological political program. Socialist realism closely used what can be called a manifest ideological scaffolding, and in the pecking order used for reading or appreciating a work of art, it was the ideological expression that was put first, while the craft in the execution was a given. So, leaving out the different attitudes in regard to confrontation with the establishment's power, there seems to be a link between conceptualist strategies and socialist realism, a connection that both modernist and postmodernist historical approaches ignore. The taking for granted of the execution gives a certain transparency (dematerialization) to the physical presence of the work. This allows the program (which could be the concept) to come through more directly and with a reduced loss of information.

The obvious limitations that plagued socialist realism came from the lack of freedom afforded by its program and by the narrowness of the skills permitted for the rendering. But there is no concern here for any essence of art, and the intentions in this respect are removed from those in conceptual art and closer to those in Latin American conceptualism.

Modernist artists tended to integrate the struggle with the media into the search for the image. Impressionists, expressionists, and abstract expressionists in particular allowed the medium itself to become an active tool for expression and a communicator. Minimalist artists had a similar attitude when they used industrial finish for their image. Minimalism and expressionism thus are strange bedfellows, sharing a vision in which, as Marshall McLuhan later put it, "the medium is the message."

Expressionism in Latin America, however, did not serve only as a formal style to communicate pathos; it also became a form of protest. It was a way of negating the minimalist industrial finish that was coming from the mainstream.

Mari Carmen Ramírez, who elaborated on an earlier perception of the Spanish historian Simón Marchán Fiz, has described the different identity we can see in the production of conceptualist work in Latin America.[1] Marchán Fiz spoke of an "ideological conceptualism" (1974) that took place in Argentina and Spain. Curiously, he ignored the rest of continental art production, but at least he had the sense to separate Latin American conceptualism from the mainstream.[2] In her work, Ramírez seeks to string together the identifying, generative elements of Latin American conceptualism, and concludes that the movement fits into a

broader Latin American art history. With her insights, she helped me clarify my own ideas on the subject.

In her essay "Blueprint Circuits: Conceptual Art and Politics in Latin America," Ramírez points out the need for a new history of conceptualism in Latin America, and establishes continuity between Mexican muralism and the work of Duchamp. In her view, Mexican muralism is a crucial version of the Latin American artistic avant-garde, and it reinvested painting with social meaning in a parallel fashion to how, later, more contemporary artists reinvested meaning into readymades. Ramírez writes:

> One could argue that if Duchamp's propositions found a fertile ground in Latin America, it was because a refusal to abandon the specificity and communicative potential of the aesthetic object was deeply embedded in the modern art tradition initiated by the Mexican Mural Movement and later embraced by the group of political conceptual artists. However, Duchamp's radical subversion of art as institution, implicit in the provocative creation of the readymade, is reenacted in these artists' work as an ironic tactic aimed at exposing a precarious activity: that of artistic practice in the frequently inoperative conditions of Latin America. Therefore, utilizing the readymade as a "package to communicate ideas" ultimately points to an underlying concern with "devaluation," the loss of the object's symbolic value as a result of any economic or ideological process of exchange (as opposed to the North American artists' preoccupation with the process of commodification). Thus, the acts of "reinsertion" carried out by these artists are intended to reinvest objects with social meaning. The readymade, then, becomes an instrument for the artists' critical intervention in the real, a stratagem by which patterns of understanding may be altered, or a site established for reinvesting reality with meaning. The readymade also turns into a vehicle by which aesthetic activity may be integrated with all the systems of reference used in everyday life.[3]

Thus, Duchamp somehow gave "permission" to use anything, not just art media and forms, as vehicles for expression and communication beyond the limitations of just expressing art. What ultimately matters is the relation art has with everyday life as affected by these political antecedents. In Ramírez's view, Duchamp tried to challenge the art-as-an-institution model by introducing readymades. With them, he made the autonomy of art relative and allowed for other connections to and within "reality."

However briefly, the Mexican muralists broke down this same autonomy by deciding that the greatest importance was to be given to political communication. But most of these attempts to modify, if not abolish, art-as-we-know-it have been utopian and short lived. All these efforts were invariably neutralized because, no matter how inartistic, they ended up being classified as a form of art, a process of co-optation in which I may regretfully be involved as well when I discuss the Tupamaros in this book. The Mexican muralists recognized the dangers of a commodified society unremittingly institutionalizing art. Devaluation of the material aspects of the work of art affected its potential ownership. This was not a casual by-product; ownership was radically questioned and invalidated, and the relations between art and social class were a major concern. Conceptualism in Latin America introduced the idea of art as a public domain, something the Mexican muralists had discussed but did not solve. Shifting from easel painting to muralism was, essentially, an expropriation of the art object in the name of the public, but the object was still there and still subject to institutional power plays. The move by the Mexicans lacked the force and radical quality of the new approach, but it was perceived by the muralists themselves as a great and perhaps even as the ultimate conquest. Siqueiros, visiting Uruguay in February of 1933, yelled to the expectant and somewhat puzzled group of friends and admirers waiting for him on the tarmac: "Down with easel painting!"[4]

The problem with Mexican muralism was that it gave mixed messages. The content of the murals was designed to liberate the oppressed. Meanwhile, the murals continued to operate as a form of visual oppression—if anything, in a much more potent way than previous art. In the museums, one at least has a choice to go or not to go, to look or to walk by. With the murals, one is trapped. And then, ownership had not really been abolished; it had only been transferred to the state. Later conceptualist work, noncollectible because it was dematerialized, was presumed to be literally impossible to "own" and thereby resistant to elitist exclusivity. This presumption, of course, proved wrong. The elite now love to collect the material bits and pieces that are left. Still, the approach of the conceptualists was at least consistent with the idea current in radical politics of the 1960s: that art things should belong to the people at large, and in this dream they were linked to the Mexican muralists. In 1921, Siqueiros, in a manifesto for the Syndicate of Technical Workers, Painters, and Sculptors, had written:

> Our fundamental aesthetic goal is to socialize artistic expression. . . . The creators of beauty should apply their greatest energies to [produce] work of ideological value for the people, so that the final goal of art, which now

is an expression of individualistic masturbation, may be an art for all, of education and of battle.[5]

This statement could equally have been written four decades later, and with the same intensity, for the issue in the 1960s (and still today) is the conundrum of individual contemplation versus collective education. Conceptualism in Latin America sought to continue both.

Sometimes, as in the case of Siqueiros, the impatient answer to the limits of their form of politicized art was to drop out of art completely, at least for a while. Siqueiros used his leave of absence to focus purely on politics so that he could seek redress for society in a more expedient manner, an expediency reflected in his assassination attempt on Leon Trotsky in 1924.[6] It is interesting that throughout his life Siqueiros maintained a longing for "pure art." "Pure" meant nondescriptive and without any utilitarian or political purpose. He believed pure art was possible, but only when class struggle and an egalitarian society were able to function without hierarchical institutions. Until then, however, the fight must go on and was of primary importance, thus art had to remain as politicized as possible.[7] For Siqueiros, however, constrained as he was by his historical placement, politicized art was reduced to content and mural presentation.

The Tupamaros were clearly placed within this same project of challenging institutions by merging creativity into the activities of "normal" everyday life, but they carried the consequences to an extreme. The group tried to set the conditions for a life in which creativity could take place, and in which the co-optation that is unavoidable in the long run is at least delayed as long as possible. As Cuban critic Abdel Hernández pointed out, the art/life binomial eventually always produces the author/hero binomial.[8] It follows, then, that the healthy aim is to increase the number of authors so that fewer heroes are needed.

Re-signification and contextualization were interesting tools because they allowed artists to deal with content, especially political content, without having to engage in storytelling and thus run the risk of degenerating into illustration. Before that, and until the early 1960s, political issues in art had been confined to content. The art object was permitted to "describe" politics—an activity usually despised by the art world—or to function as a cultural symptom of class interests. But, no matter how militant the artist, the art object could not *be* political action because then it would cease to exist as art. Art and politics appeared to be subject to an irreversible division of labor. In regard to this division (art as a form of knowing life), Soviet theorist Nikolai Chuzhak once wrote: "A method of knowing life . . . is the highest content of the old bourgeois aesthetics." And in

opposition, he called for "Art as a method of building life—this is the slogan behind the proletarian conception of the science of art."[9]

In her approach, Ramírez underlines readymades and takes the dematerialization process of the artwork to a secondary place in relation to the re-signification of the object. This gives the activity of the artist a magisterial quality that is not normally expected from someone who is confined to the exercise of a craft. But it also underlines and raises the symbolic value and importance of non-art objects. Objects become symbols of property, status, and power and, when imported, of foreign presence. As a consequence, one sees, for example, how the weight of the *insertion* pieces by Brazilian artist Cildo Meireles (particularly the Coca-Cola bottles with decals bearing political messages) changes according to where the action takes place.

Place therefore is not a sterile physical location but a context. It acts like a frame that not only introduces different readings into objects, but also gives a political signification to the style of expression. An imported visual solution used for a work of art dramatically alters one's understanding of the piece from what it would have been if a local solution had been used. This *import quality,* the imported look, is often used on the periphery to validate a work of art. This look is seen as evidence of "trend awareness," which is understood to be a sign of refinement. Moreover, the import quality also introduces several less tangible atmospheric conditions, like the mythical dimensions of a decadent and unreachable sophistication, or industrialist nostalgia about how an idealized technology might rule a society. These are part of many vicarious experiences typical of the periphery. It is a process one can also clearly see in the use of borrowed symbolic values that appear in architectural products like churches, banks, government buildings, and mansions where the aim is to express affluence. This dependence on borrowed symbols has changed little since early in the colonial period. Borrowing (as different from appropriation) poses problems for art historians and critics, for it occurs in the service of different objectives. One use may be read as simply a sign of submission to an imported style; another could be read as a co-optation that breathes new life through a form of recycling. Both will ultimately be absorbed into local culture and appropriated, and then the task of disentangling can be difficult and sometimes feel like a waste of time.[10] Viewed politically, borrowing internationally threatens the authenticity of the *local*. It promotes aesthetics conceived in a different cultural context and therefore forces the serving of interests that don't have any parallel in local society. In this sense, borrowing undermines identity.

Ramírez differentiates Latin American conceptualism in its commitment to

social change from what she calls the "reductionist posture of the then domi-nant, empirical-positivist model, exemplified by Kosuth's 'art-as-idea-as-idea.'"[11] This is helpful not only because it provides a framework with which to organize our understanding of conceptualism in Latin America, but also because it pro-vides a lens with which to see something that otherwise might be missed: that the European precursors of mainstream conceptualism were also, but in differ-ent ways, precursors or progenitive forces in Latin America.

Duchamp's work, for example, can be seen as closer to Latin American con-ceptualism than to the conceptualism of the mainstream. His intention was not to lay down aesthetic rules over reality, nor to participate in generating further isms based on re-perceiving art in relation to reality. He was interested in re-signifying meaning without altering the object. It is only logical, then, that de-materialization as it appears in Latin America had as its primary motive the wish to affect the context in which a work of art was to operate. There was much less interest in a quasi-mystical search for the essence of art, undertaken by lonely and enlightened individuals.

Dematerialization was a form of applied economics in that it allowed for an inexpensive mode of art production. It also proved effective in addressing a pri-mary concern of Latin American artists: the search to invent formats for sharing power: in art, with the viewer; in politics, with the citizens. In fact, what is cru-cial here is that at this point viewer and member of society became one and the same, with an emphasis on citizenry. Dematerialization offered a way of mini-mizing the physical presence of an art object without diminishing the human response to it. Focus could be shifted from the "thing" itself to the interaction be-tween artist, object, and viewer. Eliminating materials in this context was not a goal but rather a strategy, and as such, it avoided doctrinal rigidity.

What really mattered to Latin American conceptualists was the growth of freedom in decision. At the risk of oversimplifying, I would say that in the main-stream, the art object was on a road that went from the museum to the patent of-fice. Meanwhile, in Latin America, it was going from the museum to the militant version of an educational institution.

· · · · · ·

There are two aesthetic-philosophical means understood to describe mainstream conceptualism, notably, the *elimination of visuality* and the *mapping of the linguistic model onto the perceptual model*.[12] In Latin American conceptualism, they were by and large secondary to a drive for a more efficient communication of specific

ideas. These strategies were used, but without a formalist rigor. The emphasis on rigor was instead applied to contriving interactions with the public. The *elimination of visuality* proved a great tool with which to heighten the awareness of context. *Linguistic mapping*, focusing on the content of the message, helped create a "grammatical" analysis of visual communication as well as provide a base for the preparation of manifestos and ideological documents. It called attention to the possibilities of tautology, without necessarily requiring reduction of work to only words.[13]

A third marker of conceptualism was the *spatialization of language*, where the words composed the space determined by the limit of the page or of the wall. The control of spatialization was used in Latin America to keep the focus on the content and its evocations. It was a product of analysis in Simón Rodríguez's writings and, when used later by the concrete poets, it was a formalist instrument. Conceptualists in Latin America moved between these two poles.

The use of words and tautological turns was already in place in eighteenth-century colonial painting and poetry. In painting, they cohabited happily with figuration and introduced both poetic elements and clarity into communication.[14] The hybridization with poetry, however, is heresy in the mainstream. Buchloh, for instance, has written that the poetic element

> disfigures the precision with which Conceptual artists intervened with the means of language in the conventions of visuality.[15]

And, in 1969, Kosuth happily spoke of "the decline of poetry" and blamed poetry for "the use of common language attempting to say the *unsayable*."[16]

Generally speaking, such disfiguration and attempt to express the unsayable does not particularly upset Latin American artists. As we have seen, many entered the visual arts from poetry or, rather, expanded poetry into the visual arts. This same phenomenon occurred in Europe and can be seen in the work of two of the most interesting European artists of the second half of the twentieth century: Joan Brossa (1919–1998) from Catalonia, and Marcel Broodthaers (1924–1976) from Belgium. It is possible that different perspectives on the use and role of language lie at the heart of the divergence between Latin American and mainstream conceptualism. Mainstream conceptualism sought a form of analysis that has a lot in common with science. As Edward Wilson describes it: "The cutting edge of science is reductionism, the breaking apart of nature into its natural constituents."[17]

Wilson makes it clear that the search is not for simplicity as such, but to find "points of entry into otherwise impenetrable complex systems." The wish to

search for an understanding of complex systems is probably shared by artists and intellectuals all over the world. The definition of what constitutes a (complex) system and what designates its "constituent" parts is debatable, and that is where the use of language as a shared platform is a two-edged sword. It facilitates communication and research, but at the same time it imposes imperceptible limits on the imagination. In science, reductionism seems to be a crucial tool in the search for final theories, but in art, it may lead to skeletons devoid of the flesh of mystery.

In conceptualism, language can be viewed as a constituent part of a complex system that has the power to serve as a tool for analysis of that system.[18] Or it can serve as a vehicle for altering the system by creating new forms of consciousness in tension with the existing system. Poetry falls into the second category, and it is in that dimension that language became critical to Latin American conceptualism.

Figure 15.1. Waldemar Cordeiro, *Autorretrato probabilístico* (*Probabilistic Self-portrait*), 1967, 35 × 30 × 31 cm. Courtesy of Ana Livia Cordeiro.

In the same document, and in line with ideas that were also circulating in the United States and the United Kingdom, he characterized traditional art styles as being grounded in syntax, and on that basis he classified pop art, new realism, and new figuration as conservative movements. In his view, "the appearance of a new mass culture, made possible by electronic media," undermined the validity of these styles and introduced new variables to help transcend them. He considered the division between analogue art and digital art of greater transcendence than any aesthetic distinction, and trusted that the telecommunications network would ultimately be the agent for the development of a national and eventually an international culture.

Lygia Clark and Hélio Oiticica

The formal breakthroughs of the concrete and neoconcrete poetry movements had a strong impact on the Brazilian visual artists, as much on those who integrated the use of language into their art shortly thereafter as on those who went in the direction of performance. Neoconcretism, which was more interdisciplinary than the previous movements, generated performances and environments and provided direct bridges to the visual arts. Two of the most prominent and representative figures in this passage between media were Hélio Oiticica (1937–1980) and Lygia Clark (1920–1988). Lygia Clark participated in the Concrete Art exhibit in Rio de Janeiro in 1957. She also cosigned the neoconcrete manifesto of 1959, in which the rationalism of the concrete movement was denounced as "Pavlovian mechanicism" and a reintroduction of expression was endorsed.[6] During the 1950s, both Clark and Oiticica established themselves as constructivists sympathetic to Malevich and Mondrian. During the sixties, they started to break away to introduce their own bodies and life experiences into their work. Ferreira Gullar's views on "body-ness" in particular had great significance for them:

We do not conceive the work of art either as a "machine" or as an "object," rather as a *quasi-corpus*, that is, one whose qualities are drained in external relations.[7]

It is easy to see today that even before their neoconcrete period Oiticica and Clark were not really orthodox constructivists. British art critic Guy Brett quotes a revealing reaction of Oiticica's to Kasimir Malevich's painting *White on White* (1918):

> The drive towards absolute plasticity and suprematism are drives [*sic*] towards life, and they lead us to take our BODY (to discover it) as [life's] first probe.[8]

Figure 15.2. Waldemar Cordeiro, *Texto aberto* (*Open Text*), 1966, 31 × 197 cm. Museum of Fine Arts Houston, courtesy of Ana Livia Cordeiro.

At first sight, Clark's celebrated constructivist series of the *Bichos* (*Creatures*, or *Animals*, started in 1957 but culminated in the early 1960s) seems to be simply geometric play derived in style from the formalist guidelines of the Bauhaus or Ulm School of Design. On closer examination, the *Bichos* are revealed to be organic beings. Though reincarnated in metallic origami, the sculptures remain sensually alive. The use of the title *Bichos* becomes extremely important as an explanation of Clark's intentions and also as a device for breathing life into the sculptures. Meanwhile, Oiticica's objects, rigorous in their geometry, hang in positions that only make sense if one assumes that there must be an interaction with the viewer occurring that goes beyond the contemplation normally expected. These pieces cannot be taken solely as the results of research in rationality. In these pieces, Clark, just as Oiticica does in some of his, seems to deal with forces more fundamental than the power of reason. In that sense, her work, and Oiticica's, too, is reminiscent of the spirituality that was the underpinning of

Figure 15.3. (top) *Lygia Clark* catalogue, Fundación Antoni Tàpies, Barcelona, 1997, page 207, with *Desenhe com o dedo* (*Draw with Your Finger*), 1966, in the lower right corner.

Figure 15.4. *Lygia Clark* catalogue, Fundación Antoni Tàpies, Barcelona, 1997, page 255, with *Estruturas vivas: Diálogos* (*Living Structures: Dialogues*), 1969, on bottom of page.

suprematism as well as the syncretism involved in the use of Catholic saints by practitioners of Santería. And as in Santería, the core belief resides beneath a protective shell or disguise.

In their initial work beyond the boundaries of concretism, both Clark and Oiticica seem to inhabit a place between hedonism and magic. Whatever happens only occurs when the viewer's contribution is added to that of the artist—the art is made *with* the viewer.

By the mid-1960s, both Clark and Oiticica had evolved to a point where they were allowing the body to replace geometry. Oiticica became the lead dancer of the Mangueira Samba School during the Carnival of 1964, an activity and experience that shaped his subsequent works. Clark shifted to an aesthetic form of psychodrama and therapy, and her objects (as far as that word still applied) became props for interaction. A collaborative piece, *Dialogue of Hands* (1966) sums up their respective evolutions. In it, two hands, the right hand of each, are held together by an elastic Möbius strip and look as though they have been frozen in a dance.

The Möbius strip had been popularized in Brazil by the work of Max Bill, and its use in *Dialogue of Hands* was a fitting homage to what seemed to be the early formalist interests of Clark and Oiticica.[9] The ideas of the Hochschule für Gestaltung (School of Design) in Ulm, which Bill had founded and initially directed, arrived on his coattails. This, in turn, brought in the ideas of another Ulm teacher, the philosopher Max Bense, who emphasized the rationalization of the analysis of forms.[10] Paradoxically, however—and this is an important point to underscore—Clark and Oiticica's homage to Bill simultaneously challenged all his principles about strict rationality. *Dialogue of Hands* did not use the Möbius strip as a mathematical symbol, but rather as an irrational and emotional space within which to digest and reuse other cultures. In this, it owed more in spirit to de Andrade's "anthropophagic" approach than to anything else.[11]

Perhaps more than anybody else, Oiticica picked up the legacy of de Andrade in a search for a national whole that unified all constituent cultural traditions. Speaking of his *Parangolés*,[12] by which he meant a matrix word with very private meanings, Oiticica explained that

the "Parangolé" would thus be, before anything else, an exploration of the basic structural constitution of the world of objects. . . . There is a basic difference here, for example, from the Cubist's discovery of African art as a rich expressive source, etc. For the Cubists, it was the discovery of a cul-

Figure 15.5.
Hélio Oiticica,
Parangolé P 15
Capa 11, *Incorporo
a revolta*
(Parangolé P 15
Cape 11, *I Embody
Revolt*), 1967.
Photo Claudio
Oiticica, courtesy
of Projeto Hélio
Oiticica.

tural totality, of a defined spatial sense. . . . The "Parangolé" places itself, as it were, at the opposite pole from Cubism: it does not take the entire object, finished, complete, but seeks the object's structure, the constructive principle of this structure, the objective foundation so to speak, not the dynamization or dismantling of the object.[13]

Oiticica not only danced with Samba capes, a common image in Carnival, but also used them in his art to convey messages. Integrating popular costume with gallery art was for him an act of social creation toward the ultimate goal of a unified cultural experience. He went on to do pieces consisting of tents open to the viewer. The tents were a hybrid between his neoconcrete spatial experiences and the capes.

In his *Bólides* (*Meteors*), best described as small poetry environments, Oiticica's approach was vaguely analogous to readymades. While he often included text, he always made use of a variety of objects as well, and the weight of the work relied on a poetic tension generated by the presence of these nontextual elements. Since his *Bólides* had no narrative implications, they stayed carefully away from making any absurdist or surrealist statements. Emphasizing the importance of *relation* over *objects*, Oiticica also used the word "Trans-Objects" to refer to the *Bólides*. In 1963 he wrote about his strategies, explaining that he was not seeking simply to enrich trivial objects with an artistic aura by planting them outside everyday experience. By incorporating the readymade "into an aesthetic idea, making it part of the genesis of the work," he was aiming to have it "assume a

Figure 15.6.
Hélio Oiticica,
Bólide Vidrio 10,
*Homenagem a
Malevich—Gemini
1* (Glass Bólide 10,
*Homage to Male-
vich—Gemini 1*),
1965. Photo
Mauricio Cirne,
courtesy of Projeto
Hélio Oiticica.

transcendental character, participating in a universal idea without losing its previous structure."[14]

It is difficult to decide on a word for the process that guided Clark and Oiticica. "Recontextualization" seems more descriptive of their strategies than "dematerialization," and they were definitely interested in issues quite different from those that seemed to guide the mainstream conceptual movements. The modesty of physical materials was not a consequence of physical reductionist goals, but rather of a conscious reversal of the traditional art concept in which the art object permanently houses an artistic essence. For them, the object became a provisional and transient container for an "essence." This "essence" (whatever it was) then would immediately escape and shape human interaction,

leaving behind an empty shell. Whether the vehicle was psychotherapy or samba, the loss of concreteness enhanced interaction with the audience. Neither Clark nor Oiticica fed the spectators a product; instead, they nourished them by engaging them as viewers in unexpected ways. As Oiticica wrote in 1964:

> What emerges in the continuous spectator-work contact will therefore be conditioned by the character of the work, in itself unconditioned. Hence there is a conditioned-unconditioned relationship in the continuous apprehension of the work.

And, later, in the same essay:

> There is, as it were, a "desire for a new myth," furnished here by these elements of art; they make an interference in the spectators' behavior: a continuous and far-reaching interference, which could implicate the fields of psychology, anthropology, sociology, and history.[15]

In 1966, Oiticica took the final step:

> Anti-art, in which the artist understands his/her position no longer as a creator of contemplation, but as an instigator of creation.... There is such a freedom of means that the very act of not creating already counts as a creative manifestation. An ethical necessity of another kind comes into being here ... since its means are realized through the word, written or spoken ... This is the social manifestation, incorporating an ethical (as well as political) position, which come together as manifestations of individual behavior. [This position] is against everything that is oppressive, socially and individually—all the fixed and decadent forms of government or reining social structures.... It is the retaking of confidence by the individual in his or her intuitions and most precious aspirations.[16]

Although these basic utopian ideas were widespread in Latin America at the time, the Brazilian process of hybridization did not immediately conquer the rest of the continent. Conventional poetry and visual art forms continued to be produced and to move on in their usual ways. Yet, finding new ways of approaching creative expressions was becoming urgent for an increasing number of artists in Latin America. And while abstraction had achieved solid foundations in many Latin American countries, figuration had not died in the least and was able to help shape the conceptualist tendencies. The influence did not, of course, directly affect issues of style. But much of the challenge of art as an institution during the early 1960s did come from some forms of figuration.

16 *Postfiguration*

Notwithstanding all the nonartistic forces that shaped Latin American conceptualism, as in the mainstream, developments in painting also had an enormous impact on its evolution. For historical reasons, painting has been the major standard for art, even during times when it was declared dead. In the mainstream, conceptual art was influenced one way or another by Robert Rauschenberg's *White Paintings* and Frank Stella's reductionist *Black Paintings*. In Latin America, painting was also influential, but in a different way, since, with the exception of a few Argentinean artists that had a brief minimalist period, there was no outright repudiation of figuration by the artists that became conceptualists. Art was open to narratives, and figuration ultimately was one narrative more.

Perhaps because of that, although it was stylistically alien to any conceptual format, much of the painting done in Latin America in the late 1950s and the early 1960s was able to pointedly attack art as an institution from within a traditional format. Among the rebels, Latin American neofiguration clearly stands out. Neofiguration, also known as neo-expressionism, was a movement that spread over the continent during the early 1960s. In Mexico, José Luis Cuevas was the prime representative of the movement. His enemies were the muralist painters, who by then represented the art institutions and the establishment in a most fossilized and entrenched way (Siqueiros at the time was only a political martyr, not an artistic one). In Venezuela, it was Jacobo Borges; in Cuba, Antonia Eiriz; and in Uruguay, it comprised several artists who since the 1960s had expressed themselves primarily through drawing, and who later, in the 1970s, were lumped together into an artistic category known as El Dibujazo.[1] In Brazil, Antonio Dias and other conceptualists in the making were also working on neofiguration or on a posterized version of it.

The strongest example of contestatory figuration, because of their influential status at the time, was the Argentinean group known as Otra Figuración (Other Figuration). A very cohesive group, it was active from 1960 to 1963 and was formed by Luis Felipe Noé, Rómulo Macció, Ernesto Deira, and Jorge de la Vega. Other artists were working in the same vein, but without belonging to the group,

including Antonio Berni, Antonio Seguí, and Alberto Greco. These artists had formal references to the work of the COBRA group, which included artists such as Pierre Alechinsky, Karel Appel, Asger Jorn, Christian Dotremont, and Constant, as well as to the work of Francis Bacon. Broadly speaking, they remained within what one would recognize as painting, but, at the same time, they challenged the categories of art. They made painting a metaphor instead of an end in itself. These artists explored fragmented pictorial vision, introduced what later would be called "bad painting" in New York, and, as was the case with Noé's work, followed Argentinean artist Lucio Fontana's slashing of the canvas to experiment with the stretcher as a visual element in opposition to the canvas. Painting invaded sculpture, and the exhibition room became an installation, all without losing any of the painterly identity.[2]

Particularly in Noé's work, chaos received the most attention. Chaos was present as much in the process as in the content, and the work would not just inform *about* it, but would also attempt to be an "organized" example *of* it. Noé was the artist in the group most concerned with theoretical speculation, and he summed up his ideas in a 1964 book, *Antiestética* (*Anti-aesthetic*), that was published the following year.[3] *Antiestética* was widely read by the younger Argentinean generations and influenced some of the artists who later organized *Tucumán arde*.[4] In his book, Noé marveled that the same society was able to simultaneously produce geometric art and unbridled expressionism. This made him wonder where society was going. Was this divergence leading to a coherence of incoherence? He defines the artist not as a rebel against a society, but as a builder of society, a concept that has influenced my own thinking. One of his points is that "when one speaks of social art, one is referring to more than just art for the people; one is talking about art of excitement of the people, of political agitation."[5]

I find it very reassuring that Noé's thinking helps bypass any concern for formal connections with conceptualism. The ideological continuity that this implies shows the priority that *needs* may take over *form*. The breakdown and de-aestheticizing process that this group started, and the role that subject matter was able to conserve in this development, nurtured the ground for what was to come. Though also concerned with painterly matters, these artists addressed topical issues that included events taken from Argentina's history. They generated a new and bizarre tradition of "historical paintings" that further departed from painting about painting.

Differing radically from the mainstream, the antecedents of Latin American conceptualism are expressive tendencies and not either "cold" pop art or the minimalist currents. Alberto Greco, the only artist that kept his feet simultane-

ously in both neofiguration and conceptualism, is the key figure that links both aesthetics and sometimes even combines them in the same work. At one point, he painted gestural canvases around people he had placed in the gallery and who remained part of the exhibition. Starting from a neo-expressionist platform, he was able to develop a clear conceptualist framework into which he could easily absorb what under normal circumstances might have appeared to be an anachronism. One is tempted to speak of an *expressionist conceptualism.*

Another meeting ground for figuration and concept was a locally influential exhibition of "destructive art" that took place in Buenos Aires in 1961.[6] Artists tried to push informalism (the European parallel movement to U.S. abstract expressionism that focused more on the no-form than on individuality), a style that many of the participants had previously introduced in Argentina, to an extreme of violence and irritation. At the same time, they also criticized and made fun of the (art) establishment. The exhibit included artists Antonio Seguí, Kenneth Kemble, Luis Wells, Enrique Barilari, Silvia Torras, Jorge Roiger, and Jorge López Anaya. Although the artists were focused on the reality of Buenos Aires, it is very likely that they were aware of Gustav Metzger's "Auto-destructivist" actions in London (1959) and that they recycled those ideas. Kemble, the organizer and ideologue of the show, claims to have been inspired by an article on "junk art" that appeared in *Time* magazine. Among other points, he speaks of a reaction to living on "the edge of a destructive orgy," when a "50 megaton bomb can erase Buenos Aires and many millions of its inhabitants," and when "North American authorities calmly speak of the possibility that 165 million of the 175 million of its inhabitants may die during the next nuclear war."[7] The show was accompanied by destructive poetry readings in dadaist fashion. Argentinean critic Andrea Giunta summarizes the importance of the event as a "manifesto in images."[8]

It is more difficult to explain the link that was created in Latin America between such contradictory aesthetics as expressionism and conceptualism than between figuration and conceptualism. In an unavoidable colonial fashion, Latin America clearly was subject to the influence of mainstream formalist "movements." As soon as a style coalesced in the centers, it would have an effect on the periphery. However, because conceptualism was not a formalist category in Latin America, but rather a strategy in communication, it became a kind of metastyle. This perhaps can best be understood when discussed in relation to political and economic factors distinctive to the continent, such as the history of political instability and the foreign ownership of resources, elites more connected to power elites in the center than to their own people, and the experience of postcolonial dependencies. The appeal of expressionism in Latin America might be attributed

to the "inwardness" that traditional expressionism expects: the effort to find and articulate a core identity. Perhaps, too, it has to do with the permission expressionism gives to the use of heterodox (and less costly) materials, as well as to the possibility of letting materials express themselves. Much later, during the 1980s, similar conditions stimulated interest in the integration of high art and local craft production, giving rise to a fashion of making artwork with an artisan look to it.

It was the inexpensive production method that, to a great extent, became one of the most appealing aspects of conceptualism. A respect for the pocket coincided with a respect for identity. That is why later the Italian Arte Povera ("poor art," in the sense of lacking material resources) became attractive. I believe, however, that this sympathy for Arte Povera in Latin America was probably more a result of the name than of the work it produced. The label arrived before the works themselves, and when they did arrive, they seemed to contradict the label in several respects. The materials used by the Italian artists weren't really that "poor," and the name was given referring more to non-art materials from diverse provenance than to their cost. In 1968, in a letter to Lygia Clark, Hélio Oiticica made a cogent argument on this point:

> The so-called *arte povera* is made with the most advanced means; it is a sublimation of poverty, more in an anecdotal, visual vein, poor in purpose but in truth rich; it is the assimilation of the leftovers of an oppressive civilization and its transformation into consumption, a capitalization of the idea of poverty. Not for us, it seems that an economy of elements is directly connected with the idea of structure, a formation from the beginning, the non-technique as a discipline, the freedom of creation as a supra-economy, where the rudimentary element at once liberates open structures. [*sic*][9]

In this context, Alberto Greco's approach was to truly use the most economic and available means, and he—together with Piero Manzoni, Yves Klein, and others—set the stage for both Arte Povera in Europe and conceptualism in Latin America of the 1960s. Greco's art was more in the tradition of de Andrade's *antropofagia* than informed by a political vision or enlarged by a wish for universal and unqualified appropriation.

Alberto Greco

Alberto Greco (Argentina, 1931–1965) could have been a character created by Aub. In 1962, he introduced his *Vivo Ditos* (*Live Fingers*), a new form of art that was achieved by pointing his finger at people on the street and declaring that

Figure 16.1.
Alberto Greco,
Vivo Dito, 1962.
Photograph by
Rene Bertholo,
Paris, KWY
Archive, courtesy
of Lourdes Castro.

they were works of art. Generally speaking, it was a form of contextualization, but it was also a significant step toward dematerialization for an artist who had earlier signed people on their backs. Greco claimed that he started signing "walls, streets, and bathrooms in Paris" as early as 1954. He also claimed to have signed the whole city of Buenos Aires in 1961; however, there is no way to prove this.[10] In 1962, he wrote his "Vivo Dito" manifesto:

> Live art is the adventure of the real. The artist will teach how to see not with a painting, but with the finger. He will teach to see anew that which happens on the street. Live art searches for the object, but the found object is left in its place, it is not transformed, not improved, not taken to the art gallery.[11]

Figure 16.2.
Alberto Greco,
Vivo Dito, 1962.
Courtesy of
Vanina Greco.

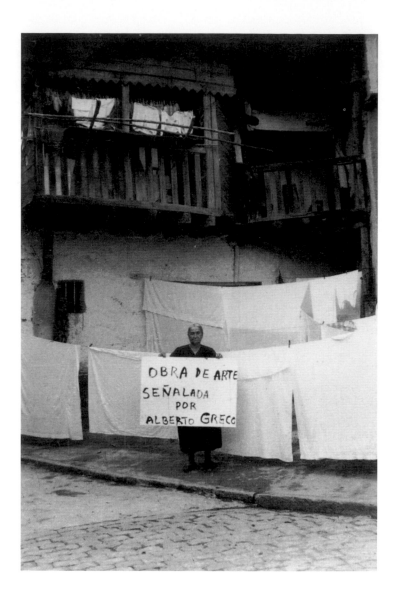

Greco's pedagogical pursuits here have to be taken with a grain of salt. He was more interested in the shock of the performance than in actual education. There was no real teaching strategy in his production, and his choices (including the pointing finger as a symbol of instructional authority) probably were made to satirize the messianic impulses of some of his colleagues.

In 1963 he had to escape from Italy to avoid jail. During a performance in a theater (*Cristo 63*), he decided to urinate onto the occupied rows at the front of the orchestra, something that is against the law in Italy.[12] Greco's last creation was his suicide, caused by an unhappy love affair. He performed it in 1965, and despite his despair, he had enough presence of mind to aesthetify his action by writing "Fin" (The End) on the palms of his hands.

Greco never abandoned painting and drawing. He had been one of the most interesting Argentinean "informalist" painters during the late fifties, and, as mentioned earlier, his drawings became an important part of the Argentinean neofiguration of the early sixties. During his years in Europe, Greco was in contact with the Nouveau Réalisme artists. Swiss Fluxus artist Ben Vautier was one of the people he signed. Ben, as he is known, produced a piece in 1962 closely connected to Greco's art: a photograph of him holding a sign saying "Look at me; that suffices." The similarity of this piece to Greco's work created a conflict between them. Although Greco acknowledged having been influenced by Yves Klein,[13] he claimed that in Ben's case, the influence was his and that Ben had plagiarized him. Still, in 1963, he gave Ben a certificate anointing him to continue the *Vivo Ditos* and his Grequismo Vivant movement. The same year, he also named Ben "follower #6 of Vivo-Dito art in the world." It is unknown to me who the preceding five followers might have been, but it is possible that Greco, concerned about the ambiguity of the dates of authorship, did this to co-opt Ben.

In spite of his earlier "Vivo Dito" statement, Greco eventually did bring people from the street into the gallery ("the found object" and the "*objets vivants*," or "living objects"). He placed them close to the wall, on which he painted informalist backgrounds. He started this in an exhibit at the Galería Juana Mordó in Madrid in 1964. That same year, he returned to Buenos Aires, where he contracted two shoeshine boys to appear as the main piece in the exhibit at the Galería Bonino in Buenos Aires.

In the beginning, Greco's European work was closely linked to that of European artists, but he slowly returned to a form of hybridization and impurity that seemed to reflect local conditions in Argentina.[14]

Greco's personality and work were very influential in Argentina. Some years later, in 1968, Oscar Bony (1941–2002) exhibited a "working-class family."[15] Bony's piece preceded that of Italian artist Gino De Dominicis's installation in the 1972 Venice Biennial by four years and, though less visible internationally until recent years, had important differences that made it much more interesting. De Dominicis (1947–1998) exhibited a child with Down syndrome sitting on a chair that was affixed high up on a wall. Though the two works have formal elements in common in terms of exhibiting actual people, Bony tried to shock the public into an awareness of the great disconnection that existed between high elite art and social reality. To do this, he brought a representative of the neglected, oppressed, and repressed (it was a time of military dictatorship) into an arena where this individual would be seen, noticed, and registered by those in power. By bringing a family from the outside world into the gallery system to

serve as the subject for aesthetic enjoyment to those who were "in," he hoped to shock the art power elite into a reexamination of the purpose of art and the circuits of distribution. De Dominicis, on the other hand, though he claimed to address immortality,[16] engaged in a form of vague (visual) terrorism against the public. He exploited a handicapped child without making any point beyond the breaking of form and protocol. Bony, in his case, denied that he set the family up as a work of art. He argued that he had offered the head of the family a job in which he was paid twice as much as he was earning in his regular job as a die-cutter. All of this was explained in the label for the piece written for the exhibition and posted on the wall. According to Patricia Rizzo, curator of a re-creation of *Proletarian Family* thirty years later, Bony considered that the family "was *in lieu* of the work of art and not the art itself." [17]

Argentinean artist Federico Peralta Ramos (1939–1992), who declared his own life a work of art, also picked up on Greco's legacy. In his case, it took the form of a painting stating that "My life is my best work of art" (1972) and then, in 1980, the achievement of what he declared his ultimate artistic goal: to lose weight through dieting until he reached the ideal shape (the loss was of somewhere between 25 and 110 pounds, depending on who tells the story).[18]

Alberto Brandt

Venezuelan artist Alberto Brandt (1924–1970) had a similar role to that of Greco in his country. Brandt is credited with introducing informalism in Venezuela. He was not a conceptualist artist nor did he consider himself as such, but in his effort to blur painting and life into one activity, he left precedents of importance to Venezuelan artists. Brandt was a colorful and fearless character. He was a national sprinting champion, a player in the soccer league, and a trained concert pianist. He also was an active member of the El Techo de la Ballena group and their magazine, which, with their postdadaist activities, left a big mark among Venezuelan intellectuals.

Brandt's paintings were mostly connected to surrealism (Max Ernst owned one of them) and often quite beautiful. Just like Greco, he enjoyed scandal and self-generated myths. His legacy lay mostly in his behavior rather than in his canvases. In 1958, during a presentation by critic Perán Erminy on informalist painting, Brandt was invited to illustrate the lecture by simultaneously executing a painting in front of the audience. Brandt started his job quite normally, but after a short while, went on to "attack" the canvas that he had been working on. Carried away, he left the canvas and continued on the walls of the auditorium in

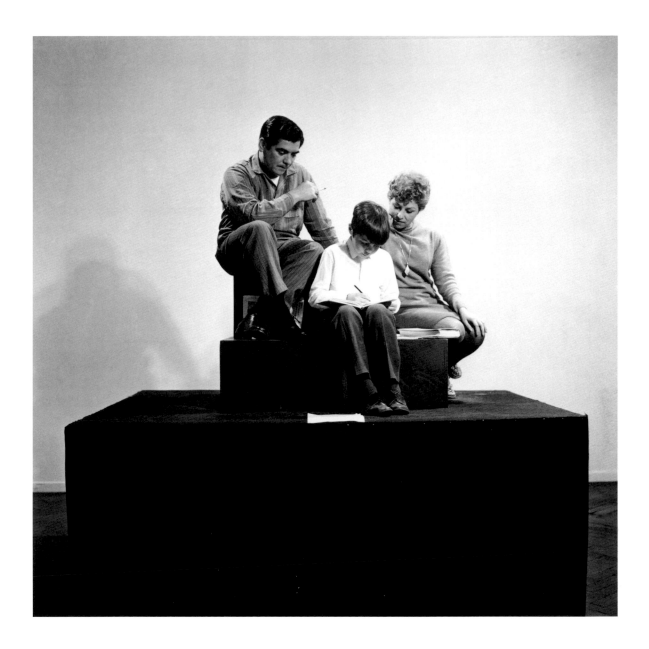

an act that at the time was seen as pure vandalism and that certainly disrupted a lecture that up to that point had been straightforward and scholarly. Later, in Spain, Brandt was jailed for dressing like an Inquisitor and because he had attempted to burn down his landlady's building. Apparently, she had taken his belongings in reprisal for his being late with his rent payments. In Italy, he was jailed for screaming "Quo Vadis Pietro!" (Where are you going, Peter!) at people walking by as he pointed at Monte Sacro (where Simón Bolívar had delivered his promise to liberate South America from Spain). Shortly after that, he was expelled from Greece for publicly insulting the king and queen. Back in Venezuela,

Figure 16.3. Oscar Bony, *Familia obrera* (*Working-Class Family*), 1968. Photograph documenting the event, courtesy of Carola Bony.

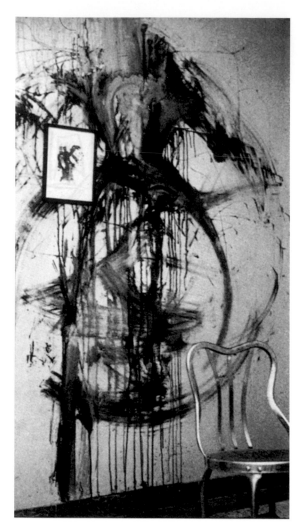

Figure 16.4. Alberto Brandt, *Performance,* 1958. Courtesy of Galería Nacional, Caracas, Venezuela.

he created yet another incident by formally inviting police to a big marihuana party he had organized specially for them.[19]

In many of these events, it is sometimes difficult to separate sheer spectacle-making madness from serious and rigorous work that challenges stereotypical thinking and ways of life. While it is true that many of the artists who performed actions like these possessed a solid theoretical background and were simply pursuing their goals in a direct and uncompromising manner, I have my doubts about Brandt, who did not leave any mark suggesting theoretical sophistication in this regard.

Nevertheless, both Greco and Brandt were quite focused on European art developments. The influence of these developments, beyond their personal reaction to the local environment, may explain the figuration-conceptualism link in their cases and also in that of other artists. Looking at a European history of conceptualism, it is accepted that many conceptualists originated in or were influenced by the Nouveau Réalisme. This interpretation is so strongly entrenched that no clear separation is made between these two currents in art. European conceptualist artists invested their energies in objects in a way that clearly connects them with figuration. Yves Klein alludes to this in his caption for "A Man in Space," the photograph of his "Leap into the Void" showing him jumping from a building: "I am the painter of space. I am not an abstract painter, but on the contrary, a figurative one, and a realist. Let's be reasonable, to paint space I owe it to myself to go there, into space itself."[20] In certain ways, it was a conceptual leap from the representation of reality to reality itself.

In many of its manifestations, European conceptualism seems to focus on a "trompe le cerveau" (fool the brain) approach as one step up from the previous "trompe l'oeil" (fool the eye) one. It is therefore open to all of "reality," not just the material dimension of it. Conceptualizing reality does not mean reducing reality to something the mind can record in written language as opposed to cap-

turing in paint. It means dismissing the limited definitions of reality altogether, so that figuration can become performance, performance can be posed as information, and information can take the place of reality.

The advantage of this shift was multifold. It helped escape the craftsmanship associated with traditional art, it facilitated communication within and outside geographic borders, and it could at some point also become a political tool. Argentinean artist Marta Minujin organized a nonpolitical experiment in 1966 that involved Allan Kaprow and Wolf Vostell. They staged three simultaneous activities in Buenos Aires, New York, and Berlin that were circulated live via radio, television, and telephone.[21]

Eduardo Costa, Roberto Jacoby, and Raúl Escari

In October of 1966, Eduardo Costa (1940–), Raúl Escari (1944–), and Roberto Jacoby (1944–) produced a fictitious happening in Buenos Aires. They documented photographically different well-known Argentinean intellectuals performing assigned tasks or self-assigned tasks (they could suggest an activity for a hypothetical happening), and subsequently merged these into one unified event. The twist was that this "event" did not actually take place, but only occurred as a report. It was the report of the "event" that was the "reality." The whole affair promoting the flood of information supposedly took place "in the home of Susana Sáenz Peña de Sáenz, erotologist and gallerist," and was titled *Total Participation*.

The original title of the Costa-Escari-Jacoby piece was *Primera obra de un arte*

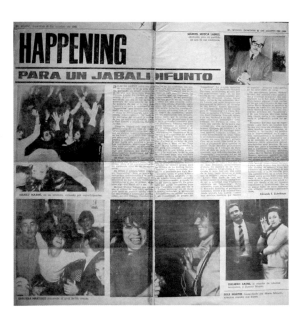

Figure 16.5. Eduardo Costa, Raúl Escari, and Roberto Jacoby, *Arte de los medios de comunicación,* Happening *para un jabalí difunto* (*Art of Communication Media, Happening for a Dead Boar*), 1966. Newspaper clipping, courtesy of Roberto Jacoby.

de los medios de comunicación (*First Work of an Art of Communication Media*), which in part echoed the heading of a manifesto they had issued in 1966. In the manifesto, they had declared among other things, "A work [of art] starts to exist in the moment in which the consciousness of the spectator constitutes it as already finished."[22]

The intention of the piece was not to make, but to *unrealize,* a work of art. One of the many news items about the *nonhappening* was titled Happening *para un jabalí difunto* (*Happening for a Dead Boar*), a headline catchy enough to supercede the original title the artists themselves gave to their piece. The work is now known by both titles, with the original kept out of scholarly respect.[23] With the help of friendly journalists and art critics, information and details of the "happening" were both planted as a news item and also made the subject of serious art criticism. Many publications picked up the information, regurgitated it, and made the whole thing into a major art event.[24] After all of this had happened, Jacoby—one of the three authors—decided to call the piece, not a "happening" but an "antihappening," an "art of mass media." Argentinean critic Oscar Masotta (who was a hidden fourth member of the team), following Jacoby's line of thought, explains that *happenings,* as mass-media art, deal in immediate, perceivable matter, dematerializing and transforming aesthetic matter into sociological issues.[25] In the case of the *Dead Boar,* the piece only begins *after* the spectator accepts it as finished. As the manifesto states in its very beginning:

> In a mass-civilization, the public is not in direct contact with cultural events but is informed through the communication media. The mass-audience doesn't see, for example, an exhibition, is not present at a happening or a soccer game.[26]

The Costa-Escari-Jacoby piece also made it into the history of U.S. art criticism. In 1969, Harold Rosenberg mentioned the nonevent while cataloguing works that "communicated art through documents." He gave examples of works by individual artists like Claes Oldenburg, Bruce Nauman, and Edward Kienholz. In the same paragraph, he then suddenly shifts from citing individual names to becoming generic and semi-informed. He refers to the trio as "two young artists in Latin America" who:

> contrived a Happening that was reported in detail in the press but never took place, so their "work of art" consisted of their own news releases and the resulting interviews, accounts and comments. Given the mythical status of art conferred by words, uncreated art is the myth of a myth.[27]

Figure 16.6. (above) Happening *para un jabalí difunto*, detail. Courtesy of Roberto Jacoby.

Figure 16.7. (right) Roberto Jacoby, Poster for Che ("A guerrilla fighter doesn't die to be hung on the wall"), 1968. Courtesy of Roberto Jacoby.

Earlier that same month, Raul Escari staged a different but real event. He had a series of leaflets printed with the exhortation "Enter Discontinuity." The leaflet directed the reader to go to different street corners in Buenos Aires, to observe certain buildings, and then, to move to other corners to receive new and different leaflets. One of the texts, which invited the public to observe the façade of the Navy Club, suggested: "You can imagine the luxury of its big rooms by looking at the marble baseboards, the big door of forged iron . . ."

A policeman, who happened to pass by, read the leaflet and decided to cancel the action. Any further distribution of leaflets was now prohibited, since it was considered an act offensive to the armed forces.[28] At the apogee of one of the bloodiest repressive regimes of Argentina, the military was sacred and not to be invoked in vain.

Nelson Leirner

Nelson Leirner's points of departure mostly stem from humor applied to art rather than from art issues applied to social issues. Leirner (1932–), the son of a rich patron-of-the-arts father (Isai Leirner) and a known sculptor for a mother (Felisa Leirner), started this anarchic path after the death of his father (1962).[29] During the first two years of the decade, Leirner worked on big Antoni Tàpies/Alberto Burri–like flat assemblages and paintings, with a heavy emphasis on the use of found materials and their deterioration through burning, wear, or arbitrary painting. Aesthetically, the work is connected with informalism and Nouveau Réalisme (his *Self-Portrait*, 1964, has two used painter palettes in a Piet Mondrian–colored yarn-filled frame). In 1967, Leirner made a *Homage to Fontana* series that started with a slashed canvas that could be closed with a zipper. The *Homages* were mass-produced and sold at cost (with an explanation of the expenditures incurred in the production).

Figure 16.8. Nelson Leirner, *Homenagem a Fontana I* (*Homage to Fontana I*), 1967, 180 × 125 cm, cloth and zipper. Private collection, courtesy of Galeria Brito Cimino.

Figure 16.9. Nelson Leirner, *Exposição não-exposição* (*Exhibition Nonexhibition*), 1967, Rex & Sons Gallery. Courtesy of Galeria Brito Cimino.

After a privileged career helped by the status of his family, Leirner applied himself to bypassing and attacking the normal commercial circuits of distribution. In a so-called happening in the Rex & Sons Gallery (a collective he helped to organize in São Paulo) that same year, he had an exhibition of works to be taken free of charge. There was, however, one condition. The pieces were chained to the walls of the gallery, with hacksaws placed next to them, and the interested customer had to try to cut the chain. The exhibition was very successful. The public was waiting in line for the gallery to open, and within five minutes all the works had been taken.[30]

Leirner's irreverence continues even today, most successfully with a series called *Rural Constructivism* (1999), carefully constructed geometric compositions made out of stretched, hairy cowhide. Leirner's work is rare in Latin America inasmuch as it systematically addresses de-institutionalization within the art environment. The only other prominent example that comes to mind is Colombian artist Antonio Caro, who on the occasion of the 1971 Print Biennial of Cali, Colombia, distributed two thousand drawings among the public who entered the building on opening night. His enormous edition of originals thus overwhelmed any of the limited editions of repeatables in the biennial.

this would finally provide an opportunity to launch a subversive movement against the artistic establishment in the mainstream. Others saw participation as plainly unavoidable, regardless of any politics. In a letter to Lygia Clark a few weeks before the opening (May 16, 1970), Oiticica explained his participation in the exhibit:

> I find it important to participate after all, even if it doesn't make sense anymore to be in a museum or gallery, except for those who see an exhibition and inform about international things connected with installations, etc . . . and I think it would be ridiculous and pretentious to refuse, specially since it would be crazy to assume that anybody in the U.S. would know much about me; you know how it is there, as soon one doesn't show up in the place, one doesn't exist, and there is no place more central and visceral than the MoMA of N.Y.[5]

The New York Graphic Workshop (José Guillermo Castillo, Liliana Porter, and myself) had similar thoughts about subversion and misgivings about the unavoidability of exhibiting if we were to continue being "artists." We tried to use the exhibit and still keep to a minimum our being used by the museum. Our attempt resulted in a somewhat laughable ruse. We made a poster and placed it above a table specially installed for us. Its message was: "The NYGW announces its mail exhibition #14." Instructions encouraged the public to self-address an envelope in order to receive the promised piece. The museum then committed itself to the mailing of a leaflet bearing the text: "The NYGW announced its mail exhibition #14." We hoped that the change from *s* to *d* attached to the word "announce" would create a self-destructive situation and leave us untainted and pure. However, the only thing we really achieved was to cause a fleeting moment of concern in the museum's administration in regard to the budgetary implications. Unfortunately, we never found out how many mailings were made so we could ascertain the damage.

The show was definitely bigger and stronger than any of the participants. Not unexpectedly, a map of our own limitations had been elegantly and precisely laid out, not by the curator, but by the system. Our work became part of a larger project; the show redefined us as practitioners of a particular style, as being eligible to be viewed in a niche, and not as political artists.

The project of merging art with reality turned out to be easily confined and muted. The utopia at which we were aiming was already agonizing at that early date; we just hadn't noticed. In art, as in politics, resistance movements were being folded into "broad fronts" that were less threatening to the status quo.

MoMA's Information show did not deviate that much from the traditional hegemonic model, in spite of its internationalist rhetoric. Kynaston McShine, the curator of the exhibition, wrote in his acknowledgments that the original idea for the exhibit had been "'an international report' on the activity of younger artists." It was then "narrowed down to what seemed to be the strongest 'style' or international movement of the last three years."[6] McShine referred to the exhibition in its "international" scope as evidence of McLuhan's "global village." However, one could see that out of 93 invited artists, 38 were from the United States, 16 were from the United Kingdom, and 13 were from Germany, France, and Italy; that meant only 26 came from the rest of the world, and many of those were émigrés living in New York, London, or Paris. Yugoslavia's 5 participants were in the Grupo OHO, and 4 of the 9 Argentinean artists were in the Grupo Frontera. Moreover, in the catalogue, the global omnipresence of *Time* magazine is cited as proof that a global culture was emerging. The true meaning of the word "globalization" was emerging even then.[7]

With hindsight, one could say that the Information show was already establishing the patterns of distribution for what Manuel Castells calls "high value production," having the artist classed as informational labor. The patterns are organized in networks and flows, using the technological infrastructure of the information economy.[8] Some months after Information had closed, the art critic of New York's *Village Voice*, John Perrcault, asked:

Is it so surprising that in a time when postindustrial ephemeralization is rampant, when information bits are speedier and more important than heavy matter or face-to-face contact, when we are bombarded with message units, when space is at a premium, when history forces us to dematerialize, that artists everywhere should come up with Conceptual Art? Conceptual Art is a symptom of globalism and it is the first—Surrealism almost was—international style.[9]

In his catalogue essay, McShine had lumped together torture in Brazil, being jailed for deviation from dress codes in Argentina, and the fear in the United States of "being shot at, either in the universities, in your bed, or more formally in Indochina," to then conclude that in this context of shared "stress":

One necessity is, therefore, at least to move with the cultural stresses and preoccupations (as if you had a choice), particularly with the obvious changes in lifestyle. The art cannot afford to be provincial, or to exist only

within its own history, or to continue to be, perhaps, only a commentary on art.

He described the young artists as attempting to be "poetic and imaginative, without being either aloof or condescending," and then a little later reassured us that "the general attitude of the artists in this exhibition is certainly not hostile. It is straightforward, friendly, coolly involved, and allows experiences which are refreshing." [10]

A period of "soft" political art was therefore starting to take shape in 1970. Some Latin American artists who belonged to that generation and who were making political work, including Cildo Meireles, Antonio Dias, and others (including myself), probably felt the change more strongly than others. In the sixties, we had been part of a political culture that surrounded the "hard" political art. It turned out that our work was only politically valid as long as more radical manifestations, like the *Tucumán arde* project or the Tupamaro operations, were taking place. Once these kinds of activities started to wane or to disappear, there was room for the object quality of the art to take over again, and our work could no longer hope to be a standard for deinstitutionalization. The ground was now being set for a return to a lower and more acceptable degree of intensity. It became clear that art and life would not be completely merged, at least not in the way Latin American conceptualists had been envisioning. From an initial hope of making art a form of politics, we had been reduced to making political art.

According to mainstream definitions, conceptualism peaked in Latin America during the early seventies. However, the production of the early seventies already had a somewhat blunted edge as a tool of resistance. Neoliberalism had started to expand its reign. It had been instituted in the developed countries in the context of economic crises, where it was reflected in the erosion of power of organized labor, the scaling back of public investments in social welfare, the growth of resistance to taxes, and the refinement of the rules of international finance. The United States and other international creditors who had substantial control of national debts in Latin America were promoting it there through dictatorial regimes that had the power to punish resistance.

The same "globalizing" forces were also sponsoring "international" inclusiveness in mainstream art and destroying political participation on the periphery. Meanwhile, manufacturing—both industrial and agricultural—shrank, while services (probably including art consultancies) mushroomed. [11] The global networks of relations and circulations increasingly used dematerialized resources such as "foreign debt." Conceptualist artists bent on keeping their identity in this

new atmosphere began to address the relation *between* things rather than the things themselves. In the United States, surprisingly, art as the production of information and not merely of objects also acquired some legal standing. In 1988, the U.S. federal courts ruled that art is information and not merchandise, and that Cuban art therefore could no longer be subjected to the embargo on goods.

Local circumstances also varied from country to country and had different effects. In Argentina, many artists from the *Tucumán arde* generation stopped their artwork completely. In Brazil, many of the artists who at the beginning of their careers were strongly rooted in a political context slowly moved away from merging art and politics, and evolved to a point where their information would be acceptable for formal exhibition. Politics remained, but in most cases they became exhibitable politics. In the safer New York environment, some artists in exile tried to continue activities outside the normal art frame, but that didn't last long either. In Brazil, Cildo Meireles, Antonio Manuel, and Artur Barrio (the latter only to some extent) were examples of this split activity. The same can be said of artists in Venezuela, Colombia, and Mexico. Claudio Perna, with his interest in a "lived-in geography," had work with some political implications, but he was mostly a gallery artist in his production format (though not so much in his success at the time). Similarly, Bernardo Salcedo deconstructed national symbols but was always keenly aware of his role as an artist. Marcos Kurtycz performed a role more similar to Greco and Brandt, operating between both worlds and interacting with Los Grupos. Antonio Dias, at the time living in Milan, introduced politics in his work, but kept his art activities within gallery boundaries.[12] The shift did not necessarily mean a true and general political and ideological softening, but it certainly indicated a shift in the ambitions for a definition of an audience and a resignation about the dimensions of the consequences art making could have for society at large. And in some artists, León Ferrari, for example, it underlined even more a dual mode of work.

Cildo Meireles

During part of this period of the early seventies, Cildo Meireles appropriated commercial products and money, tampered with their message, and then reinserted them into their normal circulation circuit. His intention was to use for his own purposes the same consumer process that was leading people away from a clear understanding of reality. It was a form of situationist *détournement*. Beginning in 1970, he used the dynamic of chain letters ("the work only exists if the other people participate"), printing ideological messages on empty Coca Cola

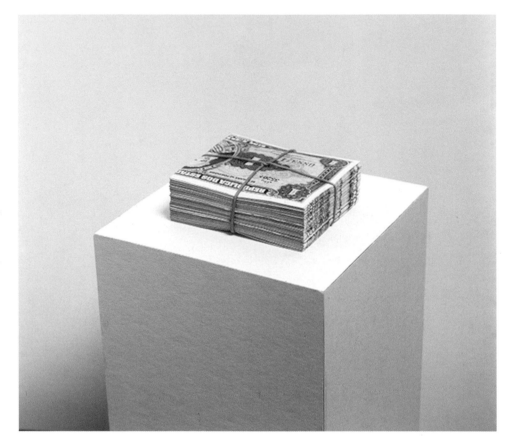

Figure 17.1. Cildo Meireles, *Árvore de Dinheiro* (*Tree of Money*), 1969, 100 folded 1 cruzeiro notes, cross-bound with 2 elastic bands, placed on traditional sculpture plinth, dimensions variable. Copyright © Cildo Meireles, courtesy of Gallery Lelong, New York.

bottles and on cruzeiro bills and encouraging people to contribute their own statements as well. The text on the bottles, applied with a decal, was white and practically invisible while the bottle was empty. However, the message became clearly visible on the dark background once the recycled bottles were reused and filled with the drink.

In a later piece (1975), Meireles rubber-stamped "Who killed Herzog?" on money bills that were sent back into normal use. Wladimir Herzog was a journalist presumably killed by the Brazilian dictatorship on suspicion of connections with the Communist Party.[13] Meireles's piece conveyed three messages at once: In asking the question, he was challenging the dictatorship; in defacing the bills, he was altering the meaning of money by changing it from an object of value to a conveyor of information; and in using this material for an art piece, he was demystifying the art object.[14] The objects he was appropriating had originally been designed for and limited to carrying their own particular message: value in the case of money, and product recognition in the case of Coca-Cola. In his pieces, he took these objects and substituted his own message for the one in-

tended. As they circulated according to their normal pattern, they now broadcast his message. He had appropriated the circulation system.

Meireles and other artists like Artur Barrio and Antonio Manuel were exceptions in a wide-ranging context in which art production was normally occurring within traditional frames of reference. The missionary zeal that had shaken the idea of "the artist" was ebbing. The challenge made to the status quo was to be expressed in the work of art itself rather than in any attempt to transform it via art's interaction with the "reality" of politics, and many artists, including Meireles, worked on both levels early on. Some pieces, like *Desvio para o vermelho* (*Red Shift*), accommodate everything, becoming a sort of epic. The installation was developed between 1967 and 1984. The first part, *Impregnação* (*Impregnation*) is a white room perfectly and overwhelmingly equipped with red furniture and accessories. The allusion is as much to Yves Klein's obsession with blue as it is to the blood of violence. Over the years, the environment grew, and *Desvio para o vermelho: Entorno* (*Red Shift: Spill/Environment*), a big red resin spill in the spirit of Carreira's blood puddle, was added in 1980. The explicitness increased further that same year with the addition of a porcelain sink in which red liquid kept constantly running out of the faucet.

Figure 17.2. Cildo Meireles, *Desvio para o vermelho I: Impregnação* (*Red Shift I: Impregnation*), 1967–1984, white room, red objects, including carpet, furniture, electric appliances, ornaments, books, plants, food, liquids, paintings. Overall dimensions: 1,000 × 500 cm, installation view at XXIV Biennial São Paulo, 1998. Copyright © Cildo Meireles, courtesy of Galerie Lelong, New York.

Figure 17.3. Cildo Meireles, *Arte Física: Cordões/30 km de linha estendidos* (*Physical Art: Cords/30 km of Extended Cord*), 1969, industrial cord, map, wooden box. Cord: 30 km in length; Box: approx. 60 × 40 × 8 cm. Copyright © Cildo Meireles, courtesy of Galerie Lelong, New York.

A piece typical for Meireles's nonpolitical production is *Arte Física: Cordões/30 km de linha estendidos* (*Physical Art: 30 km of Extended Cord*, 1969). In it one finds a poverty of materials, the device of pointing, and the use of context—all elements shared in one way or another by artists whose work fits into the category Latin American conceptualism. The cord described in the title was used to delineate part of the coastline of the state of Rio de Janeiro. Whether the cord was actually used cannot be proven, but at least it has the required length. It is presented in a small wooden suitcase together with a corresponding map. The work can be classified somewhere between the precedents established by Duchamp's *Network of Stoppages* (1914) and Piero Manzoni's *Socle du monde* (*Pedestal of the World*, 1961). It is also comparable to later pieces by Alighiero e Boetti and Walter De Maria. Boetti published his *Catalogue of the World's Longest Rivers* in 1977. De Maria's *Broken Kilometer* is from 1979 and consists of five hundred polished brass bars permanently laid out on the floors of a building owned by the Dia Art Foundation in New York. Meireles's, Boetti's, and De Maria's pieces deal with the arbitrari-

ness of measurement. In Meireles's work there is a concern with the poetry of mapping inasmuch as it brings a pseudorational construct into the realm of the senses, experience, and memory. In Boetti's, it is a poetic inventory of arbitrariness. And in De Maria's case, it is a work about the materialization of measurement to the point of becoming a monument to reductive tautology.

In most cases, the dual approach did not necessarily mean a lack of artistic coherence. The vision of the artist remained coherent (particularly in the case of Meireles), and the subject and the arena were flexible and shifted according to the surrounding conditions.

Antonio Manuel

Antonio Manuel (1947–), another artist active on the Brazilian scene, tried to keep the political edge somewhat longer, although his work also depended on references to the art world. Antonio Manuel (his full name is Antonio Manuel Oliveras) was born in Portugal and arrived in Brazil with his family when he was six years old. In 1967, he started to manipulate newspapers with both drawings and texts. The following year, he silk-screened some newspaper images depicting killings and tortures by the military onto red canvases. The pages were ex-

Figure 17.4. Antonio Manuel, *Repressão outra vez ... eis o saldo* (*Repression Once Again... This Is the Consequence*), 1968. Collection of João Sattamini, photo Pedro Oswaldo Cruz, courtesy of Antonio Manuel.

hibited covered with black felt so that the visitors entering his exhibit were faced with a group of funereal canvases. Encouraged to lift the felt, the act of uncovering became a ritual of contemplation that, given the nature of the images, also became a ritual of protest. The title was dangerously unambiguous: *Repressão outra vez...eis o saldo* (*Repression Once Again...This Is the Consequence*).

Also in 1968, he made his *Urnas quentes* (*Hot Ballot Boxes*). The boxes, which contained poems and a variety of objects, were sealed. The public was allowed to break them open with hammers provided by the artist ("shattered, and in this way the code of each box was revealed").[15]

In 1970, Manuel exhibited himself naked, as an unadorned work of art, in the salon of the Museum of Modern Art in Rio de Janeiro. He proclaimed: "The support of art failed to meet the needs of our time, and so-called works of art called

Figure 17.5. Antonio Manuel, *Urna quente* (*Hot Ballot Box*), 1968. Courtesy of Antonio Manuel.

Figure 17.6. Antonio
Manuel, *Urna quente*
(*Hot Ballot Box*), 1968.
Courtesy of Antonio
Manuel.

for a new approach in the face of prevailing obscurantism."[16] In 1973, an exhibition of his work planned for the Museum of Modern Art in Rio de Janeiro was prohibited. Manuel got the daily *O Jornal* to print an issue with the news of the cancellation and the reproductions of the works that would have been shown. Available on the newsstands for only one day (the project was now called *Exhibition from 0 to 24 Hours*), it sold 60,000 issues. In another work that year, *Super jornais—clandestinas* (*Super Newspapers—Clandestine*), he appropriated format and news from another paper, *O Dia*. He interspersed his own "art news" and headlines, like "Confusion in the Museum of Modern Art/Painter Shows Post-Art," with trivial sensationalist news. As Mari Carmen Ramirez points out, Manuel was, in effect, continuing the "insertions" strategy of Meireles.[17]

Artur Barrio

Just like Antonio Manuel, Artur Barrio (1945–) was also born in Portugal and raised in Brazil. In 1969, he adapted and clarified the ideas of Arte Povera for his purposes by speaking of "concept-from-bottom-to-top" as an alternative to the use of expensive industrial materials:

> Works made with precarious material provoke questioning in artistic circles of that system in connection with its present aesthetic reality. . . . Therefore, because of my belief that expensive materials are being imposed by the aesthetic thought of an elite that thinks from top to bottom, I present the challenge of my momentary situations made out of perishable materials as a concept-from-bottom-to-top.[18]

Consequently, in 1969, Barrio filled a room of the Museum of Modern Art in Rio de Janeiro with packages of "garbage," which were further manipulated by the public. After a month, the piece, *situação..ORHHH.OU..5.000.T.E..EM.N.Y...CITY* (*Situation..ORHHH.OU..5.000.T.E..EM.N.Y...CITY*), was moved out and placed on pedestals in the garden and on the street, defining the "external phase."[19]

Figure 17.7. Artur Barrio, *Situação..ORHHH.OU..5.000.T.E..EM.N.Y...CITY...* (*Situation ..ORHHH.OU..5.000.T.E..EM.N.Y...CITY*), 1969. Photo César Carneiro, courtesy of Artur Barrio.

Figure 17.8. (top left) Artur Barrio, *Situação..ORHHH. OU..5.000.T.E..EM. N.Y...CITY...*, (*Situation..ORHHH.OU ..5.000.T.E..EM.N.Y ...CITY*), 1969. Photo César Carneiro, courtesy of Artur Barrio.

Figure 17.9. (top right) Artur Barrio, *Situação T/T, 1.. (2. Parte),* 1970. Photo César Carneiro, courtesy of Artur Barrio.

Figure 17.10. Artur Barrio, *DELF..SITU-ACAO.+S+.RUAS...* , 1970. Photo César Carneiro, courtesy of Artur Barrio.

 A year later, and as an extension of this piece, he prepared five hundred plastic bags with different bodily excretions and placed them systematically throughout Rio de Janeiro and Belo Horizonte. The presence of the artist was reflected in the modest "order" thereby introduced into the disorder of arbitrary violence instituted by the Brazilian dictatorship. Interestingly enough, the piece was not to be read as a pointed denunciation of any particular event or policy. It was a rather vague morbid statement fitting the times.[20] With these works, Barrio was echoing but not following the political action format that preceded him in the 1960s.

Resistance in Barrio's work stopped being identifiable as a political act and instead became an un-self-conscious way of seeing. He described his work this way:

What I try [for] is a contact with reality in its totality, with all that is denied, everything left aside for its contesting character; a protest that holds a radical reality, a reality that exists in spite of being disguised by symbols. In my work things are not denoted (represented), but indeed lived; it is important [that] there be an immersion.[21]

By 1972, he had returned to installations and drawings that used a high degree of expressive power and violence but functioned within traditional art circuits.

Antonio Dias

Unlike Meireles, Manuel, or Barrio, another Brazilian artist, Antonio Dias (1944–), never departed from the traditional art format. Instead, he used it as a launching pad and packaging form for political statements. Dias produced primarily paintings, but he also did installations that became bigger and more ambitious political vessels. One of these installations (*Do It Yourself: Freedom Territory*, 1968) reorganized the gallery floor with the placement of coordinate marks that in turn served as a grid for the placement of rocks. The rocks were of good size, but never exceeded the grasp of the hand and the ability to be thrown. Each of them was tagged with a label inscribed with "To the Police."

Figure 17.11. Antonio Dias, *To the Police,* 1968. Courtesy of Antonio Dias.

His *Unfinished Monument* (1969), a more typical example of his work of the time, is basically a group of paintings and has the title above a grid formed by twenty-four squares, twenty-three of which are labeled "Hungry," with the last one remaining empty. Dias is probably the Latin American artist who most successfully explored the ambiguities of political and artistic meanings while never deviating from a closed artistic format.

Dias may also have been the most internationalist artist among his Brazilian peers. He had gone to Paris in 1967 and settled in Italy in 1968, where he was in close contact with many of the Arte Povera artists. Recognizing the growing im-

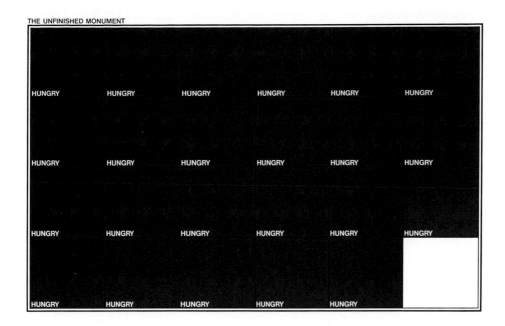

THE UNFINISHED MONUMENT

Figure 17.12.
(top) Antonio
Dias, *The Unfin-
ished Monument,*
1969. Courtesy of
Antonio Dias.

Figure 17.12a.
Antonio Dias, *The
Occupied Coun-
try,* 1971, acrylic
on canvas, 130
× 195 cm. Photo
Vicento de Mello.
Collection Daros–
Latin America,
Zurich.

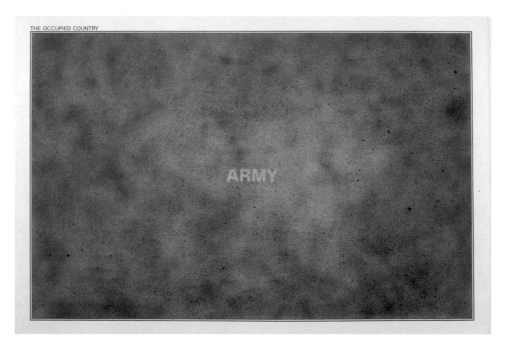

THE OCCUPIED COUNTRY

portance of English in the art market, he soon chose this language as his primary tool, an important decision, since his work was a consequence of Brazilian concrete poetry. Maintaining the minimalist look of mainstream conceptual art, Dias effectively subverted it with the inclusion of political topics and quotes. In 1971, he undertook a major series with the title *The Illustration of Art,* working first with short films, then with paintings that followed his grid structure. The

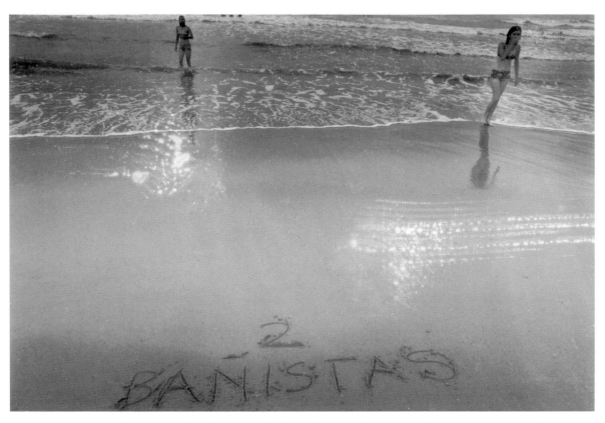

Figure 17.14. Claudio Perna, *2 bañistas* (*2 Bathers*), ca. 1974, silver print, 8 × 10 cm. Courtesy of Fundación Claudio Perna, Caracas, Venezuela.

Concepts. Here Perna proposes a reversal of terms in which the still life becomes a tool for thinking rather than seeing. He elaborated on this strategy later when he wrote that "images, as tributaries of the social sciences, become art and, beyond art, broaden the discourse of man."[27] Perna was probably the only Latin American conceptualist directly indebted to Simón Rodríguez. He credited both him and Marshall McLuhan as his big influences.[28]

Starting in the 1970s, Conceptualism in Venezuela became a more recognizable pattern as other artists came to the fore. *Acciones frente a la plaza* (*Actions in Front of the Square*),[29] a cycle of happenings/performances organized in Caracas in 1981, provided a more cohesive picture of the artists working in this conceptualist vein. The participants included Alfred Wenemoser, Yeni and Nan, Carlos Zerpa, Diego Barboza, Marco Antonio Ettedgi (credited with the idea of the project), Antonieta Sosa, and Pedro Terán. Possibly because these actions were closer to theater than to traditional gallery art, other conceptualist artists like Héctor Fuenmayor, Roberto Obregón, Eugenio Espinoza, and Sigfredo Chacón were not

included. One addition to the show not registered in the program was a perform-
ance by Teowald D'Arago. He dressed like a blind beggar and, sitting in front of
the cathedral with a sign around his neck saying "Alms for art," asked for money,
cruelly but pointedly punning on Arte Povera.

Marcos Kurtycz

Marcos Kurtycz (1934–1996), a Polish artist who settled in Mexico in 1968 (he be-
came a Mexican citizen in 1980), drew on both his European and Mexican expe-
riences to produce performances and artists' books that paralleled activities of
Los Grupos. Among his activities was the appropriation of the street as an art en-
vironment that he called *Museo de Arte Directo (MAD)* (*Museum of Direct Art*). The
acronym MAD, in Spanish, was a direct reference to the well-known U.S. maga-
zine by that name.[30] His actions were systematically directed at attacking what
he saw as stuffiness in the Mexican art scene. In 1976, he made his first *Artefacto*:
"The artifact is the opposite pole of commercial art (and the possibility for its

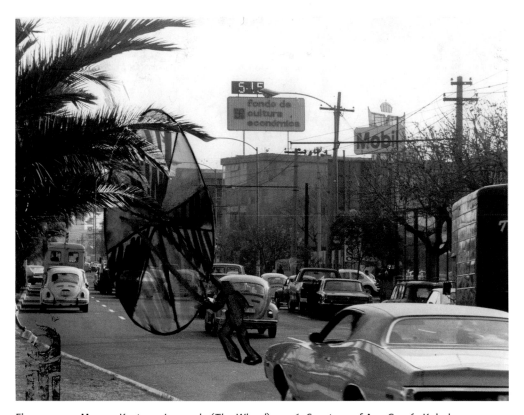

Figure 17.15. Marcos Kurtycz, *La rueda* (*The Wheel*), 1976. Courtesy of Ana García Kobeh.

Figure 17.16. (top) Marcos Kurtycz, *La rueda* (*The Wheel*), 1976. Courtesy of Ana García Kobeh.

Figure 17.17. Marcos Kurtycz, *La rueda* (*The Wheel*), 1976. Courtesy of Ana García Kobeh.

eventual destruction) . . . The artifact cannot be repeated; this would be treason, as the development of the artifact-event cannot be predetermined!"[31] It is not clear how much Kurtycz was aware of Parra's thoughts on his own *Artefactos*, but both artists seem to address the same concerns.

In 1979, Kurtycz climbed up the flagpole of the National Auditorium in Mexico City to hoist a flag for his own *Movimiento de insurrección contra las normas de*

las artes plásticas (*Insurrectional Movement against the Norms of Plastic Arts*).[32] Kurtycz seems to have been another charismatic character in the tradition of Greco, Carreira, and Brandt, wherein personality was as powerful a catalyst for other artists as the actual work he/they did. Kurtycz's energy seems to have radiated mostly from his performances.

Bernardo Salcedo

Bernardo Salcedo (1939–) was born in Bogotá, Colombia. After a period of constructing assemblages with doll parts, his work expanded in 1969 (though he never completely abandoned his assemblages) into conceptualist pieces. In many of these, he maintained the well-crafted quality of his previous works, but kept a focus on signification. Either the objects would have their own meaning

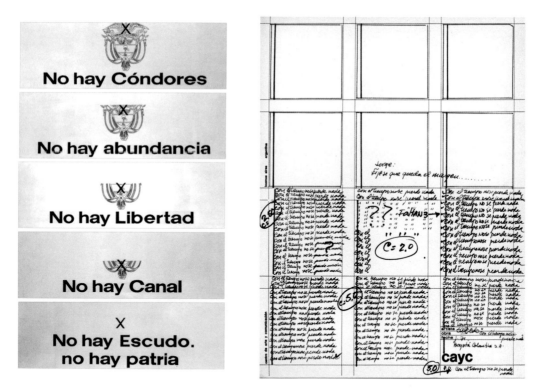

Figure 17.18. (top left) Bernardo Salcedo, *Primera lección (Desaparición del escudo)* (*First Lesson [The Disappearance of the Coat of Arms]*), 1970, billboards, 450 × 270 cm. Courtesy of Bernardo Salcedo.

Figure 17.19. Bernardo Salcedo, *Plana, Con el tiempo no se pierde nada* (*Page, With Time Nothing Is Lost*), 1971, Arte de Sistemas exhibition, CAYC/Museo de Arte Moderno, Buenos Aires. Courtesy of Bernardo Salcedo.

or he would use appropriate titles. *Una hectárea de heno* (*One Hectare of Hay,* 1970) consisted of five hundred numbered plastic bags containing hay harvested from a field. That same year, he deconstructed the meanings of the national coat of arms. The texts he used applied to the elements that supposedly defined Colombia's self-image, whose existence he systematically negates: "No hay Cóndores," "No hay abundancia," "No hay Libertad," "No hay Canal," "No hay Escudo. no hay patria" (There are no Condors, There is no abundance, There is no Freedom, There is no Canal, There is no Coat of Arms. there is no fatherland).

His work is mostly sardonic, as in his billboards announcing "One cabbage (none left)," and "Two oranges (alone) " (1972). Between 1969 and 1970, Salcedo made a series of grade-school-like sheets of repeated sentences and calculations. The calculations were nonfunctional and geared to produce formally interesting sheets (with the meaning abolished) or to underline futility (by carefully checking off entries on cash register receipts and then signing them as art). During the mid-1970s, Salcedo returned to more conventional object-oriented art, keeping some of the dadaist spirit of his first works and combining it with nostalgia. An in-between, very lyrical work is a notebook about the sea and the sky, in which he uses watercolor to make subtle blue marks again and again on lined paper, in the mode of his grade-school listings.[33]

As María Iovino remarks, Salcedo's work is best understood in the context of the Colombian literary movement *nadaísmo* (nothingism).[34] *Nadaísmo,* founded by poet Gonzalo Arango (1944–1976) in 1958, was "against any reason, a revolutionary poetry, even against the reason of beauty . . . And if after a nuclear war there is nothing left to believe in, we'll believe in the Cape of Good Hope."[35] The movement had influence not only in Colombia, but also in other Latin American countries, particularly in Venezuela with the previously mentioned group El Techo de la Ballena.

18 *The Destruction and Survival of Locality*

When we discuss art, it is usually in the context of high culture. However, profound differences exist between different high cultures. Jean Franco points out that, unlike the mainstream, the names of Latin American movements reflect social attitudes. Thus there is "modernism," "New Worldism," "indigenism," and so on. Meanwhile, European aesthetic movements in the twentieth century tended to refer to technical and formal matters. Therefore there was "cubism," "impressionism," and "symbolism," and European movements fed into one another, whereas the Latin American ones didn't, at least not to the same extent. Latin American movements arose from confronting external factors and can be described as a series of fresh starts.[1] There was always a closer reaction to the present than to an artistic tradition. This "presentist" attitude explains the rather quick receptiveness to the latest fashions. The newest imported art movements become relevant, not because of the historical importance they may hold in the mainstream, but because they are a symbol of the present. Describing this psychology, Argentinean artist Rubén Santantonín (1919–1969) wrote in his diary:

> Only the present nourishes [culture]. I want to immerse myself to the
> point of frenzy in that existential totality that I forebode as the present. I
> want to feel that I existed with my time. NOT ANOTHER [time]. I want to
> bleed existence.[2]

Santantonín was known for calling his works "things" in his effort to find non-denomination, and also for burning a sizable amount of his production shortly before his death.

Clearly, the more the pressure of the mainstream prevails with its own sense of time, the more awkwardness will take over anything that is a separate identity. By importing this sense of time into a different culture, accountability is shifted from the building of one's own history to another history that has already been built by somebody else. The irony is that the biggest pressure is coming from a culture that also lives in the present. When Europe was the great coloniz-

Since art in a capitalist society consists of the production of consumable objects and ideas, it helps both to create culture and to make a market. In areas that lack money, there is always a small segment of society that sponsors art with this function and within this ideology. It is this same segment of society that assumes the representation of the whole and gets a disproportionate recognition in the mainstream. In spite of this, in a situation where the market is minimal and has no true impact on the survival of the artist, the primary, if modest, effect of the artistic production is on the community surrounding the artist.

The impetus for the artist to continue working under these conditions therefore has to be something other than making money. The universal need for ego trips could be one good reason. Wanting to communicate with someone could be another one. However, a more interesting motivation here would be the philanthropic or missionary wish to somehow help improve the world. But it doesn't matter which of the three one picks, since all of them lead the work, when reasonably effective, to have some regional cultural importance. And this can happen even in the absence of mainstream recognition.

The picture is different in the richer areas of the world. An active market will promote the commercial aspect and transform art into sellable things. It is a process that can only truly and fully be understood within the same international context that operates with currency values. When the marketing is successful, the same as with hard currency, the merchandise is absorbed into the international market with the impression of being an international standard.

Formalist innovation and a multiplication of styles are ways of refreshing the offering of wares in the modern market. In the postmodern market, this energizing is done in a different way. The offer of luxury art commodities is increased by mixing styles and by adjusting the definition of high art to also include some vernacular and low-art forms of expression. It is equivalent to the abolition of trade barriers when organizing regional market zones like NAFTA and Mercosur. This so-called opening of the mainstream is often self-servingly explained on the periphery as happening because of a diminution in the creative capacity of the mainstream. This view may help artists on the periphery feel good; it is a nice comeback. But more likely, what we are seeing is no more than a realignment of the market.

Regardless of where one places Latin American conceptualism, the movement was a part of that same uncompleted modernist agenda mentioned earlier. It was driven by a need to communicate and to improve the world following some local interpretation of it. Utopia continued to be a goal, and artists resisted the obstacles that stood in the way of that utopia. The most moderate manifestation of

this was the effort to get rid of the stumbling block posed by the commercial object that, for one reason or another, art always seemed destined to become. Thus the thought was about how to make art that bypassed the limited state of commodity. Part of the strategy of resistance developed against local political and socioeconomic conditions also became one against the unqualified absorption of imported postmodernism.

As an opposing dynamic to this, a feeling was promoted that everybody has the possibility of gaining access to the mainstream, whereas in fact it remains denied. While the goal of the modernist utopia was to become a better society, the goal of the postmodern utopia seems reduced to achieving access to the mainstream. In spite of this mystification about access, the distance between cultures continues to exist and remains important. The cultural differences, determined by how one relates to and experiences reality, are continually increasing. Some do not have technological access and thus maintain a direct contact with reality. Others operate, as Jameson points out, in a reality that is increasingly composed of substitutes, one in which "culture" becomes a "second nature."[7]

19 *From Politics to Identity*

Even though many of the Latin American art projects of the late 1970s had a clearly political character, they lacked the general political context of the previous decade. In Mexico, nothing much was happening to help the artists. The Zapatista movement started a decade and a half later, after art had returned to business as usual. Chile lived under terror, and activists had either been killed or jailed or had gone into exile. In Peru, the Left was totally splintered, ineffectual, and eventually discredited by the excesses of Shining Path that started in the 1980s. In other countries, too, the impulse toward political activism was weakened by repression, sectarian dissension, and discouragement. Art was left to its own devices; it had to remain art and couldn't sustain militancy. For different reasons in each place, a quieting of expression took over, even in the hegemonic centers. In 1975, Michael Corris and Andrew Menard, writing about the United States, pointed out that

> the contradiction of recent American art, which defined itself in (distinct) opposition to bourgeois society, is that the decisions which seemed most viable "artistically" were precisely those which best reflected the structure of bourgeois society.[1]

Joseph Beuys's entry into politics exemplified this contradictory development in European art. In a statement for Fluxus in 1967, Beuys had proclaimed a radical directive: "to dismantle in order to build *a social organism as a work of art*" (emphasis in original). With this statement, he also announced the birth of the Fifth International. However, in the Documenta exhibition in Kassel in 1972 (the same year the situationists decided to cease activities), Beuys proposed a new government model based on his own concept of liberal democracy. He had the organizational diagram printed on shopping bags and signed them for a nominal fee. In an interview conducted by Heiner Stachelhaus in 1973, Beuys was still interested in restating some of his 1967 ideas:

> There is no other possibility to have a revolution than through art. One

has to arrive at a totally new concept of man, and also of what a government should look like. I understand the future man as a sculptor of the whole social organism of the state.[2]

Beuys proceeded to run for election in Germany as a candidate for the Green Party. There was nothing wrong with this action as far as pure politics go, but it did contradict his 1967 views about the holistic activities implicit in his views about art.

Some years later (1975), *The Fox*, a magazine published in New York by Kosuth and members of the British/Australian Art & Language group, issued a call for volunteers to enlist in politicized art:

> If you are concerned with trying to reclaim art as an instrument of social and cultural transformation, in exposing the domination of the culture/administrative apparatus as well as art which indolently reflects that apparatus, you are urged to participate in this journal. Its editorial thrust is ideological; it aims at a contribution to the wider movement of social criticism/transformation. (Our contribution will be on the art front but by no means limited to the fixed context closure of art.) We need a broad social base in positive opposition to the ideological content and social relations reproduced by official culture.[3]

This announcement was somewhat clearer and more pointed than the call made in the first issue earlier that year:

> It is the purpose of our journal to try to establish some kind of community practice. Those who are interested, curious, or have something to add (be it pro or con) to the editorial thrust . . . the reevaluation of ideology . . . of this first issue, are encouraged, even urged, to contribute to following issues.

The recruitment efforts of *The Fox* received little in the way of response, and its editorial team quickly broke up over issues that had to do with the art stardom of some of the members and the misuse of the magazine for its promotion. A general feeling of resignation grew with the dawning realization that art is elitist after all. Galleries and museums looked as though they would remain the showcases for the foreseeable future. Political activity in art, if it were to have any usefulness, would have to be targeted to the small fraction of society that had traditionally had contact with art. Twenty years later, artist Ronald Jones made a good analysis of this situation in the United States in the 1990s:

Within our current political and cultural environment, the expectation
of sudden or revolutionary reform is unrealistic. Presently, when art
threatens to inspire a fundamental realignment of the culture, it is ex-
cused from view.... To my mind the most useful model for political art at
the moment is terrorism. I'm not advocating violence, but insidiousness.
... Terrorism has become an alternative for the disempowered. Artists are
among the disempowered.... Traditional styles of political art are the ex-
pressions of a belief in creating change at the grassroots level. That is
naive and effete. I believe that a contemporary political reform is in the
hands of a class Lyotard has described as "decision makers." They are my
audience.[4]

The "postconceptualist" stance, if such a term is appropriate for Latin Amer-
ica, is fairly well captured in Jones's critique and prescription. What is not clear
is whether this redefinition of artistic ambitions was occurring due to a dimin-
ishing of conviction or because of isolation and survival issues.

The real softening, at least initially, was a blurring of the art/life division.
Many artists explained their new work as reflecting only a change of strategy and
no more than that. One of the leaders of Tucumán Arde, Juan Pablo Renzi, later
stated:

I believe that if art is critical of life, it does so through art, not through
life. It is a matter of making works of art that refer to life through artistic
gestures, and that they refer to that critical connection with life through
an aesthetic connection.[5]

The separation of art from life was returning, explained and justified by the no-
tion that by focusing on art as traditionally expressed, the artist would be able to
deal with political issues on a firmer foundation. More than anything else, it was
believed that the "interdisciplinary approach" was no longer viable. Art refo-
cused on itself as a discipline and tried to address issues of identity. The defini-
tion of identity served as an assertion of national or ethnic independence and
was therefore politically viable. It also pandered to the nationalist sentiments of
ruling dictatorships, so it wasn't confrontational. Snidely, one could add that
since crafts are a good way of representing identity, to extend the equation into
the arts was an obvious move.

Paradoxically, it was the earlier political immersion and blurring of disciplines
promoted by the more politicized artists that had brought about a period in Latin
American art with a genuine identity. Art that had been produced in response to

specific local conditions seemed able to capture much deeper identifying issues than art that described locality. The pressures of the art market were either of secondary importance or plainly irrelevant. As a result, the work reflected a Latin American identity, even though the artists were not directly concerned with this issue and were paying attention to other issues of art and politics. The potential "Otherness" of Latin America was, if present at all, of secondary concern.

Once the separation of art and life reemerged in practice, crafts seemed to symbolize contemporary needs. A different kind of local reality that was much more anecdotal and superficial took hold. Coincidentally, this also satisfied the external demand for folkloric looks that fit the new trend of hegemonic multiculturalism. Thus, something like Latin American conceptualism, which looked more global but was really more local, ended being, if not lost, at least eroded. And something that looked local but was truly the product of neoliberal globalization took its place. The new art became what we could call *neolocal art*. Art returned to the use of the material object as a vessel, and mainstream art in particular slowly turned to postmodern concerns: neoprimitivism, neo-expressionism, multiculturalism, and low and high culture.

Latin American art, somewhat reflecting the pressure of the flow of information, abandoned the true identity it had accidentally found through conceptualist strategies, and turned instead to an active search for *the identity*. The search shaped programs and definitions and became altogether a separate ideology. Caught in the middle of these new dilemmas, some artists—genuinely and, to some extent, unwittingly—tried to merge politics into the search.

The new Latin American cinema was influential in this development, both visually and theoretically. Argentinean filmmakers Fernando Solanas and Octavio Gettino, authors of *La hora de los hornos* (*The Hour of the Furnaces*, 1968), based on the experience of producing this movie, wrote the essay-manifesto "Hacia un tercer cine" (Toward a Third Cinema).[6] Although the ideas it contained reflected the needs of the whole Third World, the term "Third Cinema" was mostly applied to Latin American filmmaking of the 1960s and 1970s. "Third Cinema" intended to create a genuine Third World film industry while it addressed local issues and searched for its own aesthetics. That same year, Cuban filmmaker Julio García Espinosa wrote an essay titled "Por un cine imperfecto" (For an Imperfect Cinema). The essay starts with the statement that "nowadays, perfect cinema—technically and artistically masterful—is almost always reactionary cinema" (28). García Espinosa, who cofounded the Instituto Cubano de Arte e Industria Cinematográfica (ICAIC; Cuban Filmmaking Institute) in 1959, was interested in the possibility of a new aesthetic derived from the "imperfections" dictated by

Figure 19.1.
Antonio Caro,
Quintín Lame,
1979, silkscreen,
70 × 50 cm. Cour-
tesy of Antonio
Caro.

that by far exceeded any possible need for identification. Lame seemed to express an epiphany of alternative power with it; it seemed like an act of self-assertion in defiance of any form of identification used by the government powers. Caro internalized this signature and repeated it as a quasi ornament using local pigments. The series of works is, however, completely meaningful and comprehensible only within Colombian borders.

Caro created a public-specific oeuvre with a clear preset idea of who the viewer was that deviated from the traditional idea embedded in the word "public." "Public" usually refers to anybody who is not the artist and who may enter into contact with the work of art. In Caro's case, the "public" clearly became peo-

ple steeped in Colombian traditions and with some knowledge of the plight of the Amerindians. Anybody outside of this group would not be interested in the work and was thus willfully excluded and sacrificed by the artist.

Brazilian artists Roberto Evangelista (1946–) and Juraci Dórea (1944–) later worked in a manner somewhat related to Caro's. Evangelista lives in Manaus, in the Amazonian area, and his subject and preoccupation is the increasing destruction of the local ecological systems. He looks into indigenous rituals and works with the local population to raise awareness about the disaster in progress. His subject, however, goes beyond the balance of nature and extends into culture. He wants to help local communities sustain the vital link between their art and life, a very different art/life equation than the one sought by the earlier conceptualists. Evangelista is keenly aware of the impact of *us* watching *them*, an action that transforms *them* into a self-aware spectacle, leading to an affected folklore that only satisfies tourism. His installations, though they may have some evocations for the outsider, lose some of their power once they leave his community. Aware of the character of his work, Evangelista consistently plays down the artistic relevance of his installations. He describes his own work as using "the Amazonic materiality in relation to the cosmology of myths." [12] Even when Evangelista works on elements seemingly belonging to urban culture, like the worn-out sneakers in *Ritos de passagem* (*Rites of Passage*, 1996), the allusion is to the rubber industry of Manaus and to the sidewalk as a place of collective ritual. [13]

Dórea, who works in the hinterland of Bahia, the *sertão*, shows similar concerns. His *Projeto Terra* (*Project Earth*, 1980s) is concerned with the reempowerment of local populations in what Federico Morais calls a "reversal of public art," in the sense that public art is usually an urban phenomenon. [14] Dórea builds twenty-foot-high monuments; at first look, these are primitive constructions that look like tents made with hide and branches. With a limited material life, they become ephemeral spaces for the people where an unknown art experience encounters local traditions. Carefully photographed and described, it is the quasi-anthropological documentation that reaches the traditional art audience.

The twofold readings of Caro's, Dórea's, and Evangelista's works—canonic and peripheral—create confusion between art as commodity and art as a cultural agent. Removed from their original context and audience, the pieces can easily fit into a new collection of anthropological artifacts and be subject to interpretations that actually say more about the viewers than about the true cultural impact of the art.

Much of the politicized art of the 1960s was primarily addressed to an audience presumed to be politically sympathetic. The art production wasn't made for

a group of potential buyers, nor to convert viewers, nor to address some future audience in posterity. The artist was communicating a vision to a public presumed to have the power to demand and set standards of accountability. With the return to tangible and therefore tradable art objects, this kind of accountability got lost. Caro and Evangelista were mentioned here at some length because they seem to have succeeded in keeping the accountability process going in spite of the return to the object that took place during the seventies. During the late nineties, Caro became less interested in his personal work and, echoing Evangelista, traveled to small villages in Colombia, where he organized groups to channel their creativity into graphic projects.

Aside from these and a few other exceptions, one can say that after 1980, art making in Latin America reverted more and more to individualist activities. Artists were often torn between the market and their own principles. The market pays for making what art consumers demand and what the artist needs to live. This leaves two options. Either the artist's role is defined as satisfying the market's demand, for which there is payment, or the artist works to satisfy an internal demand (or dream), for which payment is uncertain or unlikely. During the more ideological phases of art making, artists embraced the latter, seeing their activities to be in the service of a utopian vision of society.

This drive to be recognized independent from market success was especially strong on the periphery. It was a relatively easy position to take, since there was no market of any consequence. Once it became apparent that this kind of recognition wasn't viable anymore, art was recommodified. In time, some form of a market actually did appear and, in a muted way, echoed the mainstream. Still, and in spite of this, many of the artists tried to keep as much political charge in their work as possible. In some cases, the tension led to works expressing sardonic despair. Colombian artist Bernardo Salcedo (1939–) did a piece in 1970 in which he filled grade-school pages with the endlessly repeated sentence "El tiempo es oro" (Time is money). A year later, U.S. conceptual artist John Baldessari (1931–) made a similar piece with an equally illuminating text for the times: "I will not make any more boring art," which he arranged to have executed by college students.[15]

20 *Diaspora*

In his text for the exhibition l'art conceptuel, une perspective, Benjamin Buchloh wrote:

> The proposal inherent in Conceptual Art was to replace the object of spatial and perceptual experience by linguistic definition alone (the work as analytic proposition) and thus constituted the most consequential assault on that object's visuality, its commodity status, and its distribution form.[1]

The text impeccably describes conceptual art at the time, but it also describes the gap that existed between the positions of the artists in the mainstream and those on the periphery. The description certainly captures the rupture and upheaval conceptual art achieved within the discrete field of art. It also alludes to how, centered in that field, some changes might have rippled into the distribution system and therefore into the lives of some nonartist citizens. Coming from the periphery to the center, where all this was about to happen, this description synthesizes the reasons for culture shock. There was a rarified, specialized, self-centered, and compartmentalized atmosphere that on the one hand promised an ideal level of professionalism for the artist, but on the other presented a picture of alienation difficult to cope with. Except for a "change in the distribution system," the idea of art as a potential shaper of society was totally absent. For the Latin American conceptualist at the time, minimalism became the symbol of this sharp divide. For those staying and living in exile, minimalism became an odd and unusual link between a form of art and the form of living we were used to. For those artists living in the diaspora in the centers, the artistic task seemed to be to react against minimalism.

Partly for ideological reasons, and partly because of the absence of a supporting market, émigrés were not used to thinking of art as an isolated discipline, and in many cases, they were not interested in an ivory-tower model of culture to begin with. They came to the cultural centers in a process that at the time was called "brain drain." The concept of travel then was a very clear one. Traveling meant physically leaving one cultural complex to enter another one. The impli-

cations of that traversed distance were much broader than those presumed for a purely geographic trajectory measured on a map. It was that cultural change that defined "brain drain." Today, thanks to the Internet, an *infography* has taken the place of traditional geography, and one can get brain capacities without the actual brain. At the time, however, the issues were more physical. The brain was an object, concrete and portable, and it made a difference where it was located and where it functioned.

Brain drain was a complex issue. People certainly accepted grants willingly and wanted to take the accompanying trips. Incentives for these included the escape from repression, the prestige attached to fellowships, curiosity, technical development, and the promise of economic improvement. One could also describe it as an issue of supply and demand. Countries on the periphery couldn't supply what the artist needed or demanded. And what the artist was able to supply was (supposedly) demanded by the cultural centers.

Until the midfifties, the cultural center was located in Europe—Paris in particular for art—but then it slowly shifted to the United States. It is estimated that from 1945 to 1965 alone, at least 17,000 researchers and high-level technicians emigrated from Latin America to the United States. During 1986, 25 percent of Ph.D.'s awarded in the sciences went to non-U.S. citizens, and, according to a report published by the National Research Council in January 1988, for engineering Ph.D.'s the figure reached 60 percent. In addition, 60 percent of this figure did not return to their countries of origin. Of the 500,000 people who left Puerto Rico during the period 1980–1985, 14 percent were professionals. Unfortunately, there are no figures specific to this brain drain in art. Enormous amounts of money invested in the education of highly qualified personnel in Latin America, where education was mostly free (that is, paid by the governments), have thus ended up, in effect, being donated to the United States.[2]

In my time, the total cost of college training for an artist in the United States was around $20,000. The grant I received to come to the United States was $4,000. One could say that, right from the start, the United States earned $16,000 with my relocation, not counting a lifetime of paying taxes. To be fair, this wasn't the effect of a Machiavellian ruse. Foundations were aware of what could happen, and they required a commitment to return to the country of origin after the grant was completed. In a no-win situation, foundations then opened themselves to the interpretation that they were sponsoring the use of locals for cultural infiltration, following the well-known model provided by the training of Latin American army officials. However, given Latin American political shifts and the economic deterioration during the 1960s and 1970s, it was somewhat pre-

dictable that many émigrés would try not to return permanently to their countries.

From a hegemonic perspective, most of the artists living in Latin America could be seen as "Sunday painters," that is, people who had two jobs during the week for survival and who used the little time left to produce art. Grants would help remedy that situation, at least temporarily.

The notion of a "Sunday painter" is very interesting inasmuch as it is symptomatic of an ideology that can be described like this: The artist is a producer of merchandise, and if he/she doesn't invest a majority of time in that activity, the category of "professional" doesn't apply to him or her. A partial use of time reduces the artist to an amateur and the activity to a hobby.[3]

The artists' migration of brains is based on this ideology. After an education that hones professional goals, the normal expectation is that upon graduation one will be able to support a family with the income of the acquired profession. A failure in that enterprise, as is the case with unemployed labor in any other field, generates the wish to emigrate. However, in art, once the artists emigrate, the situation does not necessarily improve. A majority of the artists native to the hegemonic center lack that same security as well. The difference in this shared misery is that the artists from the center don't dream of emigration as a solution to their problems. Unlike the case on the periphery, their envy is not directed at another country. With a much narrower gaze, envy is directed toward the lucky artists represented by the gallery on the neighboring block.

In most cases, relocation of the artist from the periphery to the center did not imply a reneging of original values and culture. On the contrary, many émigrés continued to live and operate within the same cultural framework in which they had been formed. In fact, one could say that the idea of one unified Latin America (as opposed to a conglomeration of countries) was closer to reality in exile than in the continent itself. In relation to their new colleagues, many émigrés saw it as their mission to try to cosmopolitanize them and to raise their level of political awareness and national self-criticism in a process that might lead to an easement of imperialist influence.[4] In that sense, the uprooted artists were not only a Latin American cultural continuation but also an outpost in the center. Beyond that, even those artists who chose to adopt foreign residence maintained their links with their countries of origin and exhibited in Latin America whenever possible.[5] Latin America has become, in the words of María Clara Bernal, a "non-spatial place (a place that gets consolidated under ideas like community instead of geographical space)."[6] And in a further comment about Latin American art, she notes: "The place that this art refers to is that of a 'diasporic person,'" and

"the geographical place is only a temporary arrangement in the process of evaporation."[7]

Therefore, when focusing on Latin American conceptualism, it cannot be discussed without including the artists in the diaspora. I have to concede here that the emphasis on this subject may be a product of self-centeredness. However, at the time, I felt, as did many others, that no matter how attached we stayed to our memories, we were immersed in a different set of conditions that were affecting us in deeper ways than we may have chosen or liked. In certain ways, the diaspora constituted us into one extra community (since it wasn't one more nation) of the continent and helped shape not only our visual strategies but also those of our original cultures.

While deeply linked and committed to the continent, the diasporic artists had very different things to cope with compared to those artists who continued working in their countries. At least in the United States (the part of the diaspora I will focus on the most), the push and pull of the forces of discrimination and assimilation, the fight for immigration papers, and the fear of deportation—all experienced while being in generalized disagreement with the politics of the host country—were factors that gave a different character to our actions of resistance.[8] Because of this, our diasporic resistance never reached the level of activism and risk it did for our counterparts in geographic Latin America. Exile was a luxury not afforded by those left behind; torture and jail were vicarious experiences for those in the diaspora, and that made deportation and return even more threatening to them. As a consequence, projects may have been more cautious, but the artists also were spared postactivity depressions like "the silence of *Tucumán arde.*"

Buchloh's quote unwittingly exposes the divide that existed between the diaspora artists and those in the mainstream. In the United States, minimalism was accepted as an important development in art. However, for many Latin American artists—and particularly so for those of us living in New York—conceptualism became a tool for cultural resistance and a response against minimalist art. The reaction to North American minimalism was not a symptom of art-stylistic wars, but one of symbolic meanings. This is an important point, since, stylistically, for many of us minimalism did seep into our work as part of an attempt to hone messages to reach a level where there was no loss of information.

However, symbolically, we still saw minimalism as an expression of corporate power and interests and, therefore, as politically reactionary. The whole style looked to us like objects in search of an economic power in need of an emblem—unless, of course, it already was the result of previous patronage. The design of

corporate logos shared the same aesthetic, and many of the sculptures soon ornamented the entrances of corporate buildings. Minimalism referred to amounts of information (or its absence) but not to size, which seemed extremely open ended. With their exaggerated scale and industrial finish, the works soon became symbols of dehumanization and alienation from the public. Aided by a projection of self-enclosure, the viewer was locked out and minimized. This was art in its most extreme stage of autonomy. It had evolved from decoration to monument, with the corresponding shifts in scale and ideology. It had become the ultimate apolitical statuary.

The aesthetic was not just reserved for abstraction. I would include the work of Ernst Trova as part of the same aesthetic that produced the sculptures of Tony Smith, in spite of the human figure being Trova's central motif. Thirty years later, Trova is seen as a secondary artist, so he may not have made the point as clearly as his abstract colleagues. At the time, however, he actually thought that with his *Falling Man* (1964), he was keeping humanism alive within the new visual form. The tension in his work was strong enough to move an artist like Louise Nevelson to "cool" down her own work. During 1964, I was surviving economically by painting the walls of her house (purple and gold), and she commented about the impact Trova's exhibition had had on her. It was, coincidentally, the year she switched dealers and joined Pace Gallery, the same gallery that represented Trova's work. Once in the new gallery, she abandoned her found-wood ways and started to use Plexiglas and the then fashionable industrial look.

The technological perfection required by minimalism and its investment in production demanded a response. The glass-steel equation, a symbol for modernism in developed countries, had not achieved any deep iconic meaning in art on the periphery and, if anything, only symbolized foreign wealth and imports. It reflected distance from the mainstream more than closeness. When Luis Felipe Noé arrived in New York during the early 1960s, he admired the Brooklyn Bridge and was stricken by the realization that Domingo Faustino Sarmiento (1811–1888), one of Argentina's presidents and forefathers, had walked over and admired that same bridge in the preceding century. Sarmiento is perceived in Argentina as part of a very distant past, and Noé had the feeling of being in a time warp. In the early 1960s, the bridge still felt to us very much like a symbol of the late twentieth century and not as a remnant of the nineteenth century, since it implied a level of industrial engineering typical of wealth that on some internalized level we understood as "modern." This out-of-context perception was symptomatic of the difficulties posed by assimilation. As Vilém Flusser points out,

there is a web of redundancy operating in locality, a system of mutual allusions, which remains inaccessible to the newcomer and impedes integration even if one might desire it.[9]

Minimalism, even more so in this decontextualized view, thus impressed us as a caricature of this modernity and increased our distance from it. Our alienation was made worse by its self-declared apolitical attitude—insofar as corporate decoration can be declared apolitical.

During the blurry stage in which minimalism and conceptual art cross-pollinated in the United States, the work became a monument to itself, and some of the "land art," or "earthworks," represented one of the extremes taken in this direction of monument making. Many of the land art pieces were formally and conceptually reductive, but then rematerialized into something often ecologically and sometimes visually intrusive.

The tradition of using land as a medium is, of course, longer, wider, and no less delirious than that provided by the history of land art. As early as the First World War, and motivated by pacifism, German architect Bruno Taut had already proposed reworking the Matterhorn by studding it with glass.[10] In another, but unwanted, war connection, Robert Smithson's *Spiral Jetty* (April 1970) was made in the same month and year that a U.S. army platoon bulldozed its emblem on a one-and-one-half-mile-square area in the Vietnamese forest. The soldiers wanted to leave a memento before they went back home to the United States. It is alarming to realize how the need for this aesthetic play seemed to be in the air at the time. More than the ecological humbleness the artists thought they wanted to make explicit, this may just have reflected a prevailing national arrogance.[11]

By the reaction it produced in Latin America, it can be said that minimalism unwittingly helped intensify and define the need to dissolve the separation of art from politics. From this point of view, on the periphery (and I also count the diaspora and exiled artists here), dematerialization became one way of opposing rather than continuing minimalism.[12] Shifting emphasis away from the art object and elevating the importance of context finally allowed the invasion of other disciplines, and the elaboration, intersection, and confluence of ideas. The power of re-signification gave the artist the ability to force the viewer into decision making, rather than just provoking contemplation. Now the artist could be subversive about the existing order of things.

Once the possibility surfaced of using art as a tool for subversion, perceptions became even more radicalized. Mexican poet Octavio Paz (1914–1998) had once declared: "Aesthetic contemplation is finished, since it dissolves into social life."[13] Early in 1968, Roberto Jacoby summed up the new vision by completing Paz's

statement: "The work of art is finished as well, since life and the planet are starting to take its place."[14]

Dematerialized through conceptualization, the work of art could now circulate as an idea rather than as an object making its way through the cumbersome, regulated circuits of the established art world. More importantly, it could create new situations facilitating the circulation of ideas. This became crucial under the politically repressive conditions suffered in most of Latin America in the 1960s and 1970s and into the 1980s, when virtually every country was ruled by military dictatorship. And, on a more modest level, it became a good tool in the unfriendly environment of exile. Art under these conditions had to deal with hostile laws and adapt to illogical and capricious rules regarding what was permissible.

Once Duchamp opened the way, as in Ramírez's interpretation, it didn't really matter anymore if his readymade signified an aestheticizing of reality or a de-aestheticizing of art. The important factors were the act of re-signification and claiming the power to do so. This relation of re-signification to context is what had the biggest impact in Latin America and, in fact, during 1966 and in following years, some of us who were later absorbed by the conceptualist label preferred the word "contextualist" to describe our activities. We tried to be disruptive in art, and through art we wanted to disrupt inherited perception and reorient consciousness.

The objects of admiration, therefore, were much more diverse than one would expect. Within the art in the mainstream, Paul Thek's 1964–1965 *Technological Reliquarie* series seemed much more impressive than any work by normal minimalists or by postminimalist conceptualists. The insertion of real-looking meat pieces in sterile glass boxes and attached to the glass with medical tubes appeared to be a real aesthetic subversion at the time, one achieved not by a progressive evolution of a style, but by messing it up from within.

Some artists, like the members of GRAV in Paris, shared this position exemplified by Thek and brought it to more general and theoretical levels. They viewed the artistic avant-garde as a nonregional area in which contributions and subversions were performed from within. For some artists outside their countries, the option was to minimize materiality and permanence and to incorporate performance in their work. Diego Barboza (1945–), who had been living in London and returned to his native Caracas in 1974, chose street performances as his medium. In 1970, he had thirty women, covered in nets, walk through the streets of London. *Centipede* was performed the following year in the middle of crowded streets, with people walking within a long piece of fabric constructed by piecing together col-

Figure 20.1. Leandro Katz, *Lunar Typewriter,* 1978, Cibachrome photograph, 30 × 40 in. Courtesy of Leandro Katz.

orful hoods that covered half the body of each participant.[15] Leandro Katz (1938–), an Argentinean poet who arrived in New York around 1968, moved into art and filmmaking during the 1970s. He hybridized poetry with visual art and created both a *Lunar Alphabet* and a *Lunar Typewriter,* an old model with round keys that bore the phases of the moon instead of letters.

After receiving a Guggenheim Fellowship, Oiticica moved to New York (1970–1978), where he continued working on his *Parangolé* series and other projects. Inspired by the disco and drug scene, he also worked on his less satisfactory slide-show environments, the *Quasi-Cinemas* and *Cosmococa* pieces (1973).

Eduardo Costa

Eduardo Costa (1940–) moved to New York in 1968 and quickly connected with the local art scene. He focused on issues of fashion and started to produce a series of *Fashion Fictions* (1966–1969), pieces of jewelry that acted as a second skin

made of gold and were reproduced in *Vogue Magazine*. In the published form, they acquired the real presence he was looking for. The publicity of his pieces became an integral and transcending part of his works, to the point that they are always exhibited as one indivisible work.

In 1969, he participated in *Street Works*, a series of urban projects by several artists. Using the same tourist's critical eye usually applied to cities in underdeveloped countries, Costa addressed Manhattan's decay and neglect. His projects were called *Useful Art* and were executed with the help of his friend Scott Burton. He bought "at his own expense . . . missing metal street signs at the northeast corner of 42nd St. and Madison, 51st St. and Fifth Ave., 45th St. and Fifth Ave." for a total of six. He considered this piece "a literary work with six lines." The second task was to paint the subway station at 42nd St. and Fifth Ave. on the Flushing line. The artworks "were intended to attack the myth of the lack of utility of the arts, while being in themselves a modest contribution to the improvement of city living conditions."[16]

Figure 20.2. Eduardo Costa, *Fashion Fiction 3*, 1979–1982, Mediatic Stage (detail, as seen in *Vogue New York*, September 1982). Photographer, King; model, Shari Belafonte; editor, Jade Hobson; 11 × 18 in., ca. 3 million copies; photograph of the original page, laminated. Copyright © Eduardo Costa Studio, 2005, courtesy of Eduardo Costa.

Juan Downey

Chilean artist Juan Downey (1940–1993) started as a printmaker making etchings of machine projects while he worked in William Hayter's Atelier 17 in Paris (1963–1965). Subsequently, he moved to Washington, D.C., where he made electronic sculptures (1966–1970). After moving to New York in 1969, he shifted to working with video, combining anthropological and ecological documentation that sometimes was melded into installations. Downey was very connected with the video

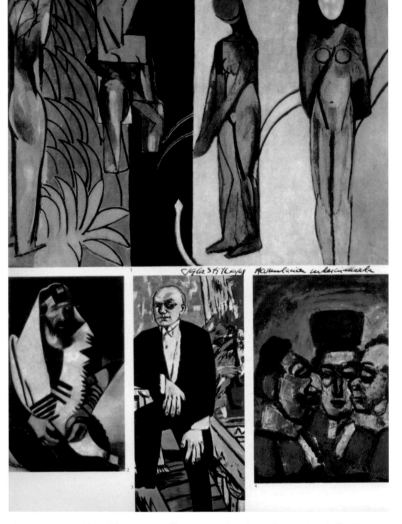

Figure 20.7. José Guillermo Castillo, *Acumulación indiscriminada* (Indiscriminate Accumulation), 1968. Collection of Luis Camnitzer.

"dumb" images (*imágenes boludas*) devoid of any symbolic meaning or aesthetic weight. Dumb, that is, symbolically unloaded objects and images were open to being filled with meaning by the observer. In a way, we had embarked on an impossible search for a nonaesthetic. In 1968, Castillo was cutting out and signing reproductions of the work of other artists from the magazine *ARTnews*. It was a twist on Duchampian readymades that anticipated postmodernist appropriation from a conceptual stance.[21]

Our difficulties in placing our work in galleries led us, in 1967, to start a series of mail exhibitions that were mainly addressed to friends and to anyone we considered interesting in the art scene.

In January of 1969, the NYGW had a major exhibition in the Museo de Bellas Artes in Caracas. The show was very successful, but it raised for us a concern that the museum was a structure that was swallowing our production. This realization forced a revision of our strategies. Castillo came up with the notion of a "super-object," a product that would be able "to function in the daily context without the need of a traditional frame of reference (museum—book) and that would affect that context by its own and absolute presence." We wrote a manifesto on the subject that included this quote and described a future show in the

Figure 20.8. Liliana Porter, *Wrinkle,* Mail Exhibition #2, The New York Graphic Workshop, offset print, 8.5 × 11 in. Collection of Luis Camnitzer.

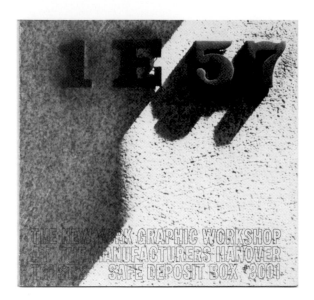

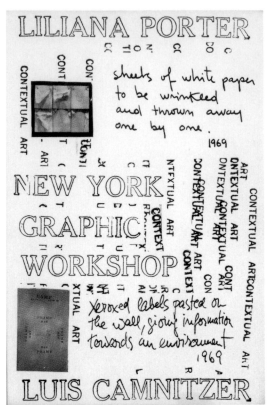

Figure 20.9. The New York Graphic Workshop, *Manufacturers Hanover Trust Bank*. Collection of Luis Camnitzer.

Figure 20.10. The New York Graphic Workshop, Contextual art, card for Lucy Lippard's exhibition 557,087, Seattle, 1969. Collection of Luis Camnitzer.

safe deposit box of a bank; it also announced a name change for the group, which was to be known from then on as the New York FANDSO Super-Object Workshop. The announcement was directed only to ourselves. We never changed the name, and I had totally forgotten about the paper until I accidentally found a copy of it in March of 2005. We did, however, do the bank piece.

While struggling with these matters, we were still eager to "make it" in the art scene. Success in New York was still equated with exhibiting in a gallery on 57th street, and after Argentinean artist Roberto Plate joined our group,[22] we rented a safe deposit box in the Manufacturers Hanover Trust Bank on 57th Street and Fifth Avenue. The space was used to organize our exhibition 1 East 57th. The show opened on May 1, 1969, and was a combination of objects we left in the box and images in a mailing piece—and our dream came true.

While this was happening, we also worried about being absorbed by the term "conceptual art," and in a futile attempt to stop the onslaught, we covered our card for the catalogue of Lucy Lippard's 557,087[23] exhibition in the Seattle Art Museum with the words "contextual art" printed with a rubber stamp.[24]

With hindsight, our work at the time seemed fairly minimalist in appearance,

but at least it was not reductive. We were seeking to achieve a maximal output toward the goal of changing our environment using a minimal input. We still classified our work as "art" and made our decisions directly conditioned by the context in which we were working. By then, we probably were much more indebted to the work of Magritte than to that of Duchamp. Or, it might be said, we

Figure 20.11. José Guillermo Castillo, *Silver Invoice,* 1965, silkscreen, 12 × 12 in. Collection of Luis Camnitzer.

had a Duchampian view of Magritte's potential. Both Magritte and Duchamp pointed to the arbitrariness of nomenclature and thus gave an opening to freedom. Magritte used nomenclature to change both the space and the meanings of an image registered by the viewer. This device seemed more incisive than the actual dematerialization of the art object. It was also a more efficient and elegant method to achieve re-signification than that provided by the use of a readymade.[25]

Keeping costs low was important for us for several reasons. At the time, we all expected to return to our countries and were therefore, even if artificially, working within that more imagined context. We were developing and honing a language appropriate for and reflective of the conditions to which we would return. We were also politically reflecting our commitment to the conditions of underdevelopment and resisting what we were seeing all around us as an aesthetic of wealth. A lesser concern was the desire to break the forms of established art or to extend the experiences of minimalism. By means of a word, a piece of wrinkled paper, a pan of water, we aimed to evoke and comment on context and heighten awareness.

The New York Graphic Workshop stopped activities in 1970, after being included in MoMA's Information show. This was a coincidence; the reason we stopped was a consequence of the politicization of the diasporic artists in New York, who had joined in a boycott against the Center for Inter-American Relations. Porter and I had become active in this larger group. Castillo, although he sympathized with the group, could not join because he was in charge of the literature department of the institution we were boycotting. It was the second boycott against the institution (the first one was to protest the bias of its inaugural exhibition in 1967, organized by art historian Stanton Catlin[26]), and it was the first time that a sizable group of intellectuals in the diaspora were willing to work together on political issues. This broader political group, which then proceeded to publish the book *Contrabienal*, became more important to us than keeping the NYGW going.

Contrabienal

Many of us were concerned that perhaps art was diverting too far from politics. This concern was reflected in the appearance of *Contrabienal*, a onetime publication initiated by a group of Latin American artists living in New York, but that included sixty-one artists from throughout Latin America.[27] The group was initially organized in 1970 to promote a boycott of what was then called the Center for Inter-American Relations (CIAR), and today is known as the Americas

Society, in New York. The CIAR was an inheritor of the old Office for the Coordination of Commercial and Cultural Relations Between the American Republics, created in 1940 and headed by Nelson Rockefeller. Rockefeller's emphasis on culture was because he believed that "intellectual imperialism, the imperialism of ideas, was at the moment just as serious a threat to the security and defense of the hemisphere as the possibility of a military invasion."[28] At the time, the danger was Germany. The CIAR (a private creation of the Rockefeller family) responded to the dangers of the Soviet Union and Cuba instead.

The artists' boycott against the CIAR was in protest over some members of its board of directors, which included several U.S. leaders whom we considered heavily implicated in objectionable policies against Latin America. The artists proposed the removal of Lincoln Gordon, ambassador to Brazil from 1961 to 1966 and involved in the 1964 military coup; Dean Rusk, John F. Kennedy's and Lyndon B. Johnson's secretary of state from 1961 to 1969, who presided over the Alliance for Progress and the expulsion of Cuba from the Organization of American States; David Rockefeller, president of Chase Bank; and George Meany, president of the AFL-CIO from 1955 to 1979, collaborator in U.S. government efforts to undermine independent unions. All these individuals were seen as allies of the dictatorships in Latin America and, in some cases, even as engineers of their installation in power.[29]

The group started as the Museo Latinoamericano, was self-defined as a conceptual institution (today one might say "virtual"), and was never intended to exist in any physical form. In the first meetings, we discussed the ineptness of services for artists the CIAR was providing, but the tone soon changed and became more political and went on to challenge the board and function of the institution. The CIAR had coordinated a series of shows by Latin American artists in top New York galleries. The Museo wrote to the galleries to request an exhibit of historical quotes instead. The quotes (from the Monroe Doctrine, referencing Thomas Jefferson's wish to take over Cuba, etc.) reflected policies of the United States against Latin America. The galleries never answered, but CIAR's project was dropped. In coordination with another group of Latin American artists in Paris (organized by members of GRAV), the Museo sponsored an international repudiation of the 1972 São Paulo Biennial in support of the victims of Brazilian torture.

Not unexpectedly, the many heated political discussions that took place during the Museo's meetings created divisions, and soon a new, more radical splinter group emerged under the name Movement for Latin American Cultural Independence (MICLA). In spite of their discrepancies, the two groups agreed to collaborate to produce *Contrabienal*. The idea was to create an alternative exhibition

place for those artists who boycotted the Biennial as well as for those who had never been invited to participate. Brazil was represented by a special section that documented examples of torture on political prisoners imprisoned by the dictatorship.

The organizers of *Contrabienal* hoped that artists would consider it a greater honor to be part of the publication than to exhibit in the Biennial. Although the fulfillment of this wish cannot be proven, it can be said that the publication was a remarkable success. Many artists collaborated with imagery and statements, among them Mathias Goeritz, José Luis Cuevas, and Rufino Tamayo from Mexico; León Ferrari, Luis Felipe Noé, and Julio LeParc from Argentina; Antonio Frasconi and Clemente Padín from Uruguay; and, beyond those who participated directly, there were 112 artists who signed collective letters of support.

However well intentioned and successful, *Contrabienal* was a project full of limitations and contradictions. It could only bring politics into the art scene and stir up, but not change, the artistic parameters. The group's publication revealed the simultaneous expansion and dilution of Latin America. The diaspora of Latin American artists, evident in all the centers, had a two-sided effect. All these political activities were still within the borders of a Latin American utopia, but the utopia had stretched into something bigger and more cohesive than what was expected from the arbitrary confines determined by Latin American geography. The artists had lost their sense of place, but they maintained their allegiance to their culture.

Although *Contrabienal* clearly took a path outside the gallery system, the concerns were deeply connected with the art systems. Another, anonymous activity, in 1971, went outside the art world under the name of Orders & Co.

Orders & Co.

Orders & Co was a U.S.-based, but Uruguayan-controlled organization. Its activity consisted of sending instructions to Jorge Pacheco Areco, then president of Uruguay. As vice-president, Pacheco Areco had inherited the government when the elected president died prematurely, and he was leading a de facto dictatorship. Orders & Co. described itself as "a private organization without any economic interests in Uruguay." Its only goal was "inverting the relation between chief executives and subjects, breaking the vicious circle of power." The explanatory letter sent to Pacheco Areco in 1971 stated: "We will dispose of certain parts of your time in the future because we consider that an individual with the accumulation of power you have only can be humanized by receiving orders." The

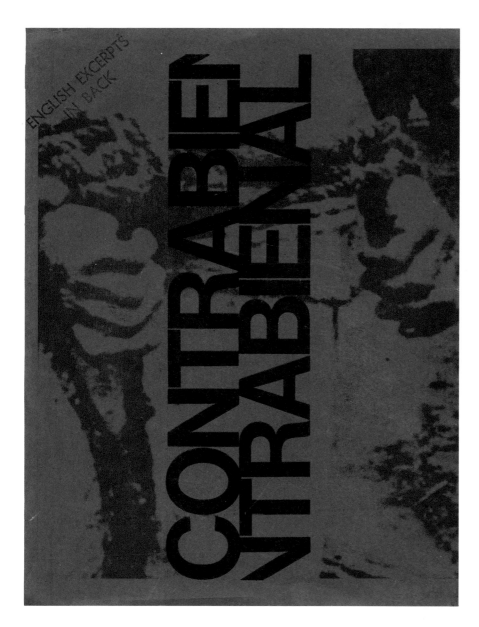

Figure 20.12.
Contrabienal.
Collection of Luis
Camnitzer.

orders appropriated predictable everyday actions so that, in performing these actions, Pacheco Areco would be obeying the company. Pacheco, however, was given the option to disobey the orders. To opt out, he had to publicly announce that he was performing those actions of his own free will and not because of the instructions given by Orders & Co. A copy of the instruction sheet and its rationale was sent to a random list of names taken from Montevideo's telephone directory. Some U.S. addresses were also included, among them apparently that of critic Lucy Lippard, who noted the event in her writings.[30]

On October 5, Pacheco was ordered to make sure his fly was closed before leaving his home. On November 5, while walking, he was to pay particular attention to every third step. On November 26, due to the closeness of Election Day, he was given a free day, at least in regard to any orders issued by Orders & Co. Since Pacheco Areco never publicly defied or acknowledged the correspondence, the operation was considered to have been successful.[31]

In part due to their political bent, all these actions—whether in Latin America or in the diaspora—tended more to underline the cultural gap with the mainstream than to close it. Manfred Schneckenburger, organizer of the 1987 Documenta exhibit, symptomatically expressed this fact in a rather unfriendly tone. In an effort to justify the fact that only one Latin American artist (Alfredo Jaar, from Chile) was included in what purported to be an overview of the best art on the market over the last five years, he declared that "it is not possible to show the situation of countries where art is always trapped between a great tradition lost and a wish for contact with the modern world."[32] This view seems to be pervasive and may help explain the segregation of Latin American art and, until not long ago, the absence of Latin American conceptualism in major topical exhibitions.

21 *The Historical Unfitting*

Until recently, all major exhibitions reviewing conceptualism had neglected to incorporate or to evaluate the contribution of Latin American artists. It is an issue about which I am of two minds. My ambivalence probably is the product of the same split I described as part of the exile experience: trying to keep one's independence while longing to break into the mainstream. In that sense, writing all this in New York rather than in Montevideo is probably conditioning my views and my ability to overlook and not to overlook certain things. But there is a more complex issue, which, of all people, the Nazi professor Paul Schultze-Naumberg (of "Degenerate Art" fame) once expressed clearly. In 1928, he wrote that "the battle of *Weltanschauung* to a large extent is fought out in the field of art."[1] And undeniably, mainstream and peripheral conceptualism were representing *Weltanschauungen* as different as formalism and political involvement.

It is this deeper clash that explains why the occasional formal coincidence between varieties of conceptualist art does not make them either equivalent or complementary as cultural practices. That both mainstream and Latin American conceptualism share an interest in textualization and dematerialization makes it tempting to lump them together. However, the persistent presence of poetry (both visual and literary) and of politics (both in content and impact) in conceptualism on the periphery makes one want to keep them separate.

The ubiquity of an art market defined and controlled by the mainstream makes it difficult both to effectively maintain independence and to discuss differences. Furthermore, it also puts the periphery in a position of unfair and unintended competition. When the conceptualist works of the periphery look like something produced in and for the mainstream, this resemblance, even if purely coincidental, is denounced as derivativeness and thus downgrades the work. On the other hand, when the difference is too marked, it is used as justification for exclusion. The result is that the periphery is removed from the game twice.

So, one can say that from a formal point of view, much of early Latin American conceptualist production conformed to mainstream requirements, yet most

exhibitions that reviewed the international history of conceptual art ignored or downplayed its role.

The 1970 Information exhibition at New York's Museum of Modern Art may seem to have been a notable exception, for it included work from what the organizers perceived as a truly international movement. Nevertheless, as we have seen, this exhibition also suffered from serious problems. "Mainstream" is usually seen and discussed as a fact, maybe one infected by dominant ideologies. But within this discussion, mainstream is not just a factual presence; it affects decisions as if it were an ideology, a self-fulfilling one at that. In 1971, the Guggenheim Museum held its Guggenheim International, a show that included only one artist from the periphery, Antonio Dias from Brazil. In a review of the show, art critic John Perreault illustrated this ideology, writing: "Since quality and originality and breadth of accomplishment seem to have been the only criteria, most of the artists represented are from the United States."[2]

However, the problem is reflected not only in shows that pretend to be international, but also when applied to surveys of external localities, like MoMA's ambitious 1992–1993 survey exhibition, Latin American Artists of the Twentieth Century.

Fairly enough, the show included conceptualist works, but the earliest works exhibited were dated 1969. As a mega-exhibit that originated in Seville "in celebration" of the fifth centenary of Columbus's first voyage, this show intended to fulfill its objective as stated in the title: to provide an exhaustive and definitive documentation of Latin American art. The "early" conceptualist pieces were by two Brazilian artists: Antonio Dias, who was otherwise represented with non-conceptual pieces of the late eighties; and Cildo Meireles, who was correctly represented with his *Tree of Money* of 1969.[3] León Ferrari was totally absent from any category. Hélio Oiticica, whose most influential body of work dated to the early 1960s and connected with what later became known as conceptualism, was represented by one piece, dated 1958, from his constructivist period. All other artists included, and who began their conceptualist work during the 1960s, were only represented by work from the 1970s.

After Seville, the exhibit traveled in Europe and finally came to MoMA in New York one year later. By then, it had expanded to include three Oiticica pieces, all of which belonged to his constructivist period, were dated 1959, and still had nothing to do with conceptualist concerns. The predictable effect of this stratagem became clear during the stop in Paris. The press release of the Hotel des Arts (where one part of the exhibition was displayed) emphasized the work as belonging to the 1970s and as basically being conceptual with a political spin.[4] The

apparent goal of moving Latin America's history forward by one decade had succeeded.

These anecdotes, of course, could be dismissed quite easily as paranoia, but my paranoia in this had surfaced long before the show opened. While the curator was in the process of selecting work for it, I had a long conversation with him. I raised the issue of the importance of dates and how these would affect the image of Latin America vis-à-vis the center. I do not believe I could have been the only artist who approached him on this matter. In my particular case, he had already selected several pieces that were dated 1970 and after. I expressed my concern about the historical accuracy of the show, offered to reduce my participation from the chosen six to just one picked from many modestly sized pieces of the midsixties, and suggested he do the same with other artists. The conversation was very friendly, and I left MoMA's offices persuaded that I had made a convincing point. In fact, I probably had only drawn attention to a threat to the notion that whatever happened in Latin America was a consequence of earlier creations in New York.

Several major overviews of conceptual art were organized during the decade of the 1990s, each one trying to put on record a definitive history. Some of these shows were self-contained as a pocket in twentieth-century art history; some intended to provide a link with so called neoconceptualism. The more ambitious of the first kind took place in the Musée d'Art Moderne de la Ville de Paris and was called l'art conceptuel, une perspective (November 1989–February 1990). There wasn't a single Latin American artist in it, and, in general, the introductions read as if no art was being made outside of Europe and North America. A 1995 exhibition in the Museum of Contemporary Art in Los Angeles, Reconsidering the Object of Art: 1965–1975, was a little more open and included Argentinean artist David Lamelas.

In 1994, the Centre Pompidou organized the exhibition Hors limites, l'art et la vie 1952–1994 (Out of Bounds, Art and Life, 1952–1994). Hors limites did not concentrate on conceptualism as such, but its aims were to explore many of the topics touched on in this book. The title announced the very important topic of the blurring between art and life, and then the exhibition, without any explanation, proceeded to focus on European and North American artists. An extensive and otherwise interesting and useful chronology printed at the end of the catalogue was a little more inclusive. Although not represented in the show, Oiticica was mentioned as being somebody important. The only other reference to Latin America was one citation to Mexico: it was a reference to a piece that U.S. artist Robert Smithson made there in 1969.

Although the lopsidedness of the hegemonic account of these events is most evident in mainstream exhibitions, the burden of blame doesn't lie only on the shoulders of the hegemonic institutions. Some Latin American organizations, often connected with big corporations and economic interests, contributed to the blurring of any differences between conceptualism on the periphery and that of the center, hoping that Latin American artists would be recognized.

The Centro de Arte y Comunicación (CAYC), a gallery space in Buenos Aires that combined the display of art with the lamps manufactured by its owner, provides a good case study. The CAYC was particularly active during the late 1960s and the 1970s. It had the advantage of being economically prosperous, at least when compared to other Latin American institutions. During that time, the CAYC tried to push Argentinean and Latin American artists into the mainstream. While there is nothing wrong with this, the strategy employed was more debatable. First, its director, Jorge Glusberg, included himself in a group of artists promoted by his institution. Second, given the focus on self-promotion and assimilation, what could have been a serious program of balanced and eclectic exhibitions was reduced to opportunistic switches designed to gather mainstream wind in his sails. Glusberg held the view that mainstream was a contagious quality that could rub off on his artists if they intermingled with big international names.

It is only fair to say that CAYC wasn't alone in this strategy. Fame by association was also used in other countries. One outstanding example was Germano Celant's handling of Arte Povera, the group gathered in 1967 under the name he brilliantly coined. The name was then used two years later to title the book that launched the Italian movement into the international arena.[5] But the book didn't stop with the initial Italian artists. It included eleven artists from Italy, sixteen from the United States, three from Germany, three from Holland, and two from England and raised the suspicion of wanting to validate the Italians through the use of a majority of non-Italian artists. By 1985, when P.S.1 in New York held a retrospective exhibit about Arte Povera, the validation was evidently no longer needed, for the show was scaled back to the original Italian artists that had initiated the movement.[6]

Stressing a formalist approach, at least initially, CAYC overlooked the importance of the politically oriented conceptualism that was taking place under its nose (as exemplified by 1968's *Tucumán arde*). Not only did CAYC play into the hands of a cultural homogenization (mostly based on imported prepackaged values), but it also tried to assert its importance in this task by carpet-mailing the world. Promotional material was incessantly sent to all individuals with some

degree of power in the international cultural scene, and CAYC became a carica-
ture of solicitation.[7]

As an activist who has been very perceptive about power struggles in her own
environment, Lucy Lippard was the one who had to call attention to Argen-
tinean political conceptualism on its own terms. In 1970, the occasion was the
preface to the catalogue of her exhibition 2.972.453, which took place in the CAYC
gallery. In it, and guided by the caution that was required under the Argentinean
dictatorship of the time, she stated:

> Social change, radical politics, computer storage/retrieval methods, group
> therapeutic techniques, modern disposable living, lack of faith in existing
> cultural institutions and economic systems have all affected the emer-
> gence of dematerialized art. Because it is usually lighter physically and
> easily reproducible, its mobility and immediate geographic range is
> greater than that of painting and sculpture. Rapid dispersion makes inter-
> national development and interrelationships clearer. (Some of the first
> work in this field I was aware of was made by the Rosario group in
> Argentina.)[8]

Rosario is a city about 250 miles northwest of Buenos Aires. The Rosario group
mentioned by Lippard was the team of artists that produced *Tucumán arde*.
Meanwhile, in a second introduction to the same show, CAYC director Jorge
Glusberg affirmed that conceptualism "does not center interest in the contents
of the work of art, but on the nature of the information itself" (unnumbered
index card).

Both Glusberg and Lippard underlined the dematerialized quality of the new
works of art. For Lippard, dematerialization was a good tool to use for explo-
ration, one that paralleled other forms of art and was also effective for the dis-
semination of dissent. She saw the potential of conceptualist strategies for
dealing with issues of social liberation in a local context. For Glusberg, in con-
ceptual art, "the merchandise is pure information."[9]

Earlier, in 1969, CAYC had organized an exhibition of computer graphics. This
may explain Glusberg's need to present conceptualism as an example of a bare-
bones information system. In the years following, CAYC continued with a dual
focus on art and technology and also on a catchall "systems art." A switch took
place in CAYC some time later, when Italian critic Achille Bonito Oliva invented
the international movement known as trans-avant-gardism, which embraced
Italian, German, and U.S. postmodernist neo-expressionism. The CAYC joined the
promotional drive for this movement and included some Argentinean artists in

trans-avant-garde exhibitions. CAYC 's aesthetic and political flip-flops—at some point politicized artists were also included—should probably be understood in context. Political repression in Argentina was enormous; CAYC 's finances were bolstered by government lighting contracts, so taking some unpopular stands could have had disastrous consequences.[10]

CAYC was not alone in promoting an internationalization of styles. One could say that the path had already been opened in a grand way by the São Paulo Biennial two decades earlier. That biennial, copying and competing with the Venice Biennial, was a tool to attract international art to Latin America. This policy was then followed and refined during the 1960s by the Instituto Torcuato Di Tella in Buenos Aires, which, in spite of the 1968 scandals, also had some influence on Latin American conceptualism. Other organizations, smaller biennials, and institutes that later proliferated around the continent addressed the work of regional artists in their own environment, but primarily for reasons without any noticeable ideological motivation.

It took until 1984, when the First Biennial of Havana opened, to have a major forum available to discuss power in relation to art. The first four versions of the biennial attempted to sift through the intricate mesh of assimilative art as opposed to identity art and socially active art. As a biennial that was self-declared to be a "clearinghouse," aesthetic issues had to remain open. The installation format and conceptualist strategies were heavily represented in all subsequent biennials in Havana. However, that was a sign of openness and did not mean that these strategies were actively endorsed as particularly appropriate for a mission of change. Despite the receptiveness and clarity of the Havana Biennials, it is interesting that the topics for discussion sponsored by these biennials never included the role of the "object" as a cultural agent. Instead, they were focused on the more obvious narrative quality of politics. The more important task of understanding how art articulates a community by helping visualize reality and myths, and thus develops its own guidelines within that community, has been overlooked. For a variety of reasons, the Havana Biennial faded during the last decade of the twentieth century and, unfortunately, no other arena has appeared where these issues can be discussed and were one could develop strategies to help resist the impositions of the mainstream.

Some time ago, the neosituationist collective Luther Bisset Project made an interesting point that can be extrapolated to art and to the topics overlooked by the Biennial: "A myth should be as alive as the community that narrates it; when it becomes sterilized, one can also say that the community has ended."[11] It can be said that when the mainstream takes over, that is precisely what happens. The

communities on the periphery are forced to substitute the myths of the mainstream for their own myths, and dictated art for their own art, and then they stop living. To stay alive, artists then move to create, not within their own history, but within a borrowed history. So, we are condemned to the desire of being recognized in that borrowed history, but the desire is inevitably coupled with the right to resent it.

ethical decisions and leads one to hypothesize about the vacillations that a Benetton offer could create in any politically inclined artist. Confronted with the opportunity to use one of these ads as a vehicle, tapping into the power associated with the medium, a refusal is neither easy nor obvious. The issue is totally different from the previous political use of billboards by artists like Alfredo Jaar in Chile (before settling in the United States), Bernardo Salcedo in Colombia, the BUGA UP group in Australia, and the several U.S. artists who worked in the 1980s on the alteration of existing billboards. In the hypothetical Benetton-type offer, one is faced with a different conundrum. Given the dissemination power of the company, some consciousness-raising could be achieved by the literal text and image. One would thus have a corrupt tool, but one that was ideologically successful.

Advertisements may offer Third World images, but they do so at First World prices and, slick and spectacular, within First World aesthetics. The shift of political causes into advertising implicitly lays the groundwork for a move of the (fine) artist into a formalist mode, thereby further distancing life from art. Art therefore is again confined to the status of a fragmentary discipline, incapable of subversion, but within an ever more confusing situation.

On the one hand, the aesthetics reserved for art have been absorbed into "life" by the way commerce is operating; but on the other, we are also being increasingly kept away from reality and from any news about reality. Television networks have developed techniques of incestuous news making. With increasing speed, TV series take plots from "real-life stories" picked up from the news. Newscasts, then, take the development of their own television series as news items.[16] The steadily advancing globalization of information carries this network-specific usurpation of life by spectacle to the periphery. Debord expressed it clearly when he claimed that it is not only an economic hegemony, but also the hegemony of the spectacle that defines the domination of underdeveloped regions.[17]

Fortunately, even in Debord's terms, the spectacle on the periphery can sometimes generate its own antibodies, especially if it takes into consideration a strong sense of locality. In the supercity, the neighborhood is probably the only space left where locality and community can strengthen each other. Superbarrio (Superneighborhood) is the name taken by a Mexican social activist whose aesthetics are connected with the wrestling scene and the comics culture that surrounds it, and with a tradition of street theater and of circus activities that generated the "*carpas*" (tents) on the border with the United States.[18] Superbarrio became the character that used spectacle with its grand superhuman potential to address small local crises, thus strengthening the community.

Superbarrio

Superbarrio Gómez's reason for being was to save tenants living in poverty from being evicted from their homes sometime in June of 1987. According to myth, a street vendor who had actually been a wrestler heard a housewife in the process of being evicted exclaim, "We need Superman to save us from these evil people." So Superbarrio got a costume and a mask, embroidered an "SB" on his chest, and started to show up during evictions.[19] Closer to the truth, on June 9, 1987, in a meeting of the Asamblea de Barrios (Neighborhoods Assembly), a woman in the audience remarked about the need to have a defender for the poor and raised the issue of her own eviction.[20] The organizers of the meeting visited the woman's dwelling, prevented her landlord from evicting her, and consequently decided to create a symbolic figure for future actions. Thus Superbarrio Gómez was created.[21]

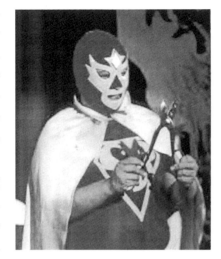

Figure 22.1. Superbarrio Gómez.

Superbarrio went to court to present legal objections strong enough to prevent more than 1,500 evictions in five years. Since eviction notices are publicized in advance, Superbarrio is able to be present during the critical moments. It also helped the cause that, over time, a team made up of several different people gathered under the name. While it is not known how many Superbarrios were in action nor how they coordinated their actions, it is claimed that at least three individuals were involved.[22] In an interview, Superbarrio explained that

> what we do is to transform protest into a festive party.... We have to
> open the faucets of creativity, of popular ingenuity, of collective memory.
> We have to rescue our traditions and our cultural forms for the battle; we
> have to reinvent those forms of action where people are not spectators,
> but protagonists.[23]

His explanation of his strategy signals the enormous burden of creativity needed just to hold the ground. The process and speed of the recirculation of information made his aims increasingly unattainable; nevertheless, he persisted. In 1989, Superbarrio went on tour in California and Baja California to denounce the treatment of immigrants (as a consequence, Fresno declared March 2, 1989, as Superbarrio Day). In 1990, in front of the U.S. embassy, he showed how tamales are made. The occasion was the trove of tamales found in Noriega's refrigerator by the U.S. invaders, who mistook them for cocaine packages. In 1996, Superbarrio decided to run for president of the United States. He visited cities

along the Mexican border and mixed truth ("The American Dream can't be free trade in the South and protectionism in the North" and "There can't be economic integration without political integration") with humor (he claimed he had political endorsements from Superman, Spider Man, and Batman).[24] In a long and quite serious speech, he pointed out, among other things, that 3,200 undocumented workers were killed trying to cross the Río Bravo between 1984 and 1994.[25] While Superbarrio has kept his spectacle going, his later actions became more sophisticated. The spectacle began to follow the traditional model of image making used by politicians, shaped as a way to accumulate power and then, in the next step, to influence the flow of information in order to maintain that power. Superbarrio adopted the format and translated it for the purpose of empowerment. In his presidential campaign, and wearing his garb and mask, he also gave a speech to the students of Harvard University. Asked if he was going to remove his mask someday, he answered: "Distrust all politicians who wear masks and don't show their true faces."[26] His position, however, was less ambiguous: based on the theory that all the citizens of the Americas should have a right to self-governance, he proposed that all Latin Americans should be able to vote in U.S. elections.

23 *Beyond Art*

If I weren't able to write, during moments of euphoria I would
be a guerrilla, during those of passivity, a magician. To be a
poet includes both things.

—JOAN BROSSA, "FASES," *LA PIEDRA ABIERTA, 1968*

Fortunately, the Latin American experience with art as a form of resistance, both conceptual and nonconceptual, and regardless of technology, belongs to a tradition of de-institutionalization. The function of art, one of the institutions to be addressed, became something very relative and porous. What became more important than ever was the distinction between activist creativity as a tool to create culture and promote independence, and art as a globalizing commercial enterprise. This distinction does not preclude the making of art in its canonic forms, nor does it preclude technology. But it adds something that is not rooted in the canon of art skills: a sense of community on the periphery and a concern for exploring and sustaining that sense. The situationist artist Constant expressed the idea behind this "meta-artistic" view: "Without a social revolution, the slogan 'Art is dead' only means 'The remaining freedom is dead,' therefore, down with anti-art."[1] This still remains a good admonition today. It defines the art area, understood as the area of activist creativity, as a temporary kind of parking lot or, even better, a reservation, where our backs are not and cannot be turned, and from where we are always ready to resist and act.

It is this focus that truly dematerializes and contextualizes art, taking it beyond our traditional expectations. It does so inasmuch as it distinctly puts it in a different hierarchy, separate from the physical media that shape its visual appearance. As long as this view is maintained, the division of art from life can, at the very least, continually be questioned and challenged, and the longing for utopia can be kept alive.

Faced with the technically cumbersome task of filmmaking, and commenting on his notion of "imperfect cinema" many years after publishing his essay on this topic, Cuban filmmaker Julio García Espinosa wrote:

Imperfect like life, which never ends, because only what ends dies. Imperfect because I believed and believe that art is a disinterested activity and that to reach it we have to transverse through the poetics of an interested path, that is, imperfect. . . . We have to fight for the difference, against uniformity, against homogeneity in taste, for sensitivity and thought.[2]

Conceptualism at large could be defined as a wishful step toward a disinterested path and toward perfection. It is a way of removing from the materially defined crafts all the interplay of anguish, emotions, quests for knowledge and mystery, wishes to push an audience to reach the unknown, desire to improve humanity, and whatever else one usually throws into the art pot, to then put it into the realm of ideas. It is debatable whether, in fact, all those things were removed during the history of conceptualism. Yet, it would seem that in much of the conceptualist production, many things are still missing. Often, expediency is achieved with one-liners at the expense of ungraspable things. But no matter how complex or schematic the result, it is clear that the artist remains responsible for both form and content.

Both of these responsibilities should be discussed here. In regard to *form*, pure dematerialization is no longer enough of a challenge against the art establishment. In the mainstream, the events surrounding a work by U.S. conceptual artist Lawrence Weiner caricaturize how the power of commodification can reach past the art object and envelope ideas. In 1992, Weiner had installed his piece *Eine Kartoffel Zwei Kartoffel Drei Kartoffel & (Mehr)* (One Potato Two Potatoes Three Potatoes & [More]) in the German town of Ditzingen. Because of a promise of purchase, the piece was left installed past the period reserved for the exhibit. When it became clear that there was no money to buy the installation, the artist demanded its removal. The installation was then stored, and a legal process was initiated. The proceedings of the case included a determination of who might be liable for the storage expenses. Weiner's dealer, Brigitte March, proclaimed: "Without purchase there is no property right. What is stored is material without artistic value,"[3] and she therefore argued that the gallery should not be held responsible. Her dictum ultimately applied only to the ability of transaction; nevertheless, she took for granted that she had removed the action part as well, thus invading Weiner's territory. And even if Weiner himself had renounced the action part, it would seem that this could not be undone.[4] While Weiner's piece had some physical presence (otherwise it wouldn't be stored), it becomes clear that under the circumstances it might be better, if the action is to

remain pure, for the artist to create pieces on a level where possession and trans-action become irrelevant and meaningless.

In regard to *content*, there is another, maybe even higher level of responsibility, at least one that is more complex. Intentions and effects change according to the public addressed. During the heyday of conceptualism, while going through all the steps to pin down a message, both a mainstream conceptualist and a periphery conceptualist may have ended up with a scribble on a scrap of paper. Both scraps looked the same. But the information left on the scrap of the mainstream artist was, in most cases, about the information and the scrap itself; the information left on the scrap of the periphery artist was more often likely about the artist's surroundings. The difference is not minimized by the probable absence of any social change due to either, and reviewing the history of activism in art, it is fairly clear that the effect was very limited. Yet, there is the importance of how that piece is inserted in the social context, what it is supposed to unleash and what it can unleash. Back in 1923, René Magritte had written that aside from those who seek gold, the artist should create what he is looking for. Conceptualism may have been the best strategy to refine the mission of *looking for*.[5]

.

Activism in art has generally been based on the promulgation of positions, an activity aimed at a consciousness ruled by logic and information. To be successful in this, the use of the means of the oppressor and competing with them was inevitable, something already exemplified in Simón Rodríguez's work of two centuries ago. Nevertheless, activism in art, particularly in conceptualism, made important contributions mostly by challenging and cracking open the acceptable artistic means of the time. However, the decisive step to distribute and democratize not so much the ownership of art objects but the artistic power was mostly lacking. This inability was not due to a lack of political lucidity, but to the very literal application of lucidity, which translated into "programs." None of the programs considered the possibility of allowing the unknown to become part of a political platform. Artistic means were used to communicate a predetermined message, and the possibility that poetic evocations could generate new creations was effectively ruled out, a problem still unresolved today for two reasons: one is technical dazzlement; the other is a restricted definition of empowerment.

Today, as in other times, the artist is threatened by the seduction of the exploration of new media and technologies. It is easy to confuse new art with new

one of its guidelines, it seems fitting to mention here that the Uruguayan elections took place in an exemplary electoral process on October 31, 2004. Information that would normally only deserve a footnote, if any space at all, should therefore have a place in the text. The Tupamaros, who during the electoral campaign did not renege on their ideals, received 42 percent of the vote within the Broad Front coalition. With that percentage, they became the largest group of true ombudsmen in any government ever. Concurrent with the election, a referendum was held to amend the constitution and declare water a public good immune to privatization. The amendment was approved. With the inauguration of the new government, a few months after his statement, Mujica was elected president of the Uruguayan Parliament. During the first two days, the new government declared its independence from foreign powers; created a Ministry for Social Development; signed a treaty to link power networks with Argentina, Bolivia, Brazil, and Paraguay to avoid outages; sent a delegation of doctors to Brazil to study ways of acquiring medicines outside of the monopoly circuit; signed a beef-for-oil treaty with Venezuela; started a search for the hidden burial places of the "disappeared"; reopened one of the main breweries whose closing had caused massive unemployment; prepared a rational plan for replanting sugarcane (another industry whose demise had caused massive unemployment); and resumed diplomatic relations with Cuba.

The changes the world underwent during the last three decades of the twentieth century had tempted many into a position of cynicism and skepticism toward the pursuit of social justice, a possible product of faddish idealism. Movements that pursued these ideals, as much through political radicalism as by seeking educational reforms and using conceptualist strategies in art, seemed understandable only within the context of that fad and, in the case of politics, seemed seriously misguided and devoid of any historical significance.

Certainly, many errors were committed in the name of those ideals, but it is possible that the problem was not so much with the idealism as with the perception of time. The participants in all of those dynamics firmly believed that a strategy of subversion would be immediately rewarded with social change. Thus, the major mistake may have been a misplaced hope for instant gratification. One is tempted to use as an obvious analogy the assumption by the U.S. government that the 2003 bombing and invasion of Iraq would be received with flowers.

It is a happy coincidence that the absence of flowers in Iraq—that lack of an instant reward—turned out to give Latin America some breathing space and allow for a resumption of its own history. More importantly, it has to be recognized that the new developments in the continent are happening on a ground

fertilized by these same movements that had been met with skepticism. Instantaneity here may mean three to four decades of persistence rather than an immediate, fleeting spark.

From the perspective of the traditional mainstream and the centers of power (however one chooses to define them), the plight seems to remain the same, and so does the general policy. As early as 1948, George Kennan, then director of Policy Planning at the U.S. Department of State, observed in the name of the United States that

> the U.S. has about 50 percent of the world's wealth and only 6.3 percent of its population. In this situation we cannot fail to be the object of envy and resentment. Our real task in the coming period is to devise a pattern of relationships which will permit us to maintain this position of disparity without positive detriment of the national security. To do so we will have to dispense with all sentimentality and daydreaming and our attention will have to be concentrated everywhere on our immediate national objectives. We need not to deceive ourselves that we can afford the luxury of altruism and world benefaction. We should cease to talk about such vague and unreal objectives as human rights, the raising of the living standards and democratization. The day is not far off when we're going to have to deal in strict power concepts. The less we have been hampered by idealistic slogans the better.[12]

Nearly half a century later, those same "strict power concepts" are being navigated in a tide of regression and obscurantism that perceives reason as a form of unpatriotic activity. Recent developments in Latin America seem to raise some hope against this onslaught. Ironically, this is happening in a moment when local light may not be sustainable against a global darkness in which ethics are increasingly reduced to a form of passive resistance. "Ethics as a new aesthetic" seems like a needed proactive step. Still unresolved, however, is how that step can be complemented with the continual subversion and poetry required for the expansion of knowledge. In whatever form it took, the art of the past did not include all the needed variables—that is, all the variables possible—to enable us for a better life. Yet, some good seeds have been planted.

Notes

Introduction

1. Paris, 1953; cited by Ohrt, *Phantom Avantgarde*, 61.

2. This doesn't mean that craft wasn't or shouldn't be used as an exploration lab. In 1962, I met Hans Haacke for the first time in the Pratt Graphic Art Center. He was making inkless etchings with dots in the tradition of the German Group Zero. I left after some months and returned in 1964. One of my first questions was about Haacke's work, if he was still making dots. I was told that some weeks after I left, people heard Hans joyfully celebrating that the dots had connected and had formed a line.

3. Lippard and Chandler, "Dematerialization of Art," 31–36. In this essay, the authors blur the division between minimalism and conceptual art.

4. One of the titles I considered for this book was *Contextualization and Resistance*.

5. The exhibit started at the Queens Museum of Art in New York, May–August 1999, and subsequently went to the Walker Art Center in Minneapolis, the Museum of Contemporary Art in Miami, and the MIT List Visual Arts Center in Cambridge. The intention of the exhibition was to decentralize the view of the development of conceptualism and to see all the regions of the world as provinces within an overall federation and as equal partners using conceptualist strategies to respond to local issues within local histories. This approach was then followed and adjusted to a more truly global perspective by Beyond Geometry, an exhibition that started at the Los Angeles County Museum of Art (LACMA; 2004). This show presented a unified history, but with full acknowledgment of the work produced on the periphery.

6. Morgan, "Conceptualism," 110.

7. Ozenfant, *Foundations of Modern Art*, xi–xii.

8. One tends to underestimate the power of publishing houses. Thanks to the influence of José Ortega y Gasset's publication *Revista de Occidente*, a rather esoteric book like Oswald Spengler's *Decline of the West* was much more of a household book in Latin America than it ever was in the United States. The Mexican publisher Fondo de Cultura Económica, owned and run by an exile of the Spanish civil war, was another powerful filter and educational tool that at the time guided intellectual culture in the whole continent. In general, French structuralism, Umberto Eco's writings, and the works of other intellectuals were also much more immediately accessible, and South African apartheid was genuinely abhorrent in Latin America a good decade or two before the U.S. press decided to publicize it.

9. Papini, *Gog*, 18–23.

10. Ibid., 198–214.

11. Chen, "Erratum Musical."

12. The production of these artists included monochromatic paintings with a meaning solely defined by a joking title, as in the work of Paul Bilhaud, followed by that of Alphonse Allais in 1882. They prefigured Kasimir Malevich and Yves Klein. *Mona Lisa with a Pipe* (Eugène Bataille, known as "Sapeck," in 1887) was made well in advance of Duchamp's tampering. Even an example of silent music had already been created during that period: Allais's "Funeral March for the Deaf" (1884), which had a corresponding blank score sheet. See Altschuler, "Pranksters of Paris," 82–87, and Cate and Shaw, *Spirit of Montmartre*. The groups had anarchist tendencies and, with their antibourgeoisie ideals and acts, set the stage for Alfred Jarry and his *Ubu roi* a few years later (1896). One of the poets of the group, Rodolphe Salis, ran as a candidate during the 1884 elections with the intention of having Montmartre secede from Paris (Cate and Shaw, *Spirit of Montmartre*, 28).

Chapter 1

1. "Constellation," in the sense given by Theodor Adorno, was suggested to me by Mari Carmen Ramírez, the argument being that "genealogy" implies a lineage that is not present in Latin American conceptualist expressions. "*Compota*" was the contribution of Héctor Olea, who suggested the term after reading a version of this manuscript in the mid-1990s. Olea believes that "*composta*" is the original word, which generated, in turn, not only "*compota*" but also the English "compost." Gonzalo Fernández de Oviedo first used the word "*composta*" in the introduction to his *Historia natural*. According to Olea, it is a "historical salad which doesn't completely fit an intellectual order and where the author's tribulations enter as much as the picturesque and human aspects of testimony, confronted with the awareness of a more complex reality than history can reveal" (personal communication to the author, October 1999).

2. Camnitzer, *Una genealogía*, 179.

3. Camnitzer, "Contemporary Colonial Art," 224–230.

4. Camnitzer, "Ponencia," 78–80.

5. Rodríguez, *Obras completas*, 1:315; emphasis in original.

6. Ibid., 2:134–135.

7. Richard, "Neovanguardia y postvanguardia ," 232.

Chapter 2

1. Lewitt, *The Turning Point*, 18.

2. Benjamin, "Author as a Producer," 86; emphasis in original.

3. Argentinean artist and critic Nicolás Guagnini, using compatriot artists as exam-

ples, points out: "I have never seen a worker take off to [organize a rally on the] Plaza de Mayo after seeing [an abstract] painting by Lozza, but I did see the petite bourgeoisie thrilled by [political and realistic work] by Berni and Castagnino without interruption since the 1950s" (personal communication, June 18, 2001).

4. Grippo's work is actually a transition piece between the more politically active production of the generation of the 1960s and the more identity-oriented work that was produced during the decades following.

5. Grippo, *Victor Grippo*, 49.

Chapter 3

1. See Buchloh, "Buchloh Replies," 160–161.

2. Mas'ud Zavarzadeh's use of the term "intelligibility effect" as "a historical understanding of the material processes and contradictory relations through which the discourses of culture make sense" illustrates this point ("Theory as Resistance," 50).

3. For a discussion on the subject, see Buchloh et al., "Conceptual Art and the Reception of Duchamp," a discussion between Benjamin Buchloh, Rosalind Krauss, Thierry de Duve, Martha Buskirk, Alexander Alberro, and Yves Alain-Bois.

4. An interesting reverse example is that of Rudolf Borchardt (1877–1945), a German poet and translator who around 1910 decided that Dante should have written the *Divine Comedy* in German rather than in Italian. Borchardt translated Dante's work into archaic medieval German, describing his position thus: "The genuine archaism intervenes in history after the fact, and forces it at will to change for the duration of the work of art, dismisses from the past whatever is not needed, and creatively surrogates out of its feeling for the present whatever it needs . . ." (letter to Josef Hofmiller, February 1911, cited by George Steiner in *After Babel*, 339). I was directed to this quotation while reading Amos Elon's *The Pity of It All*.

5. George Brecht was skeptical about his work fitting into conceptual art because he was interested in a "total experience." His doubts only make sense within the narrow confines of U.S. conceptualism, and it is no surprise that he moved to Europe. U.S. conceptualism concerned itself more with rules derived from the geographical area in which the art game itself was taking place.

6. Applying this point to an analysis of the early twentieth century in Latin America, Mari Carmen Ramírez goes as far as to talk of "ex-centric avant-gardes." The term is used to denote the absence of the European conditions for the traditional avant-garde, in which art had separated from and reached an autonomy and alienation from everyday life. Avant-garde artists (according to Peter Bürger) attacked the function of art as an institution in bourgeois society. In Latin America, with an ill-defined bourgeois society and a lack of the European infrastructure that nurtured the arts, the equivalent process was full of contradictions and paradoxes, leading to idiosyncratic results. David Alfaro Siqueiros, for example, would call for a reintegration "of those values that had disappeared from painting and sculpture while adding new values," when trying

4. Rodríguez, *Obras completas*, 2:25.

5. Cova, *Don Simón Rodríguez*, 170.

6. Johann H. Pestalozzi (1746–1827) developed his system in Switzerland and, like Lancaster, started with a school for the poor.

7. Rodríguez, *Sociedades americanas, edición facsimilar.* The facsimile reproduces a version printed in 1842; also in *Obras completas*, 1:356.

8. Rodríguez, *Sociedades americanas*, 1:260.

9. Rodríguez, *Tratado sobre las luces*, in *Obras completas*, 2:152.

10. Ibid., 151, 155. This paragraph still seems alive today and, among other things, also sums up the works Argentinean artist León Ferrari (1920–) created between 1962 and 1964, in which he explores the relation of meaning with the distortion of writing. Ferrari's works from this period became very influential for subsequent generations of Latin American conceptualists. The drawings of this period were exhibited under the title of *Politiscripts* in the Drawing Center, New York, in 2004.

11. The word "painting" here refers sometimes to "*pintura*" and sometimes to "*cuadro*," and in the latter is used as a metaphor or as a diagram.

12. Rodríguez, *Tratado*, 2:157. The word "abstraction" is obviously used here in a literal, nonartistic way.

13. Mallarmé, *Selected Poetry and Prose*, 105–106; translated by Mary Ann Caws.

14. Mallarmé, "The Book, a Spiritual Instrument," in ibid., 84.

15. Rodríguez, *Tratado sobre las luces*, in *Obras completas*, 2:183.

16. Cova, *Don Simón Rodríguez*, 14.

17. Morales, *Simón Rodríguez*, 16.

Chapter 6

1. The name "Tupamaros" had a triple reference to (1) Túpac Amaru, the rebellious Inca leader executed by the Spaniards in 1782 in Cuzco, whose real name was José Gabriel Condorcanqui; (2) Uruguayan gauchos fighting for independence from Spanish rule during the early nineteenth century who identified themselves as Tupamaros in honor of Túpac Amaru; and (3) a related song by a group of folksingers (the Olimareños) that was extremely popular at the time of the development of the movement. The name first appeared in a moment of internal rift among the factions forming the MLN in a leaflet titled "T.N.T.," or "Tupamaros No Transamos" (We Tupamaros Do Not Compromise).

2. The Socialist Party had become increasingly an establishment party and no longer fit the views of younger generations who had become more radical. Anarchism in Latin America had arrived through several waves of exiled European anarchists, the last one caused by the defeat of the Spanish Republic by General Francisco Franco. The Cuban Revolution became a big bone of contention for the older anarchists in the Federation, who could not accept the structure of the Cuban government and who were also resentful of Castro's crackdown on Cuban anarchists. Both issues overrode the